THE EXECUTION OF
SUN RA

VOLUME II

The Mysterious Tale of a Dark Body Sent to Earth to Usher in an Unprecedented Era of Cosmic Regeneration and Happiness

THOMAS STANLEY

THE EXECUTION OF SUN RA

The Mysterious Tale of a Dark Body
Sent to Earth to Usher in an Unprecedented Era
of Cosmic Regeneration and Happiness

Grateful acknowledgement is made for permission to reprint excerpts from the following previously published and unpublished material: Abram, David. *Becoming Animal: An Earthly Cosmology*, Pantheon Books, an imprint of the Knopf Doubleday Publishing Group, a division of Random House LLC, 2010.| Agamben, Giorgio. *Profanations*. Zone Books, 2007.| Blass, Charles interviews Sun Ra on WKCR, undated cassette.| Crump, Thomas in *The Anthropology of Numbers*, Cambridge University Press, 1990.| Danner, Mark. "After September 11: Our State of Exception." The New York Review of Books, 2011.| Fisher, Mark. *Capitalist Realism: Is There No Alternative?* Zero Books, 2009.| Hinds, John and Peter, interviews with Sun Ra, 1988.| Jahn, Robert G., and Brenda J. Dunne. "Margins of Reality: The Role of Consciousness in the Physical World." ICRL Press, 2009.| Kagie, Rudie, "Rudie Kagie Interviews Warren Allen Smith about Sun Ra," 2008.| Massumi, Brian. *A User's Guide to Capitalism and Schizophrenia: Deviations from Deleuze and Guattari*. MIT Press, 1992.| Ridout, Nicholas, and Rebecca Schneider, "Precarity and Performance: Introduction." TDR: The Drama Review, MIT Press, 2012.| Rycenga, Jennifer interviews Sun Ra for "The composer as a religious person in the context of pluralism." Graduate Theological Union, 1988. Transcribed and edited by Dan Plonsey, 1992.| Schaap, Phil, interview Sun Ra on WKCR, 1987.| Sinclair, John. *Sun Ra: Interviews & Essays*. Headpress, 2013.| Somé, Malidoma Patrice. *Of Water and the Spirit: Ritual, Magic, and Initiation in the Life of an African Shaman*. Putnam, Penguin Random House, 1994.| Stewart, James, "The development of the black revolutionary artist" in *Black Fire: An Anthology of Afro-American Writing*. Black Classic Press, Sterling Lord Literistic, Inc., 1968.| Strassman, Rick. *DMT: The Spirit Molecule: A Doctor's Revolutionary Research into the Biology of near-Death and Mystical Experiences*. Inner Traditions/Bear & Company, 2001.| Szwed, John. *Space is the Place* Pantheon Books, an imprint of the Knopf Doubleday Publishing Group, a division of Random House LLC, 1997.| Wade, David. *Symmetry: The Ordering Principle 1st U.S. ed.* Wooden Books. 2006.| Wetterwald, Elisabeth interviews Joe Scanlan as "Consumption and the Self" also as "Poesie du flux tendu: un Entretien avec Joe Scanlan." les Presses du Réel, 2003. Any third party use of these materials or any other excerpts contained herein is expressly prohibited. Interested parties must apply directly to rights holder for permission

Editing by Kirby Malone
Editorial assistance by Kifah Foutah
Book design by Allison Leigh Morrow
Cover art by Erica Fallin based on
an original photograph by Paula Stanley.
Inner cover glyph by Paula Stanley
Indexing by Dianna Haught

This *Execution* features the photographs of:
William Brower
Leon Collins (http://imichiganproductions.org)
Yusef Jones
Lee Santa (http://lee-santa.artistwebsites.com)
Paula Stanley
Charles Steck (http://www.steckphotography.com/)
Michael Wildermann (http://www.jazzvisionsphotos.com/)

Please address all correspondence to the author at:
omni@musicovermind.org

ISBN: 978-1-60047-997-7
Library of Congress Control Number: 2014937404

Wasteland Press
Shelbyville, KY USA
www.wastelandpress.net

The universe sent me
to converse with you.
Sun Ra

☥

This is a good book,
a book of information.

Cynt,
Space is the
Place,)
Thomas

This execution is dedicated to
Malcolm X, Chelsea Manning,
Mordecai Vanunu and everyone
else who has ever had to
tell a secret.

CONTENTS

Sun Ra

ACKNOWLEDGEMENTS

Many forces coalesced to put this book into your hands. I am aware of and quite grateful for this coalition. Some of these forces are people, some of whom will be thanked here. My incomparable mother, Joan Stanley, has been a constant strength and nurturer. What a gift her reassurances have been through the most trying parts of this journey. Her intelligence and love of language were an asset throughout the duration of this project. Her love has no bounds.

My children — Illana, Yemonja, and Cedar — surround and inspire me. In a sense this *Execution* was written to support their eventual work as parents. I am eternally grateful to Paula Stanley, who lovingly and patiently shared our daughters and their passage from incredible girls to amazing young women. It was Paula who insisted that we see Sun Ra and the Arkestra in Madison. That was my first live Sun Ra experience and it has never ended. Tamara De Silva has been my partner in parenting (round two) and has had to bear the brunt of life lived with this book and its many burly demands. It was Tamara

who created the psychosocial preconditions that necessitated this task, and I must thank her for the path that she cleared.

While the support of friends, old and new, is implicit in a project such as this, certain alliances must be emphasized. Bobby Hill and Imani Drayton-Hill have been my friends longer than anyone else. They know music and art and the connection between them and human progress; they have lived to actualize their ideals. We are all better off because of this, but their love and confidence have been a very precious and personal gift. Larry Alexander and I were co-authors on the *P-Funk Oral History* project. He has since been a good friend and solid comrade in the struggle for tonal justice. Bill Warrell was more responsible than any other single force for bringing Sun Ra's music into my community. His contributions to this project are both substantial and spiritual. Bevis Griffin is a rock-and-roll legend that most of you have probably never heard of. His friendship is a new alliance, but he arrived in my life quite serendipitously to tell a very timely story about grace and endurance, and he knows that the work we did was, in fact, a sort of preface for this book. Larry Witzleben headed my dissertation committee and in that capacity prepared me for the particular disciplines of writing really big things. At George Mason University's School of Art, there were many supporters but singling out some over others might be messy or controversial; so, those of my colleagues who were down with the book should consider themselves thanked! Add to these Luke Stewart and Leo Svirsky, prodigious young musical forces whom I have been privileged to build art with. Through numerous conversations (live and digital), their formidable ideas about history and consciousness have subtly informed the dialogical flesh out of which this text is formed.

Sonny has more friends than I could ever hope to, and several of these were instrumental in providing sources and

literary voices and has been a silent partner in my attempt to make a meaningful addition to the universe of words for longer than I can remember. When I asked him for support with this *Execution*, he first warned me that books as a mode of communication were very last-century, and then he promptly scheduled me on his television program in time to help take my crowd-funding campaign over the top. Greg Tate is the triangulation of Sun Ra's myth science through Amiri Baraka and hip hop. His foreword will energize your embrace of the story that follows and I am thankful for all that he has added to the intersection of music and letters.

Some of the forces that propelled this work left the planet long before its pages had been written. These include my friends David Mills, Larry Sifel, Carolina Robertson, and my dear father, Thomas W. Stanley. David was the lead writer of the *P-Funk Oral History* and a generous supporter of my art and scholarship. He was a meticulous writer and I have attempted to follow his example. Larry was a luthier, neighbor, and another early sponsor of my activities as musician and writer. He taught me about guitars as tradition and technology. Carolina was my teacher at the University of Maryland and provided my brassy template for the seminar as an arena of activism. She left the planet shortly before the completion of this book. My father should be here. He taught me how to love and without great love, all works are small.

Last, but not least, highest honor is reserved for Sun Ra and his crew, with Marshall Allen deserving immense gratitude for keeping Sonny's warp coils warm without allowing the Arkestra to become another faded tribute band. He is a master of living music and its connection to the imperishable soul. Thank you, Marshall for doing what Sun Ra asked you to do. May there always be an Arkestra to play Sun Ra's cosmic music.

A FEW REMARKS
ON ROMANCING THE RHIZOMES OF RA,
AND OTHER LOVE LETTERS,
FROM CHOCOLATE CITY TO THE MAGIC CITY
by Greg Tate

How to theorize Sun Ra? Therein lies a question and quest for the ages. How indeed with a figure who was such a fecund generator of ideas about everything born of woman, nature and all that Other stuff never dreamt of between heaven and earth in Horatio's philosophy? How does one further attempt to frame a system of logic around Ra who spurned all reductions and containments of human energies that did not feed the logistics of his own spectacles of the absurd? Like all the Magi of Great Black Music Ancient And To The Future, Ra believed the makers of African song engaged in what Jimi Hendrix once called a "magical science." Like George Clinton, Ra also understood that "everything good is nasty and nothing is good unless you play with it." Ditto Ra's faith that once the music was capable of raising the roof, one could sprinkle on whatever sort of "meta-foolishness" one wished – grandly-cum-goofily extrapolate upon the signifyin' equations blasting forth from dem sonic fictions. Part of the magic demanded one not only make things sound funkybutt

and free but hella-fun also. Ra had a nice bit of fun when he did magic-science. The necessity of funny business extended to his own poetic philosophizing as well. How serious any-one took Ra was never his worry. He was that rare prophetic figure who knew you were mis-educated about most things but embraced rather than railed against public ridicule and misapprehension. Never less than serious in his intentions or even his transcendental Black Cultural Nationalism, Ra never proposed some overarching reform salvation for the blood-ied but unbowed earthbound Black Bodypolitic. His central paradox was his belief that Black people's best hope lie in dis-ciplining their darkly energetic Astro=Black imaginations to orchestrally outwit their narcoleptic-gray oppressors. Thomas Stanley has given himself the daunting task of taking Ra seri-ously as a critical thinker while not violating Ra's refusal to exclude paradox, play, outright contradiction, jokes, puns, bon mots and loopy homemade aphorisms from the kaleidoscopic critical mix. If Stanley doesn't succeed in rationalizing Ra's arcana for academia he's certainly made the gamest attempt yet at rhizomaticising the many-splendored knotty tangle of Mr. Mystery's soaring and sonorous metaphysics.

THE IMMEASURABLE MIXTAPE: USER'S GUIDE

The mixtape is a well-established, deeply venerated grass-roots organ for sharing and discovering new musical experience. Since it emerged in the late 1960s and early 1970s, countless human minds have been completely blown by this pre-digital DIY platform for reprogramming recorded music onto cassette tape. So deeply anchored in the hearts of the people is this cultural form, that it has stubbornly retained its original name even as the physical substrate for this expression of sequenced sonic collage has morphed from magnetic tape to optically read discs, and, finally, shedding its body altogether, into the coded form of an mp3 playlist.

Each mixtape is a network across which flows a highly condensed exchange of value. It is a unique network in that this exchange is in full effect even in a network of only one node. Mixtapes are alter-radio in a very practical sense, allowing listeners to overcome and effectively bypass commercially fostered norms, trends, and filters in a way that was sporadically possible only for the briefest window in the history of

broadcast radio as a pro-music enterprise. This overcoming is a crime, an act of civil disobedience with a downbeat, a clear violation of applicable law. The anti-institutional nature of mixtapes shields them, to some extent, from the spiritually corrosive effects of the overground, official economy (in which the music was most likely produced) and enhances their apparent gift value. Paradoxically, this aura of authenticity has been adaptively co-opted by several musical communities (dancehall reggae or go-go, for instance) in a way that has allowed the basic idea of the mixtape to serve as an indispensable vehicle of commercial post-mass dissemination.

It is with this expanded appreciation of the mixtape as sonic heritage and nomadic ark of cultural dispersal that the author has chosen to graft this book project to what might possibly be the greatest Sun Ra "mixtape" (of all time). As you begin our journey, you will notice, at the bottom of each page on which a new section begins, a musical note alongside the title and discographical info for a particular musical track recorded by Sun Ra. It is suggested (without pressure or presumption) that each chunk of this text might best be digested to the accompaniment of the recommended musical selection. Kind of like a sonic meta-text or a semantic condiment.

I have included a playlist for this immeasurable mixtape in the first appendix. This allows the ambitious reader seeking the full effect of this literary endeavor to acquire the tracks and create a playlist within the audio database software of his or her choice. I would recommend enabling the crossfade playback option, thus allowing your reading to be supported by a seamless arc of uninterrupted tone science. I don't think it matters at all if the mix sequence and chapter order fall out of sync. What does matter is that my mix and this *Execution* be received as coterminous gestures of analysis, interpretation, and tribute, as gifts offered lovingly both to you and Mister Ra.

Sun Ra

CALLING PLANET EARTH

This book must be written now — before the world ends, again. The reader has every reasonable expectation from its title that this will be a book *about* Sun Ra, the late jazz mystic and self-proclaimed oracle of the omniverse. It is not that. *Space is the Place: The Lives and Times of Sun Ra*, John Szwed's excellent bio-ethnography of the man who called himself Le Sony'r Ra, stands with a small cluster of other important works that have as their subject matter a jazz musician of the last century who asked his friends to call him simply Sonny. The title of my work is an appropriation of a parable Sun Ra frequently told that was (like many of his extraordinary pronouncements) based on a doubling of meaning found in common words. Sonny reminded us that the English word *execute* means to put a plan into action as it also means to kill. Jesus, he said, was killed by Pontius Pilate and that *execution* simultaneously put into action

> **RECOMMENDED LISTENING**
>
> **Ancient Ethiopia** from *The Solar Myth Approach*

1

whatever plan was attached to the Nazarene's unique presence in the world.

Sun Ra spoke frequently of Death as the common enemy of mankind. We are each granted an unpredictably small number of years to function in these bodies, until the relentless pull of entropy sucks us back into the (star) dust from whence we came. At the point of the body's terminus, whatever plans we have asserted and pursued are interrupted and may very well grind to a halt, unless of course you happen to be Steve Jobs, Jimi Hendrix, Jesus, or any other individual whose life force far exceeds the historical footprints of their bodies. This includes Tupac Shakur, especially if Pac's holographic image can still rock live audiences and, more importantly, persist as the basis for contemporaneous collaboration and continued capitalist production. And it must include the mythic musician known to the world as Sun Ra.

So, in a sense, I sit at this keyboard as a tool of Sun Ra's impulsion, still responding to his unique presence and, in this response, crafting what I believe to be a triggering event for his plan to save the people whom he loved and served from the remains of the world that we have co-created. For nearly half a century, from stages scattered across this planet, Sun Ra scolded us: *It's after the end of the world**, and then, just to rub it in, would ask *Don't you know that yet?* Sun Ra's authority, his power and his ability to stand confidently before a global audience with such a cryptic mouthful of absurdly weird

* The author has used two conventions when referencing Sun Ra's language: In the case where Sun Ra is being directly quoted within the body of the text, quotation marks are always used and a proper citation is always offered in the endnotes. Where Sun Ra has been directly quoted within an indented blockquote, no quotation marks are required, but an endnote citation is always supplied. When, as in this case, Sun Ra's language is being referenced in a generalized way or when Sun Ra is being paraphrased by the author or by secondary sources, italics are used and there is no corresponding endnote entry. Phrases like *space is the place* and *it's after the end of the world* can be seen as spanning Sun Ra's music and his other expressive platforms.

shit was predicated on the strength of his musical art and its connection to the florid pageantry of affect and perception that is the miracle of human spirit. The book is a silent form, speaking internally through the conventions of language and the habits of rhetoric. On what authority, then, is my work founded? How will you know if I am telling the truth or if it is a truth that matters? And if it isn't the truth, does that make my testimony more or less valuable?

AUTHORITY

A student in a writing class I was teaching once included in an assignment (with some biographical focus) a description of the car accident that had damaged her spine and put her in a motorized wheelchair. A solid writer, she described in double-spaced detail the day her body and her life had been so brutally rearranged. Malcolm X writes in his *Autobiography* how the correspondence he developed with Elijah Muhammad, while incarcerated in Massachusetts for burglary, and the self-education prompted by that correspondence, changed or, as Malcolm

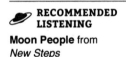
RECOMMENDED LISTENING
Moon People from *New Steps*

said, *saved* his life. Many, maybe most lives have such a hinge, a point of articulation that dramatically divides before and after, first and second acts. Sun Ra is not a car accident, and I am certainly not Malcolm X, but the grand fault line of my little life is undoubtedly its intersection with Sun Ra's massive project.

For me, he was the exemplar of an artist-activist working in a sphere of meta-political concerns that must be

addressed before any work of revolt or reform can be success-
fully mounted. Since our encounter, Sun Ra's heliocentric
effulgence has draped over most of the major movements of
my life, including my studies of Garifuna music in Central
America and my involvement with Lakota cosmology and cul-
ture as a participant in the once-banned *Wiwayang Wacipi*
(Sun Dance) ceremony. Sun Ra rejected the label of leader,
preferring instead to cast himself as teacher and catalyst. He
was, on many levels and in many ways, my teacher. Students
are to teachers, what crops are to farmers, and I am eternally
grateful to Sun Ra for the many doors of thought and spirit
that he opened for me and, of course, for the inexhaustible
hours of listening pleasure that I continue to find in the allu-
vial abundance of his recorded music. My work, in a sense, is
a highly personal love letter made public out of necessity, and
it is something of a qualifying exam to be weighed and graded
by readers of today and tomorrow.

I was introduced to his live act in 1982, at a rock club called
Merlin's in Madison, Wisconsin. I remember that show as a long,
disorienting experience. As Sonny's Arkestra swung through
big band standards and played show tunes at odd tempos, Ra
and his cast repeatedly changed costumes. Shimmering capes,
bighead monster masks, and tuxedo jackets came on and off
with no apparent rhyme or reason. In between the Ellington-era
swing numbers that I could almost recognize as the music of my
parents, Ra peeled off his own compositions separated by dense
synthesizer interludes that I imagined as perhaps the music of
my then un-conceived children. My first tryst with Sonny and
his crew was a dizzying theatrical frontal assault. I stumbled
out of Merlin's and into the night air, clueless as to what I had
just been through. It was clear that the experience had been
musical, but that awareness only served to obscure the true
purpose and nature of this eccentric extended performance.

I returned to Washington, D.C. in 1983, to work at the late Hodari Ali's Pyramid Bookstore near Howard University. My first Sun Ra albums — *Nidhamu* and *Star Watchers* [sic], both with fairly crude hand-decorated jackets — were acquired not long after I had moved back east. I bought the two LPs from a record rack owned and maintained by local radio personality and people's musicologist Jimmy Grey at a now defunct Haitian-owned health food store on the eastern end of the H Street corridor. At that time the area was still an infamous corner of the post-King-riots-eviscerated hood; today it is the bleeding edge of gentrification.

These records were inscrutable to my novice ears — large ensemble improvisations without much in the way of lead in, build up, or discernible center. They seemed roughly recorded, too loud for my tastes and strangely "off" for an artist whose reputation I was bumping into more and more frequently. "Damn," I thought, "eighteen cats playing together and no two of them are playing in tune." Today I have a much better appreciation for microtonal voicings and ensemble logic and could not be separated from either of those two priceless tablets of vinyl without a (nonviolent) struggle.

I first met Sun Ra in early 1989. I think I have the year right, but am unsure of the date. I had been listening to his music for less than a decade, and had caught up as best as one can with the aesthetics of *arkestraphonics* as a way of presenting modern big band music. In the late '80s, the 9:30 Club, like Merlin's, also catered primarily to a rock and punk audience. It was then located on F St. in downtown Washington. There was a stretch during this time period when the Arkestra could be heard at the 9:30 several times during the course of a year, almost always in front of a full house. Ras Kwabena-I, a street-vending afro-entrepreneurial dread whose long shoulder bag (full with sandwiches, self-published poetry and incense)

hung as low as his knee-length locks, knew some members of the band. Prior to the beginning of Sonny's set that auspicious night of first contact, Ras-I beckoned from the wings with a crooked finger. "You want to meet Sun Ra?" he asked. My eyes ignited at the impossibility of the offer, the brashness of the suggestion. *Sure.*

Sun Ra sat in the middle of one of the 9:30's dressing rooms, a mirror to his back artificially enlarging the cramped dingy space. He was talking, but I couldn't tell to whom. It wasn't really a conversation. Band members and fans drifted in and out as he spoke — a sharply delivered diatribe composed of equal parts current events, convoluted biblical references, and what I would later surmise were the core tenets of Ra-ism. His words were couched in a playful annoyance — a mock anger, inflated by language that was saucy but never vulgar, and drolly dumped out into the space without eye contact or inter-ruption in a thick, unburnished, but always-understandable drawl. I was meeting Sun Ra just before the chain of health crises that would ultimately cripple and destroy his physical form. At that time, he was still a very large man. His portly, sequin-draped body occupied the center of some imaginary orbit. His gravity was the reason why some twenty men and one woman (vocalist, violinist, and dancer June Tyson) were moving purposefully around his stationary mass, girding themselves with their own sparkly armor, preparing for a battle of souls and sounds.

I was deeply moved and somewhat perplexed by my first block of time with Ra. There was something that was just odd about the man — queer beyond gender, self-formed. I spent the following week trying to put language to his novel pres-ence and his equally unusual mixture of prognostication and judgment. At the time, I was employed as a crisis counselor at a halfway house for the most disturbed of mentally ill adults.

Ours was the last stop before hospitalization, a final shot at getting it together under 24-hour supervision with lots of drugs. I was, by then, well acquainted with the charisma of the insane. There was among our clients, for example, one young man who stayed mostly in his room generating finely rendered pencil illustrations of the most horrible scenes of female dismemberment. When he came out to mix, Glenn had an unnervingly hilarious way of working the words *meat cleaver* into the answer to every question and doing so in an equally disturbing, gravelly, halting monotone. What do you want for dinner, Glenn? *Pork chops...uh...green beans...uh... meat cleaver...and uh, rice.* Glenn was doing *Sling Blade* before Billy Bob Thornton had even written the script.

There was an intensely manic Asian woman who claimed to be able to turn lights and other electrical appliances on and off with her mind. One day while I was sitting in the living room doing paperwork, she entered, held up her hands palms-out, and the television came on. "See?" she asked, vindicated. Of course, I was only able to spend some portion of that afternoon looking for where she had stashed the remote control before I conceded her win.

Without question, however, the star of our clonapine-burlesque, pre-asylum show was a former staff member who had, you could say, gone native. Gladys had been raised by an abusive father who also raised German Shepherds. The father had sometimes confined his daughter in one of the kennels. Gladys smoked incessantly with the nicotine stains on her fingers and nails bearing witness to the conviction of her habit. When she got especially frustrated, depressed, or otherwise unnerved, Gladys would engage in an act of self-abuse that staff came to call head-banging. She would find a hard surface (the stone retaining wall in the backyard of the house was a favorite) and repeatedly smash her head into it, usually with

enough force to draw blood. Gladys' forehead bore a thick pad
of scar tissue as evidence of her commitment to this hobby.
Gladys and I both shared a love of animals. As a former staff
member, she was able to manipulate the house rules to keep
a number of pets, including a large dog (of course, a German
Shepherd) and a talking crow. One day, as Gladys was decom-
posing towards a cycle of head-banging, I saw an opening for
what I thought was a brilliant, if risky, intervention. New rule,
I announced: if Gladys was going to head-bang, then Thomas
was going to head-bang with her. I meant it. She knew I meant
it. She admired and respected me (as I genuinely admired and
respected her). The behavior stopped. It didn't come back while
I remained a counselor at the house.

So, I played with the idea that Sun Ra was a functional
schizophrenic. Somehow his loyal crew had shielded him (for
decades) from the more debilitating symptoms of his condi-
tion. Thelonious Monk and Bud Powell were both famously
compromised. Of course, no sooner had I formed my amateur
diagnosis, than it had ruled itself out. It just wasn't consis-
tent with the case file of an artist who had maintained a large
organization and with it spent nearly a half-century vigor-
ously and tirelessly encircling the globe with performances
and recordings. Sun Ra was, from my vantage point, clearly
not a "normal" human being. Being around him could tingle
with an otherness that demanded explanation. He had slid
completely off either end of any applicable bell curve. He
wasn't crazy and he wasn't on drugs. What, then, was he?
Having eliminated madness, I started looking seriously at
Ra's own stipulation: that he was a member of an unknown
angel race, an emissary of the Creator, on a demanding, if
distasteful assignment.

I went back to Ras-I at the end of that week of bewildered
brooding. "Is Ra a prophet?" I asked. "Sun Ra is insane," he

shot back with a maniacal laugh of his own. I didn't believe him. Over time, Sun Ra's ontology became less and less relevant as I focused on the delivery of his payload wherever and whatever its source.

From that first entrée, I slowly built relationships with band members in an attempt to follow this most intriguing being. Sun Ra's music and presence became food. I went to every performance that I could, which meant chasing the Arkestra and its mercurial captain up and down I-95. I did whatever was required to crash their backstage sanctuary and was not above grabbing a piece of equipment and blending with the crew to get past security. I heard many of Sun Ra's spaced-out homilies, and while I now wish that I had recorded some of them or at least taken and retained better notes, I also understand that this would have been a violation of the access that had been granted. On October 6, 1990, I taped one formal interview with Ra in his hotel room prior to an outdoor performance produced by Bill Warrell's District Curators organization. Today Warrell divides his time between producing sensitive paintings and independent films, but he is an unsung legend in DC's progressive music scene of the late '70s and early '80s. A partner in the original 9:30 and a co-founder of d.c. space (in its time, the capital's primary venue for avant-garde jazz), Warrell recognized Sun Ra's importance as a defining cultural figure of the late twentieth century and was behind some of Sonny's most memorable shows (e.g., at the Old Post Office Pavilion, 1984). Katea Stitt (radio personality, daughter of saxophonist Sonny Stitt) worked with Bill and was responsible for setting my meeting up. That interview and others with Sun Ra and his bandmates are quoted throughout this work.

I cannot posthumously paint myself into Sun Ra's inner circle. From my distance, the closest thing that I ever saw to

such a circle was the upper tier of Sonny's performance organization — the handful of men and one woman (June Tyson) who had worked the closest and longest with him. This does not include important contributors such as Pat Patrick, Eloe Omoe or others who had left the planet before I began following the band. For the other members of his group, Ra was chief executive, the boss. For many of these he was also a beloved and mentoring father figure. I can remember watching Sun Ra casually reaching into his pocket to retrieve a few bills in response to an Arkestra member's request for funds. It was a well-honed gesture that I had seen my own father perform on many occasions.

The aura of revelation and artistic mastery that surrounded him attracted many. I was but one more drawn to the flame. And although I was never alone, I don't remember it ever being crowded. I think the band appreciated the interest and adulation that Paula and I directed towards Sonny. They had plenty of experience with young white folks who had eagerly surrendered to the suck of Sonny's vapor trail. A black couple with an equally intense attraction might have seemed amusing or refreshing. I don't know, but I am forever thankful that my intrusion into those generally tight and intimate backstage quarters was never rebuffed. On the contrary, everyone was quite welcoming and genial.

I loved being around Sun Ra. I loved being close enough to smell him, to feel his enormous vitality. And Sonny's voice, with its gentle drawl and pudding articulation, is my audio imprint of something blacker and older than integration or television. Something pure and foundational. It is my grandparents and those that preceded them. It is their stories told in a land that they fell into out of wooden tombs, reborn as (once-men and once-women) into iron chains, proto-cyborgs, if you will, iron-encrusted composites of metal and men.

11

Sun Ra might not sound that way to you. In fact, he might sound silly. If you're a spaceways neophyte, he'll certainly come across as more than a little odd. To me he never appeared (even when he was doing quite normal things) to be a normal human being. If he had ripped off his skin to reveal a bulging green head and a couple of tails, I would only have tried, as a courtesy, to act surprised. I love him like a disciple loves his guru. He seemed to me to be much as he described himself — a missionary sent to do good for natives lost in the craw of primitive barbarity. If, in the end, I prove to be just another savage who has been duped by an ideology with a few more bells and whistles than my own, then I will at least be in very familiar company.

This work is by no means an attempt to read Sun Ra as a text and render his ideas as some type of social philosophy or quasi-religious program, although it must necessarily appear in places as exactly that. Sun Ra spoke for himself and this is certainly no late attempt to do that. It is, however, a tale based on what I saw and what I heard, which makes it ethnographical in some rudimentary sense. I was paying attention. It is in this way a true response filtered through that half of my life lived since meeting Sun Ra as a man in my late twenties, right about the time astrologists would refer to as my "Saturn Return." What I have since witnessed and lived has been the catalyst for a journey of study and application that has radically changed my view of human progress. It is a positive change.

Frank Zappa asked in song, "Who you jivin' with that cosmic debris?"[1] Sun Ra, I think, is doubly exposed to charges of snake-oil slinging of the cosmic debris variety (as is anyone who would attempt to lend credence to his improbable claims). It's not that he never presented himself as a serious conduit of serious ideas. He intentionally *over-presented* himself as such, enfolding his cosmogospel in a gaudy coat of self-anointed

messianic allusions (or, some would say, delusions). Sun Ra had a perversely bifurcated relation with the Bible. On the one hand, the record shows that he valued the core moral text and creation myth of Judeo-Christian culture enough to study it assiduously and quote from it frequently. As a young man, he conducted his own intensive research on the history of the peoples and geography of the Bible. On the other hand, Sonny was never above ragging on the good book as a work of anti-instinct propaganda that was as likely to do great harm as good. John Szwed tells us that Sun Ra saw the Bible as an odious cultural totem that must be "demythologized, decoded, and brought in tune with modern life."[2]

Sun Ra frequently told the story of how he was abducted by aliens while studying to be a teacher in Normal, Alabama, home within Huntsville, of historically black Alabama A&M University. Szwed suggests that Sun Ra's unique personal (re)creation myth can be read as the earliest hints of the now familiar alien abduction trope fused with the historically rich African American tradition of ecstatic epiphanal encounters (signs) being interpreted as a call to preach. The aliens had glowing red eyes and took him to Saturn. (I've seen him hold his cupped hands up to his eyes binocular-style when describing the aliens' red eyes.) On the planet Saturn, they warned him of a period of earthly social chaos and environmental decay. What rational person would take such a man seriously? These presumably highly advanced beings then returned him to the Jim Crow South through a process called *transmolecularization*. His *act* could only be taken as an act, right? Wasn't it all just so much showmanship and salesmanship, maybe performance art, maybe just crap? Betty Carter famously told Art Taylor it was the latter: "He's got his metallic clothes on, his lights flashing back and forth, and he's got the nerve to spell orchestra a-r-k-e-s-t-r-a. It's supposed to have something

to do with the stars and Mars, but it's nothing but bullshit. Sun Ra has got whitey going for it. He couldn't go uptown and do that to blackie. He would be chased off the stage in Harlem or in Bedford-Stuyvesant."[3] Notably, the esteemed late jazz vocal virtuoso appeared to believe that bullshit sells better downtown than uptown, which may be difficult to prove.

Sun Ra got the joke, and he got the punch line and he wasn't afraid of setting himself up to be either or both. He lived an understanding that the gruesome set-up that we call history is just not worth the pretense of discursive engagement. What matters is the finisher, the kicker. It was not that he was incapable of being like Malcolm X, advancing a Black Nationalist polemic at Harvard, of debating and defending his radical ideas in a serious academic setting. That just was not his job description. He was often *ridiculous* in any consensually meaningful use of that term and I think this set-up for ridicule was a calculated defense mechanism, the protective outer husk of his ontological spore. As Ken Goffman reminds us in his natural history of countercultural movements, "Counterculturalists tend to be jokers, bohemians, and libertines. These qualities subvert serious analyses, but we shouldn't diminish the importance of these stylistic undercurrents...Countercultural playfulness represents the nonauthoritarian refusal to take oneself, any ideology, or any code of righteousness too seriously."[4]

The non-musical residue of Sun Ra's life is a noxious, fluffy speck of toxic, life-renewing co(s)mic lint — once activated, a particle of deceptive potency. Sun Ra made us laugh at and with him to make his point, to remind us that, having ended the world, our journey was really just preparing to begin, and this, for a young species that is understandably a little insecure about its sense of historical progression, is laughable in the extreme. In that spirit, if *The Execution of Sun Ra* makes

you laugh or seems a tale that can only be taken with a kilo of salt, then I have achieved a mode of communication that is appropriate to my task.

But I believe that, as you read this tale of mercy and madness, you will (as I have) begin to hunger for the release of our *Alter Destiny* — Sun Ra's construct for a posthuman future that excels beyond either our present condition or our skewed vision of progress. You may sense the reinvigoration of your natural spirit as you drape your imagination across the template of possibility offered by Sun Ra's bold and timely intervention. You might thirst for the horizons of brother and sisterhood made possible by a resetting of this dog-eared battle that has passed for civilization over these last few thousand years. You might come to understand that you hold in your hand an alternative way of conceptualizing historical changes of the same scale as religion's promise to reboot the cosmic motherboard and give us all a second roll of the dice, only (thank God) without the religion. And you will begin, I think, to appreciate the practical beauty of an imminent eschatology that does not require waiting on angels. The Angel already came. He had an orange beard. The Angel has left the building. The second stop is Jupiter and the Second Act is on us — *I and I*. Perfect intersubjectivity. Yes, the Rastafarians were right about that, too.

EVOLUTION

When the first six stones are brought into the *inipi* — the domed sweat lodge used for the Lakota purification ritual — they are to be revered as the oldest ancestors. Any rock found in nature has found its place there through geological processes of formation and translocation that occur on a glacial timescale, probably beginning before any human was alive. The rocks chosen to join in this cultural activity have been disturbed, moved from their original destiny into a new one. The rite will transform them as much as the

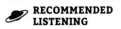
RECOMMENDED LISTENING
There Is Change in the Air
from *The Antique Blacks*

humans who have come to pray. The stones will change color, crack, and splinter, maybe even explode. Unlike the humans in the lodge, the rocks stand a good chance of being destroyed (not just purified) by the intersection of extreme heat and cool water. The elders who left us with these ways, who told us to sit upright in perfect reverential silence as these first six (symbolizing the four directions plus Father Sky, and Mother Earth)

were well aware of the ego-effacing nature of this gesture of stone respect.

Morality is never a script from which can be read the behavioral essentials of righteousness. Sun Ra spit out the word "righteous" like a glob of snot. Repeatedly, he reminded us that this empty robe was not even a small part of his ministerial portfolio. Morality defines what to do beyond the merely practical or the superficially respectable and enters into our decision-making only when it matters that we consider ourselves and our acts as transcending the immediate contingencies of our puny existence. Morality is always an opening. But not an opening towards perfection of behavior, character, or anything else. The impossibility of such perfection is all that is signified by righteousness as a condition of conduct. Morality is not righteousness. It is an opening towards innocence and the powerful creative energy of non-guilt. Sun Ra talked frequently about innocence as an overlooked ethical category in the punishment-driven social culture inherited from America's founding Puritans.

> They go out looking for dope addicts and all those kind of people, but what they should look for, they should have a police department looking for the innocent and the ones who are gifted by the Creator and take care of them. Don't care how bad they are, it would be overlooked because they did exactly what the Creator wanted them to do, but they got all these jails and all these courts and everything to go out looking for people doing wrong. They don't have no police force to go out and look for people who are doing right or want to do right.[1]

He was, in his weirdly degendered childlike manner a blast of innocence in the very midst of popular music's golden age of debauchery. In much the same way that he kept the sex scenes out of the original theatrical and VHS releases of *Space is the Place*[2], Sun Ra managed to park his eccentricity

in a place that was at a hard right angle to normality without ever appearing malicious or lurid.

> When President Barack Obama in his elegant address accept-
> ing the Nobel Peace Prize declares to the world that he has
> "prohibited torture," we should pause in our pride to notice that
> torture violates international and domestic law and that the
> notion that our new president has the power to prohibit it fol-
> lows insidiously from the pretense that his predecessor had the
> power to order it—that during the state of exception, not only
> because of what President George W. Bush decided to do but
> also because of what President Obama is every day decid-
> ing not to do (not to "look back" but "look forward"), torture in
> America has metamorphosed. Before the War on Terror, official
> torture was illegal and anathema; today it is a policy choice.
>
> Mark Danner, New York Review of Books[3]

Regrets are weighty, like pyramids and cheap jewelry. Like anchors of backward-folded responsibility, they tend to freeze action and paralyze initiative. America the Beautiful is only salvageable from its historical origins as a project of continental slaughter and transcontinental theft by a uniquely effective ability to deflate the dam of conscience and remove regret from the equation long enough to release the Protestant project of Americanization upon the World. American Exceptionalism is the ideological warrant for this terraforming enterprise. American Exceptionalism: Nothing, except America. Everything and everywhere will be rendered functionally *okay* as the world (re)creates itself around an American socio-political sensibility and this (re)form — which necessitates not just the extermination of terrorists, but the concomitant search for elusive *moderate** Muslims and

* In the current geo-political context, *moderate,* when appended before -Muslim, -Arab or -Palestinian is understood to mean *pro-Western*. The construct *moderate muslim* should therefore be understood to have connotations of self-betrayal no less shameful than *uncle tom has* in an Afro-diasporic context.

equally elusive *clean* energy as well as assurances that global financial collapse is containable, if not reversible — is the only project which can be certain of standing down this state of exception. Sun Ra's legacy, as will be shown, is the erection of his own wall of exception that is best comprehended as a necessary counter-response to the most deeply primary conditions on which the American imperial project is founded. It is the fulfillment of that project by derailing it at full speed.

Sun Ra's favorite song was "Somewhere Over the Rainbow." He occasionally played it in concert, often as a solo piano piece. His definitive version might be the one recorded in the summer of 1977, at the Bluebird in Bloomington, Indiana, and released in that same year as a Saturn LP of the same name. Written for *The Wizard of Oz* by Harold Arlen and Yip Harburg (an outspoken atheist), Dorothy's hopeful affirmation of a dimension — a homeland, a dreamland — beyond her earthly sorrows voiced sentiments that many black people living in the American south in the '30s could relate to. Judy Garland's Dorothy was, after all, enduring her own Kansas-bound apartheid of gender and economics. She was a hysterical little girl, an accessory to important people, a dreamer enfolded in the delusions of her dream. Her clarion song is an unambiguous declaration that her vision is real and that there is a land called Oz and it is both quite far and extremely near. The first verse in the song begins with an iconic octave leap (*Some --- Where*). "Two people singing in unison will create a circle pattern on the oscilloscope while two people singing two notes an octave apart will create a figure eight pattern," writes Kay Gardner.[4] An octave spans eight notes. Sun Ra told me that the "number eight is the number of God."[5] It is written as a pair of closed loops, which when written in cursive, approximates the infinity symbol rotated ninety degrees. In Western art music, the octave is a shocking interval. The Italians saw it as

disruptive. The octave offers near perfect consonance, a qualitative doubling. In fact, its frequency ratio is 2:1. The octave is recognized in every musical culture that is to any extent organized around the idea of musical scales. "Any music no matter how it is produced if transposed up or down by any whole number of octaves, retains its original character in a way which no other interval allows for," writes Thomas Crump in *The Anthropology of Numbers*. "An octave, even if it is a subjective element in music, still has a precise and elementary numerical base."[6]

Sun Ra spoke frequently of equations as the epistemological foundation for his take on the world and his creative responses within it. *You've got to have equations*, he would frequently say. His sonic art was made of moving air, set in motion by the instruments of his time and organized according to the musical principles of his age, primarily the principles of a culture called jazz that valorizes immediacy and bodily engagement in its norms of creation as well as composition and determinacy. Equations are relationships codified in symbolic systems, including systems of letters and numerals. Jazz and all other musical idioms have become powerful systems of meaning and sensation worthy and capable of repetition because they are mathematical and equational. Bop chord changes are equations, as is the circle of fifths. This sense of numbered order is not limited to those aspects of the music that reside in and are communicated by a printed score, tablature, or any other formalisms of notation. The most outsized free jazz solo or bizarrely atonal sound art explorations are also held together, as communicative offering and affective stimulus, by numbers.

Had the evidence of Sonny's equational analysis of the planetary condition been limited to onstage and backstage rants, lyrical content, or even his voluminous recorded interviews,

we might still be justified in viewing his work as thinker and teacher as simply an appendage to his life as a performing musician, an elaborate epiphenomenon. Beyond the forums catalogued above, Sun Ra took responsibility for documenting his thought in more historically durable form. While still in Alabama, he began writing his ideas down in something of a running journal and continued that practice through his move to Chicago in the '40s. In Chicago, with business partner and manager Alton Abraham, Sun Ra was part of Thmei Research, a circle of black men who sought answers to what were then quite probing questions of history, identity, and power. From the energy of these collective investigations, Sun Ra published a series of broadsides and pamphlets. These he distributed on the streets of Chicago's Southside, at the time a nucleus of African American cultural and intellectual life second only to Harlem. In fact, with the founding of Johnson Publishing Company in 1942, it could be argued that Chicago had become the most influential city in the national life of African Americans. Some of Sun Ra's publications were collected and transcribed by John Corbett and published with supporting scholarship in 2006 as *The Wisdom of Sun Ra: Sun Ra's Polemical Broadsheets and Streetcorner Leaflets*. Perhaps regrettably, the personal journals that were the core of Sun Ra's written work vanished during his and the Arkestra's brief relocation to Montreal in 1961. Assuming the lost writings were continuous with the material published in *The Wisdom*, maybe they weren't stolen as some (including Sonny) have suggested, but destroyed by Ra himself as a necessary component of his seemingly endless masterwork of self-reinvention. Declaring the loss of those first journals as evidence of a cosmic conspiracy, he abandoned the practice.

The Chicago period writings assembled by Corbett bear the heavy imprint of the religiously-inclined Black Nationalism

THE EXECUTION OF SUN RA

that dominated the city that was the headquarters for both Elijah Muhammad's Nation of Islam (NOI) and Noble Drew Ali's Moorish Science Temple (MST). Muhammad (The Messenger) famously taught that the Caucasian belonged to a devil race (note the inversion reflected in Sonny's concept of an angel race) created by an evil scientist on the island of Patmos. Of course, it could also be said that Sun Ra left his imprint on these movements. Both Szwed and Corbett have noted that Ra and those around him at the time claimed that the NOI only started to publish their highly successful *Muhammad Speaks* newspaper after seeing Sun Ra's broadsides.[7] The Moorish Science Temple, founded by Noble Drew Ali, is less well known than the NOI, although during the time span in question, their membership was larger than Muhammad's group. The NOI would later come to world attention through the international celebrity of Malcolm X and Muhammad Ali. Members of the MST also claimed to be blacks of an Asiatic origin (as opposed to sub-Saharan, West African) and took the surnames *Bey* or *El*. They dressed in turbans, fezzes, and flowing robes that might have complemented the Arkestra's onstage attire.

As he moved east, ultimately landing in Philadelphia, Sun Ra's attention became less centered on racial origins or injustices. In the most oblique sense, Sun Ra would have to be seen as a black nationalist. His mission of service, however, was planetary, which is not intended to imply that Ra was post-racial in his outlook on the social and mythic significance of race, nor that he was a humanist. Sun Ra can be neither credibly severed from the African American tradition nor accurately contained within it, a point that will have to be readdressed and reframed throughout this work. Sonny, the teacher, looked out at the preponderance of humankind and saw a pool of chronically underachieving students too distracted and improperly motivated to release their own

22

considerable potential. During the course of our time together in this labyrinth of words, we will discover the social product of Ra's prolific life as an equationally-based energy packet designed to catalyze, release, and disperse that untouched potential. His work was aimed in the direction of human development. Sun Ra's finished written expressions survive in the form of a volume of mostly poetry with a few short expository pieces he published in 1972, under the title, *The Immeasurable Equation, Vol. 2: Extensions Out.* My slightly weathered copy is one of the original single-sided staple-bound versions† assembled under Alton Abraham's supervision and sold at shows beginning in the early '70s and was a gift from Arkestra member James "Jac" Jacson (bassoon, drums, voice). *Sun Ra: The Immeasurable Equation. The collected Poetry and Prose* was reissued as a commercially bound volume under the supervision of German musician Hartmut Geerken and researcher James L. Wolf in 2006[8], and contains all of the works found in the original plus enough additional material to fill more than 500 pages. At about the same time, Alton's son published a version titled *Sun Ra: Collected Works Vol. 1 - Immeasurable Equation.* It contains Adam Abraham's reflections on the father who left home when he was three and whom he credits with helping to "create the cosmic, otherworldly theme that the Arkestra would become famous for."[9]

What is clear is that Sun Ra left a copious record of his investment in the entire community of humankind as a single system of suffering and searching. A voracious reader, Sun Ra's contributions are in no way minimized by acknowledging his thought to be a grand synthesis, a constellation of knowledge and insights drawn from the sediment of human achievement and reassembled in his experience as a uniquely

† At the time of this writing, a book dealer in Chicago was selling this version of *IE* for $950.00

creative, well-traveled (including Saturn) black man in twentieth-century America.

Sun Ra's entire life might be seen as a platform for something of an immeasurable equation. That equation does not begin with him or us, and passes seamlessly through the here and now and into what lies beyond. Essential to Ra's cipher is the notion that there is a *post*human (angel?) lurking in each of us. This is the actor/agent of our Alter Destiny.

> I'm trying to discipline myself — I mean my other self, because I'm not too worried about my *self*. Because they teach you not to be selfish anyway, not to think about your self. So I think about my other self — that's the self that's never really had a chance. The music that I'm playing, that's my other self playing. And that disturbs some people because they never gave that other self a chance. The natural self. So that's my natural self playing.
>
> Sun Ra, interview with John Sinclair[10]

In what we will come to understand as *exceptional times*, art's only remaining function is to feed that nascent other self. This feeding neither swaps nor edits ideology. It is a developmental catalyst, a seed crystal around which the self may be reorganized. It is not a blueprint and comes with neither expiration date nor users' manual. The other one, the alter self, grows as she or he is fed the food of postcultural nutrition. Babies are innocent as long as they exist within preculture. Sin and sinners are constructed as a consequence of living in a community of culture. Asked to explain his work to a befuddled Toronto broadcaster, Sun Ra expounded: "The music is about feeling. It's not about what I know; it's about what I feel. When you lose feeling, then we're really dead. Most people on this planet have no feeling anymore. They don't even care about each other. They get into religion and philosophy and they think that'll do it, but it hasn't done it yet."[11] What's left

when culture is rinsed away, its narrow norms, mores, and standards, its sins flushed beyond reach? Only feeling, that is, the felt presence of immediate experience. How then, do we make something of our lives together that is maximally and mutually supportive of this necessarily ephemeral and individual capacity? What is the political phenomenology of feelings? In rehearsal, Sun Ra demanded the attachment of appropriate affect to everything played, down to individual notes. "I can tell that you don't feel that," he might say. "You're playing it. You're playing it correct, but this [is] all about feeling."[12]

What would a civilization built on the value of feeling look like compared to a civilization based on the value of commodities and institutions, that is, objects? This is the moral question (and practical quandary) beating in Ra's work and words. It is a challenge, an enticement. It is a thinly veiled threat.

On the second page of the first chapter of *Space is The Place*[13], Szwed tells us that Sonny's mother named him Herman after a great black magician of the same name. Of course, this information has long been a stock item in the web of legend that surrounds Sun Ra. But which African American magician would have most likely inspired his mother and which magician would Sun Ra have been most likely to have woven into the very beginning of his painstakingly-crafted biographical myth? Szwed asserts that the Herman in question was Benjamin Rucker, professionally known as Black Herman, the most famous African American illusionist of the early twentieth century, arguably of all time. A rival and contemporary of Harry Houdini, Black Herman (Rucker) was born in Virginia in 1892. In his teens, he took up with an itinerant showman and health tonic salesman whose stage name was Prince Herman

and when the Prince died in 1909, Rucker adopted both his name and road show. Now re-branded Black Herman, Rucker became extremely popular for his elaborately staged cultic routines, and is noted for breaking the color line that routinely separated black and white audiences of the time.

There are, however, many magical "Hermans" to contend with in this time period, with any potentially being the source of Sonny's first name as listed on his birth certificate. As far back as 1894, the *Cleveland Gazette* — the longest publishing black newspaper — ran an announcement that informed its readers of a performance in nearby Mt. Vernon, Ohio, featuring a Professor Willis of Pittsburgh who billed himself as "the Black Herman" and was not only "considered the greatest Afro-American magician" but "owns and manages his own troupe, which, by the way, are all white performers."[14]

And then there is one Alonzo Moore. Born in Tipton, Missouri, sometime in the 1870s, Moore also performed magic under a very similar name — *the Black Hermann*. He, too, apprenticed under a Prince — a man named Edwin Maro, whom the public knew as the Prince of Magic. Moore concocted his name, however, as homage to Herrmann the Great, the French magician Alexander Herrmann who in the mid-1800s had established a reputation for presenting magic tricks as tactical deceptions and not as mysticism or supernatural ability. This level of candor was rare among his generation of illusionists. Touring throughout the country with major minstrel (or Black vaudeville) acts like the Hottest Coon in Dixie and the Cotton Belt Jubilee Singers, *the* Black Hermann's stately production was called "Oriental Magic" and followed a neatly printed program guide of well-executed illusions. "Alonzo tore paper into bits that turned into ribbons as he tossed them to the audience," we're told in Frank Cullen's encyclopedic *Vaudeville, Old and New*. "And from a handful of ribbons he produced a gallery

of flags, culminating in a large Old Glory that brought cheering people to their feet."[15] In 1904 he joined Black comedian Billy Kersands' minstrel troupe. Kersands himself played a typically oafish, exaggerated darky to howls of delight from both white and black audiences. Apparently the man was quite funny (as many minstrels are). Moore's stint with Kersands' Minstrels even included a trip to Britain where they shined for Queen Victoria.

Here is where is it really gets complicated (and quite interesting) as we attempt to get our Hermans untangled. First, it is possible that the Professor Willis in the 1894 *Gazette* announcement might be merely an erroneous reference to Moore. Moore, however, who might have been born as late as 1876, would have been a bit young to be the successful artist described in that paper's announcement (and Rucker, of course, was still trying to escape from diapers). Add to the confusion a 1903 listing from Washington, D.C.'s *The Colored American* which referred to a Black Herman performing as part of the Hottest Coon in Dixie review. That clipping identifies the magician as Mr. Carl Dante[16], so do we have a third Herman? A fourth, if Prof. Willis is a distinct performer? More relevantly, Rucker would have been twenty-two at the time of Sun Ra's birth in Birmingham and would have only been working as a solo act for five years. It's less than likely that Black Herman (no *the*, one *n*) could have been the inspiration for naming a child in 1914, but what about Moore? Any tour of entertainers attempting to reach the colored audiences of the Cotton Belt would have had to play in Birmingham (a/k/a *The Magic City*). At the time of Sonny's birth in 1914, Moore's notoriety was in place; Rucker's was ascendant.

As for Alexander Herrmann, well, the white magician at the front of our succession of Hermans doubles the letters in the name *Herman* in a way that is consistent with older spellings

in the original German but does not exactly match any of our African American magicians. As we will see later, this kind of doubling is an important cog in Ra's hermeneutic clockworks. Herrmann was quite famous, and in 1896, expired while traveling on his private railroad car after performing in upstate New York. Apparently, this *white* magician's whiteness was tricky enough that some claimed he was of Portuguese descent and a lawsuit filed against him in London by a rival magician accused him of being a "Polish Hebrew."[17]

Black Herman (Rucker) would have been growing in popularity during Sun Ra's youth while *the* Black Hermann (Moore) would have already achieved celebrity at the time of Sonny's birth. Moore, on the other hand, is reported by Cullen to have died circa 1914, although other sources say he lived until 1930[18], although his performance activities had all but ceased by the early '20s. So to which does Sun Ra owe his eponymous connection to the tradition of African American conjury? Black Herman was a consummate businessman who amassed the considerable fortune needed to sustain the lavish lifestyle of a Harlem Renaissance socialite. He marketed tonics and elixirs and sold a mail order manual of "secret instructions" which, for only one dollar, promised to "unlock a storehouse of information and power." His act was not the orderly presentation of convincing illusions couched in arabesque pomp that had built Moore's reputation on the minstrel circuit. Within the usual fare of vanishing rabbits, card tricks, escapes from chains, and other legerdemain, Black Herman built a performance persona around an invented back-story that claimed heritage as a Zulu from the African continent. His magic was a vestige of survival techniques used by his forefathers to escape colonial subjugation.

Later in his career, Rucker began claiming to be able to defeat Death. He would assemble a pre-show several days

before one of his scheduled performances in which he would descend into a deep stupor. Observers invited to check him for a pulse or signs of respiration were unable to find any trace of life. Herman's apparently lifeless body was then thrown into a wooden box and buried in a designated plot of loose earth just outside of the venue. Days later, when it was time for the full show, he would claw his way out of the ground before an aghast audience. Unlike White Herrmann, Rucker had no hesitancy building upon allusions to the dark powers of Voodoo and other occult arts. "Black Herman himself once cryptically prophesied, that he would 'come through once every seven years,'" we are told by Yvonne Chireau, a scholar of African American conjury, "to stake his claim to immortality."[19] Rucker died in Louisville, Kentucky in 1934, collapsing onstage in a manner so similar to his act that the public had to be invited to visit the funeral home before they were convinced that the legendary performer was, in fact, deceased. Returned to his beloved New York City, Benjamin Rucker's remains were interred in the same hallowed ground that now shelters the spent "spacesuits" (as Sun Ra aptly referred to our biological bodies) of such musical luminaries as Miles Davis, Duke Ellington, King Oliver, William C. Handy, Coleman Hawkins, Jackie McLean, Celia Cruz, and Max Roach. Interestingly, the body of Alexander Herrmann is also decomposing in the Bronx's Wildwood Cemetery. Alonzo Moore died destitute and alone in Norwood Park, Illinois, in April of 1930. It is suggested that *the* Black Hermann died destitute and was cremated on the same day that he died, in the hospital in which he died.[20]

For years, the precise date of Sun Ra's birth was a fairly vague matter of contention and debate. This, of course, was because Sonny did whatever he could to obscure or confuse the mundane truth of his earthly origins. Having finally seen this controversy settled to the satisfaction of most by

good research, I am loathe to upend and similarly cloud the matter of how Sun Ra received his praenomen (first name), especially in a work that is not primarily concerned with biography (as either objective or method). Several things are possible, including the party line, which holds that, in 1914, Ra's mom gave her son the stage name under which B. Rucker would later become hugely famous. This author is not suggesting that this is entirely improbable. As early as 1915, Rucker was already billing himself as the African Zulu and playing to large audiences, including a benefit for the black high school in Jackson, Tennessee[21]. Another possibility holds that the name *Herman* had some other source, completely unrelated to magic or magicians of any color. A third and perhaps even less palatable (but more chronologically plausible) version is that Sonny's mother named her baby boy after seeing A. Moore in the decade prior to Sonny's birth, at which time Moore would have been quite well known, especially throughout the South. She was inspired by *the* Black Hermann enough to name her son Herman Poole Blount, dropping the doubled *n* for sake of simplicity and convention. In both the second and third versions of this universe of Hermans, Sun Ra, it must be assumed, has encouraged whatever kernel of authenticity grounding the magic of his given name to drift and become attached to the larger-than-life figure of Rucker's Black Herman, who, after all, Sonny would have easily seen as a proven ally in his own war against Death. What is important, if obviously so, is that Sun Ra had chosen through the retelling of the Black Herman naming myth to connect himself firmly to the considerable *information* and *power* of this early master of the showmanship of illusion, the illusion of showmanship.

Magic is central to Italian continental philosopher Giorgio Agamben's postmortem on happiness in modern life. Social law argues that happiness is the reward for merit, while

primary instinct cries out for magical dispensation as the only reliable toolkit for a happy human life in a world of constant challenge and attrition. Agamben cites Walter Benjamin's mescaline-enabled observation that the failure of magic is the original sin of childhood unhappiness. "Happiness," Agamben writes, "coincides entirely with our knowing ourselves to be capable of magic, with the gesture we use to banish that childhood sadness once and for all."[22] Magic, or conjuring, is the abolition of the self's alienation from the world achieved by discovering the secret nomenclature underlying the cosmos and its objects. By this power of tongue (word-sound-power), the magically endowed accomplish the mastery of mind over matter simply by speaking into place the order that is desired:

> But according to another, more luminous tradition, the secret name is not so much the cipher of the thing's subservience to the magus's speech as, rather, the monogram that sanctions its liberation from language. The secret name was the name by which the creature was called in Eden. When it is pronounced, every manifest name — the entire Babel of names — is shattered. That is why, according to this doctrine, magic is a call to happiness. The secret name is the gesture that restores the creature to the unexpressed. In the final instance, magic is not knowledge of names but a gesture, a breaking free from the name.[23]

Herman Blount was a magic name that vanished in erasure so that it could be replaced by the names of the most dominant celestial body and the Supreme God of the mightiest of ancient African civilizations. Sun Ra is a magic name. John Gilmore told me the story of how Herman Blount (who at the time was performing mostly as Sonny Lee) became Sun Ra, as he claimed to have heard it from Alton Abraham. It was while Sun Ra was working in Chicago as an arranger and piano player for Fletcher Henderson's organization. At the time there was a dance instructor named Sammy Dyer who trained

the chorus girls. "And one day, Sun Ra was rehearsing the chorus girls and Sammy came in and said: 'Your name is Sun Ra,'" recounts the sax player that Sun Ra used to call Honest John.[24] When both Henderson and Sonny seemed a bit taken aback by Dyer's sudden pronouncement, the choreographer repeated his dictum and it was taken at the time as "an indication from the Creator to take that name."[25] *Le* Sony'r Ra was the name on Sun Ra's passport, although this officially sanctioned name was almost completely unknown to the audience who bought Sun Ra's records and concert tickets. He also claimed many other names, including names of mystery, names of splendor, names of shame, secret names. He could be a loquacious, open conversationalist, a braggart even, but Sun Ra also appreciated the power of secrecy. "Not only does it [secrecy] strengthen the conjuror's illusion but it makes the magic work because the secrecy in magic gives the magician a sense of control over his inner life."[26] Leaving the door open (through obfuscation and omission) that he might actually be what he said he was (angelic ambassador of the Creator — i.e., a magical being) was a key to Sun Ra's success in getting his whole idea in front of us before we could turn him off or push the panic button. He was so thoroughly weird, eccentric beyond even the studied affectations of show people. If his humanity couldn't be confirmed, his rap was the only data left that might resolve the matter. So, we listened, carefully, in a way that we probably wouldn't have to a similar message delivered by a mere musician with less exotic credentials.

Sun Ra equated a return to happiness with a return to the primacy of feeling, intuition, and instinct. And since it was a return that didn't require that there ever had been such a state, this equation fully exploits the power of Happiness as Myth. Agamben's *Profanations* begins with an essay exploring the earliest use of the Latin term *Genius* by ancient Romans to

describe a personal deity that arrives to meet the individual at birth and remains closely attached to him or her throughout his or her life. Something like, but much more intimate than, a guardian angel hovering over the individual, something similar to the ancient Egyptian body double *ka*. For Agamben, the individual's *Genius* was "the principle that governed and expressed his entire existence."[27]

Sun Ra followed his Genius. He was himself in a way that was profoundly free of pretense, even when he was pulling our leg or putting on a show. He talked about all of us being at our best when we relied on our *natural selves* and acted from intuition. "I'm a natural, you see, like birds come here to fly, I just have a gift that's on a cosmic level."[28] Sun Ra believed that the Bible is hostile to instinct and intuition. "It's a[n] anti-man book, anti-earth book. It doesn't offer man any hope whatsoever," he said[29]. Intuition is our most natural mental capacity upon which all other cognitive feats are established. Sun Ra talked about feelings as fundamental. Before we can communicate the mathematical statement *2 + 2 = 4* as a logical proposition, as a sentence, we must first grasp its truth as a feeling, as a sense. It is only after we have convinced ourselves through the closed loop of private intuition that we then mount a public act of persuasion using the framework of reason and its externalized, socially common twin, language, to make our case.

ASEXUAL REPRODUCTION

Mrs. Stowe agreed with the observations of her time that, beyond a certain age, usually the early teens, Negro children ceased to advance under schooling. Bostonians told Lyell in 1847 that they segregated Negro pupils because they could not keep pace with whites after the age of fourteen. An eminent Virginian scholar once candidly attributed this alleged fact to "the advent of puberty and sexual development"; it was well known in North Africa and the Middle East, he said, "that the negro eunuch was a vast improvement in shrewdness and general intelligence over the unaltered black."

J.C.Furnas, *Goodbye to Uncle Tom*[1]

I would like to think of Sun Ra as the most celebrated asexual in history. There are many militant gay thinkers who would argue that any claim of asexuality must be read as a self-loathing fiction masking a deeply repressed homosexual identity. In his highly personal discourse on gay artists in popular music, John

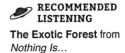

RECOMMENDED LISTENING

The Exotic Forest from *Nothing Is...*

Gill criticizes Sun Ra for being "out about so many things...but not about his sexual orientation."[2] Sun Ra's gender presence was in fact softened and obscured in a way that might suggest to some a gay male identity. I am not the first person, for example, to see photos of the late gay disco vocalist Sylvester in a metallic sequined skull cap and think, *wow, that dude sure looks like Sun Ra.*

Shortly after arriving in New York in 1962, Sun Ra began recording much of his music at Variety Recording Studios in midtown Manhattan. The studio was owned by Fernando (Fred) Vargas, a sound engineer, and Warren Allen Smith who was a public school teacher from Connecticut who had majored in philosophy at the University of Chicago. The two met in 1950, and were lovers and companions until Vargas's Death in 1998. Variety became an important site of production for Sun Ra, and his relationship with its ownership team was a cordial and extended one. Variety was eventually instrumental in helping Sun Ra create some distance from his long-time Chicago-based business partner and Thmei Research cofounder Alton Abraham, with whom Sun Ra's relationship had begun to fray.[3]

In a 2008 interview, Smith reflected on the nearly thirty years that he and Vargas worked closely with Sonny. He recounts the large (25-30 piece) ensembles that Sun Ra would summon to rehearse during the day, and record deep into the night, with musicians frequently sleeping on the studio floor to avoid hotel expenses. Immediately following the sessions, Sun Ra and Vargas would retire to the control room for marathon editing sessions. Smith emphasizes the long hours Vargas and Sun Ra spent in close quarters to suggest nothing more than the confidence built, and opportunity for candid discussions, while cutting tape. Smith was skeptical of Sonny's professed asexuality. "I don't believe that something

like that exists. Everybody has his or her sexual orientation, be it secret or open.... I don't think I ever talked about his sex life, but I am pretty sure that he knew Fernando and I were a gay couple. It made no difference for him, so he was not like a religious fundamentalist who would object to work with people like us, you know. He was just the kind of a guy, if Fernando was drinking wine, he wouldn't have wine. I heard that none of the guys was ever using drugs. At least they didn't do it in the studio, but we did have them sleeping overnight. He seemed to be with a pretty clean group." Smith describes his partner as an outgoing, unreservedly gay man, "a good gossip" who would "tell stories about the pope's testicles." Freddie was, in fact, apparently fascinated by Sun Ra's own medical condition — an undescended testicle that was the source of chronic discomfort. "Fernando and I had a very open relationship without taboos. We would discuss anything." When pressed, however, Smith's lover and business partner would offer nothing to clarify the matter of Sun Ra's sexuality nor to refute his claims of being nonsexual.[4]

Celibacy (pre-meditated sexual abstinence) is not the same as asexuality (absence of sexual attraction). In fact, the two cannot coexist in the same individual at the same time. Asexuality is not pansexuality. That is, it is not the case that the asexual has allowed his or her erotic attraction to migrate out of any gendered human category and onto the world at large. It is not, therefore, a subcategory of sexual fetish. It is like a hunger that is common in others, but that some do not have. Some people like chocolate, some vanilla, some any of a thousand other flavors, but as much as we can appreciate the widespread popularity of ice cream, we can certainly agree that there must be some people who never crave it and some who are repulsed by any thought of eating frozen dairy confections.

Without any substantiated claims of Sun Ra ever having acted as a sexual person over the course of his many decades in public life, we should take him at his word: "I have never been able to think of sex as a part of my life though I have tried to but just wasn't interested."[5] Among his many other unsolicited diagnoses, Sonny came here to assert that the hokey-pokey is certainly *not* what it's all about. Ra saw sexual attraction and fulfillment as a "gimmick"[6] and an *anti*-discipline and, if for no other reason, he was just not going to be bothered. Note that, unlike the ascetic acting within a religious covenant who renounces sex as sinful or impure, Sonny saw it as a colossal distraction from his life-consuming mission. Time spent copulating was time better spent composing, and the time spent *chasing* sex? Well that was just a completely tragic waste of valuable time. Not Sonny.

In an overcrowded world where human sexuality is deeply conflicted in so many painfully demonstrable ways, are we not justified in seeing asexuality as a social frontier of great importance and promise? If sex has become a scorched battleground of rape, abuse, exploitation, commodification, disease and commerce, is not the asexual a refreshing beacon of detachment? Capitalism discovered early (very early) that sex sells and everything sells better with sex. And under this free market rubric, our precious children have been sexualized in the name of fashion, thus shortening the innocence of childhood, occasionally obliterating it in the most bitter of ways. The late Jon Benet Ramsey looked like a sex doll, because her parents dressed her up to look like a sex doll so that she could compete in openly publicized events where other parents also dressed their daughters to look like sex dolls. The end result of all this competitive, free market sex is a borderline neurotic, sex-addicted, sex-deprived individual awash in a 24-hour-a-day, *pornoramic* mediascape that uses sexual reference (high

and low brow) the way newspapers once used ink. There is something woefully unjust about a culture that offers unlimited opportunities to think about sex while only allowing a much smaller number of tightly scripted and normatively delimited opportunities for sexual fulfillment. This is a prescription for inescapable and pervasive frustration, which is, of course, always where the seller wants to meet the buyer. It is also a recipe for countless reported and unreported disasters of a very personal type.

Knowing that Sun Ra was an asexual instantly forced his interpretations of otherwise ordinary love songs to be heard as the seeker's devotional cry to the object of his devotion. In just this way, Sun Ra could inject a sublime thrill into such quaint standards as "Beautiful Love" and "I Dream Too Much," elevating them into a celestial myth space far beyond earthly romance. Sonny's queer lack of sexuality was a part of his innocence and a critical signifier of his core message and the core message of any renunciative path: *You'd be quite surprised at what you're capable of doing without.* I have heard from Damon Choice and others that Sun Ra used to turn to his Arkestra and declare: *Leaders will ask you to give up your lives for them, I ask only if you'll give up your Death for me?* Nothing that is essentially incorporated into human being — not sex, not Death, not religion, or money — nothing that we are or have been is beyond evaporation as our ontology catches up with our time. And if a brother is willing to make that point — to demonstrate it, perform it — by forgoing sexual pleasure, then I believe that must be one very important point to make.

ANTICHRISTOS

In a world ruled by law and divine order,
You rise as high as your dominant aspiration.
You descend to the level of your lowest concept of your self.
Free your mind and your ass will follow.

 Funkadelic[1]

A t this point I will pause and proffer something of an apology to the many atheists whom I hope are reading this *Execution* and have perhaps been a bit put off with all of this God talk and Bible talk. I will warn you that there's yet more to come, but in this section I would like to attempt to take on the relationship of Sun Ra to theistic theory and the Ibrahimic tradition as directly as possible. "Now they come to the place where they got to prove: there is a God, or there isn't. And if there is no God, they have to be God, so you still got a God. You got to have a head. You can't have a body without a head," said Sonny.

RECOMMENDED LISTENING

Door of the Cosmos from *Sleeping Beauty*

"And they do say Christ is the head of the church. But the head is nailed on the cross, right? Nailed down. So now, that's an equation."[2] Acknowledging that the country in which he was born was founded by and for Christians operating under explicitly religious motivations, Sonny is reminding us that the retooling of society according to a more secular plan must still account for a considerable amount of Judeo-Christian mythic scaffolding lying around, the persisting effects of which must be accounted for, even if work crews toil morning and night to dispose of these unsightly leftovers. Sun Ra was born at a time and in a community in which belief in the Christian God was unassailable dogma around which the rest of thought and action was arranged. The unchallenged authority of the black church in African American life was reason enough for Sonny to rebel against its core assertions. Importantly, Szwed reminds us that Sonny's mother raised him free from the strict church attendance that was the norm among the black working and middle classes.

> The existential appeal of Christianity to Black people was the stress of Protestant evangelicism on individual experience, and especially the conversion experience.[3]
>
> Cornel West

If Sun Ra rejected the Christian Church as institution and social model, why didn't he just (re)form himself as one or another version of Afro-Asiatic Muslim? He certainly would have found ample lived expressions of just such African American appropriations/adaptations of Islam during the time he was in Chicago. Both the Moorish Scientists and members of the Nation of Islam rejected dominant biblical interpretations in favor of a Bible whose epic dramas of exile, enslavement, and exodus foreshadowed the grueling sojourn

of blacks in the West. But Sun Ra was turned off by the geo-
graphically and temporally abbreviated reign of Pan-Islamic
Empire. "I knew they'd go so far and they couldn't go any fur-
ther, because that's the way it is with Islam. It looked like it
was gonna conquer the world one time and they stopped, just
stopped. And they haven't been able to get it together since."[4]
That kind of truncated dominance wouldn't have been appeal-
ing to Sun Ra.

Even the most ardent atheist must submit to one near
universal convention of temporal management that exposes
the ultimate and extended hegemony of Christendom on this
third stone from the sun. Even members of cultures having
their own well-established nomenclature and systems for
marking the passage of years must begrudgingly respect
the fault line marked by the birth of the christian savior
according to a Roman calendar system. Because of its (fairly
recent) historical dominance, the Christian west is uniquely
positioned to cleave Time for everyone else, measuring every
date against what preceded and what followed the birth of
their messiah. State and church can be pushed further and
further apart, but every time you date a check, it's right there
in your face: 2014. Two thousand and fourteen what? *Anno
Domini* — in the year of our Lord. Whose Lord? What used to
be similarly called B.C. meaning *Before Christ* has now been
cleaned up a little by scientists and other academics who
instead substitute B.C.E., i.e., *Before* the *Common Era*. This,
of course still leaves the current or common era, the one my
check was written in, as the Christian Era, the era belong-
ing to Christians. "It's up to so-called Christians to change
the world. They have to tell the truth. They have to tell the
truth, now. And the main one that have to tell is black folks
in America; they can change the world. All they got to do is
to tell the truth. The truth about what is happening to them.

The truth about what they are. They have to be their real self now. They can't be pretending like they're slaves or like white folks have some control over them."[5] Sun Ra's work involved a retooling and replacement of foundational myth structures supporting ontologies and the time spaces in which those ontologies function. This prime tactical objective required him to address the myth structures underpinning the society and culture he found himself in. In America that includes systems of thought that were founded in Christianity. Even our ransom is paid in marked bills: They say *In God We Trust*. And that's an equation, too.

God is a small word covering a vast idea. In large parts of the world, expressions of anything other than God belief are so non-normative that they can be severely punished by force of law or even provoke mob violence. Pakistan's tiny Christian minority must live under constant threat of that country's dreaded blasphemy codes (laws that are easily manipulated as weapons of social vengence) or face the vigilante violence of the offended majority. In the trans-Atlantic, open, secular society built by Europeans, people politely ask each other: "Do you believe in God?" Depending on the answer, they then position themselves at opposing corners of the discursive ring. In this corner are those who deem themselves too smart to swallow the theistic fantasy world. Across from them stands the equally maligned rival camp, condescendingly wondering how their soulless, benighted counterparts can find any contentment in their meager, morally relativistic lives. This writer cannot imagine any circumstances under which that potentially explosive question should ever be asked or answered. I also can hardly imagine a more trivial question. Does Gravity exist? Does it matter if *you* think so? Presumably, this God that everyone talks about is (the) Supreme Being. *If* there is such an entity, or factor, as God actually existing in

the real world, then the opinion of human being on the existence of Supreme Being would obviously leave the facticity of such a God completely and utterly untouched. Similarly, His, Her, or Its existence must be equally beyond the reach of every holy book ever written and all the most eloquent sermons. Sun Ra said "it is better to accept God for what he is, rather than what you would like him to be."[6] This powerful, quintessentially Eastern idea nullifies the rationale for most of the activity of organized religion. Religion's authority is bound up with its claim to separate true divinity from any counterfeit facsimile, the Living God from all posers. To justify these claims, religion offers doctrinal evidence that amounts to a résumé for the Almighty. Thus in their dogmatic specificity about whom and what God is and must be, these institutional forces attempt to subdue the Anonymous Mystery which must surely belong to the Divine alone. For Lakota traditionalists, faith is hemmed in unanswerable questions, and mystery is allowed to stand as is. *Wakan Tanka* translates as Great Mystery. Not *a* Great Mystery or *the* Great Mystery. There is no article.

Sun Ra was a Baptist by birth. His grandmother was an ardent believer, even if his mother seems to be of a more agnostic temperament. His funeral rites were conducted in a Baptist church in his native Birmingham. By his own admission he was not religious. "All the churches have to shut their doors. All the governments got to turn their thing over to this force which can lead the planet properly," he calmly observed. "They have to do it, or die. Now that's my message."[7] This statement, collected by Jennifer Rycenga as part of her doctoral research on the religious life of musical composers, provides a clear sense of Sonny's disdain for both church and state. Is the kind of sweeping change of the global religious and political guard that Sun Ra is implying here achievable?

43

Were such an inversion in world order, in spiritual and political authority, to happen on such a large scale, would it also necessarily occasion a resetting of our year count, perhaps with some other abbreviated suffix to mark the new era? If the tenuous stability of the geopolitical order has become predicated on oscillating crises and perpetual war, how could such a large-scale change in planetary direction *not* be a positive thing, a net good? I think it's obvious that Sun Ra was offering himself as lightning rod for just such an impossibly huge holistic change.

Space and time, inextricably conjoined since Einstein, now recreate each other. Space is the place created by new time, fresh time. Time that hasn't been all bloodied up and spoiled by History, which is anti-Time, a period of waiting for Time to begin. Sun Ra is an active reconfiguration of the fabric of time fashioned into something other than a burial shroud for the slain body of a Palestinian Jew. The Alter Destiny is also A.D. and maybe we're living in it now.

What did God mean to Sun Ra? He interchanged the terms *Creator* and *God* in a way that didn't always reveal the distinction in context, but he did see the terms as having different referents.

> God is an English word of comparatively recent origin and is not the Name of the Creator of the Universe...Any object of worship is God but not every object of worship is the Creator of the Real Universe.... Gods there be many but there is only one Creator of the Universe...
>
> Sun Ra, from "Lucifer Means Light Bearer"[8]

Creation in its most vulgar sense implies certain prerogatives. If a musician creates a song, he or she will certainly claim ownership of that song, with ownership being a kind of sovereignty attached to the idea of the song as a property.

This means that at least for the life of the composer, the one who wrote it will determine a song's purpose. Purpose is teleology and one of the cornerstones of empirical science is the restriction of teleology to sentient being, with advanced teleological aims being the exclusive province of the human being. Science eschews above all else the notion of a teleological factor in the cosmic tissue. Any "destiny" implied by the world of facts is simply a tensioning and direction implied by the interplay of inanimate, brute, unintelligent forces. Purpose is outside of nature. Bees have an elaborate repertory of instinctual behaviors, but only the appearance of purpose. That is, this apparent purpose is in actuality Nature's purpose, which is always synonymous with physical law. But human cities are no more outside of Nature than the hives of our comrades the bees. Any purpose that Civilization might therefore appear to have should rightly be seen as part of Nature's plan. And what if the nature of a civilization is to be built with trap doors or clearly marked routes of egress for use in the event that the ride gets too bumpy, or the project seems headed off the edge of a cliff. The Myth of Apocalypse, whether embodied in John's tripped-out Revelation, the Hopi's Medicine Hoop, or the Hindu's Kali Yuga, are not intended to offer negative reinforcement to keep us in line, but rather are positive attractors offering the promise of a time-out from all this well-ordered Death and nothingness.

The basic ingredient of Civilization (as of any durable process) is love. Parental love is an instinctual bond — no less instinctual than the bond between a crocodile and her brood. The love we receive from our parents is reflected and amplified through the prism of culture. That is, we're only trying to be good children, giving back to those who gave so much to us. The result is a multigenerational pact between the living and the dead to continue *their* work and to keep *their* presence

active, even after their bodies have long passed from dust to dust. Noble, it all seems so noble, especially in the beginning. Now, at the end of the future, we find that our lives have become crowded mausoleums, empty of their time, full with the inheritance of a lot of dead people's thoughts and actions. Our bodies become prisoners of what people who no longer have bodies once did with them when they did. I actually think this is a large part of what Sun Ra was pointing towards when he repeatedly declared that we live in a world ruled by Death. As a sediment of bodies and their broken promises accumulates beneath our feet, we inch closer to the off switch for the whole damned thing. It's all quite Natural. We're programmed that way. It's a part of our instincts.

Jump.

HIDDEN FIRE

A pinprick of knowingness has flashed against
my innate background of not-knowingness; in it
are contained all the universes.

Nisargadatta Maharaj[1]

ometime during the last years of his earthly life, Sun
Ra performed at the Bottom Line in New York. Prior to
the show, Sun Ra was, as usual, stationed stoically in
the middle of a dressing room that hummed with activ-
ity. At this time his movement and, to
a lesser extent, his speech had both
been impeded by his declining health.
That day he was using an old-fash-

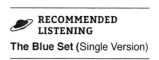

RECOMMENDED
LISTENING

The Blue Set (Single Version)

ioned brown wooden cane to get around, and as he sat, he
mindlessly* twirled the cane between his fingers, idly pass-
ing it from one hand to the other. Two extraordinary things

* Months after having written this sentence, the author now concedes that he never
actually witnessed Sun Ra do *anything* "mindlessly".

happened that evening while I sat there soaking in Sonny's loving take on the daily news. That's what Sun Ra often seemed like during many of these backstage rap sessions — an anchorman serving up a cosmic news report. In the middle of Sun Ra's sermonizing, a tall dark brother entered the room. He threw his body at Sun Ra's feet and, with tears streaming down his face, cried out in what I heard as a heavy West African accent, "I had heard you were dead. You're alive, you're alive." Everyone in the room loved Sun Ra, mind you, but we were all stricken by this man's outpouring of genuine adoration and relief. The man composed himself and a broad smile took over his face. Apparently he was a musician who had previously played in one of Ra's groups.

After he became ill, I didn't always understand Sun Ra, especially if he was speaking quickly, and the second unusual thing that happened backstage that evening hinged on what must have been an auditory fumble on my part. The African percussionist had calmed down and blended into the circle and Sun Ra had continued his monologue. I was sitting in front of him. He twirled his cane as he spoke. To this day, I am sure I distinctly heard the artist who I had come to revere above all others say, "Would you please take my cane for me?" It did cross my mind that this was an unusual request but that perplexity was overruled in an instant by the impulse to comply with what I heard as a clear directive. When I (ever so gently) wrested Ra's cane from his hand, I could tell by the expression on his face that whatever he had said, it was anything other than what I thought I had heard. I sat there with the kidnapped cane now in my hands. His eyes locked onto mine, and for reasons that I don't fully understand, before my embarrassment had had time to fester into panic, I realized that I had succeeded in delighting Sun Ra. He wasn't one for a lot of probing eye contact, but in that clutch of precious

seconds in which his eyes melded with mine, I could tell that my misunderstanding, my intuitive leap, had thoroughly amused the grandmaster of surprise and for one lusciously pregnant moment, I felt like I had gotten the maestro's attention. *Touché* said Sun Ra's eyes. *Well-played* said his grin. I had been spontaneous before the Throne of Serendipity. I had been recognized. I returned the cane. The night continued. The African percussionist joined the band onstage. He played a small hand drum with metal rattles, more like a tambourine than a Middle Eastern *riq*. (In retrospect, I'm pretty sure it was a *panderio*, a Brazilian instrument.) He tore it up, rocked his jingly instrument like a mother rocking her child.

Sun Ra © William Brower

CATALYTIC CONVERTER

Everything that now appears debased and worthless to us is the currency we will have to redeem on the last day. And we will be guided toward salvation precisely by the companion who has lost his way. It is his face that we will recognize in the angel who sounds the trumpet or who carelessly drops the Book of Life from his hands. The bead of light that emerges from our defects and our little abjections is nothing other than redemption.

Giorgio Agamben[1]

There was in Ra, and continues to be in his music, the witness of alternatives to all of this and what it's got going on. The evolution of humanity was his theme — from revelation to revelation, immeasurable, revolution to revolution, like heartbeats of truth. The breathing of always.

Amiri Baraka[2]

Treating Ra's wisdom as program or project by trying to find a prescriptive thread in his lifelong discourse on humans and their fate is not a very fruitful way of employing the energy of what he called *Myth Science* that is his unique endowment. There are better ways to receive what Sonny offered. He cast himself as a "catalyst." In chemistry, a catalyst lowers the energy required for a reaction without being consumed by the reaction or incorporated into its end products. A catalyst is not a reagent. Absent the catalyst, the preconditions for the reaction may be in place, but the likelihood of crossing the energy threshold needed for the process to run downhill is much lower.

Jacson told me that Sun Ra was about thirty years ahead of his time. Today, there is a lot of looking back at Sun

RECOMMENDED LISTENING

Sunrise from *Blue Delight*

Ra, only to find him standing with us, in our today, or a few steps ahead of us, in our tomorrow. Sun Ra departed during the early phases of both the Digital Revolution and the War on Terror. The preconditions for the reaction that he arrived to catalyze existed only in embryonic form while he was physically present, but his work survives his (fleshly) body, extends its reach into our history and conditions and predicts our post history. The reaction is developmental. It would have happened anyway, like a tadpole losing its tail.

Sometimes Sun Ra wore two hats — one on top of the other. He made many of the hats worn in concert by the members of his Arkestra. I have always thought that he was a man of enormous intelligence. I mean much more than the considerable intelligence that is implied by mastery within jazz, a very intellectually demanding discipline. If weighing and dissecting brains is how we honor the intelligence of their former owners, then Sonny's cranial contents should have been just as worthy of scientific quantification as Albert Einstein's. What does it

mean for such a hypertrophic thought organ to be born into the unique biographical bracket that delimits Sun Ra? It means he had to work with the cultural cards that he had been dealt, so he first inverted them all. The dichotomy of race into which he was born was black versus white. He supersedes that polarity, over-laying it with one of his own: human versus angel race. Gender — ordinarily the most brutally concrete of identity traits — became a transparent mist. That old-time religion — the social glue of black society — is rebuked in such an uncompromisingly harsh and complete way that it would have been seen as blas-phemous if anyone had bothered to take him seriously. Even the work of this quintessential Southerner does not mature into its signature form until he arrives in New York in the early '60s and then relocates to Philadelphia in 1968. There, in the northeastern city, where ideals about power and the individual once congealed into the fresh mythscape of a New Nation, Sun Ra staked out a humble space in a nondescript row house on the northern fringe of a sprawling African American ghetto. There, in a city of brotherly love where the police still wage a blood feud against a family named Africa, a war that culmi-nated in the incineration of six adults and five children and a neighborhood because the cops chose to drop a bomb on a house in an attempt to evict the people living in it, the city where the New Nation's bold ideas about its soul and destiny would first be solidified into binding words, Sun Ra lived out the last years of his creative life. Inversion is a recurrent remediation.

Jerry Gordon met Sun Ra as a customer at Gordon's land-mark Third Street Jazz & Rock record store in Philly. A little more than a year before Sun Ra's Death, Gordon launched his Evidence record label with five CD-reissues of rare Sun Ra releases from the late '50s and '60s. The material subse-quently put out by his label seemed intended, not just to follow a chronologically accurate sequence, but to reframe Sun Ra's

legitimacy as a jazz musician by appealing to familiar and widely accepted styles. "He's not some kooky guy whose only tradition is that of the avant-garde," the Evidence founder told the *Philadelphia Inquirer*.[3] Of course, most listeners in the 1990s were ill prepared to appreciate how advanced and disjunctive the now familiar textural and harmonic devices employed by Ra on these early jazz sides were when heard in their time. Gordon is a fan of Sun Ra's and cautioned against over-intellectualizing his art and its meaning. "You understand Sun Ra only by listening to the Arkestra and abandoning yourself to the music."[4] In his meditation on Chicago's jazz life in the '60s and '70s, Gerald Majer went into detail about the psychosomatic (mind-body) effects of this abandonment to arkestrated tone science:

> I could grant that the Arkestra was absurd, I laughed too, feeling the simple delirium of it, like when you were a kid and you'd spin and make yourself dizzy — a stupid thing to do, but you liked it anyway, did it again and again no matter how often you were warned. That goofy spinning gave you a different sense of your body and of the ground under your feet — the precious gravity that, cultivated and regulated since you were an infant, made you a person, made you human. As you turned and turned, you felt how your body wasn't necessarily together with itself, it flopped and stumbled, it lurched and wheeled on its own as you tried to catch up, laughing, your own existence suddenly a crazy joke.[5]

There is a power, a challenge, in Sun Ra's musical art, but that power rests dormant until it is allowed to interact with Sonny's word-sound. Specifically asked to describe what young musicians should do to keep Sun Ra's music alive, senior Arkestra member, and successor to Ra as the organization's leader, Marshall Allen (alto saxophone, flute, *dousn gouni*, EWI) insisted, "They have to listen to Sun Ra talk. For weeks and weeks and weeks, all he and I did was talk. Talk. I

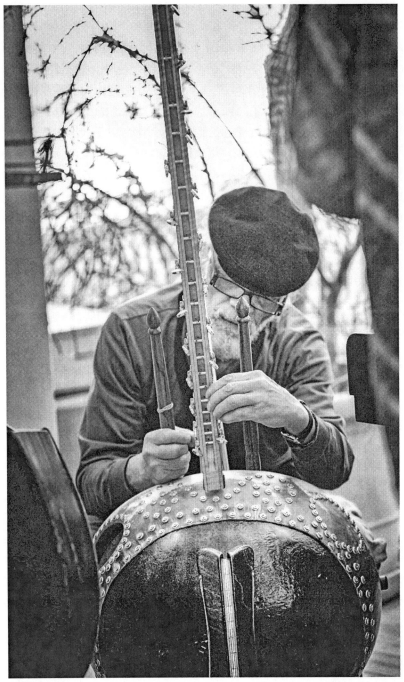

Marshall Allen

© Yusef Jones

sit all night in the restaurant and talk. All day long, talking, and I'm with my horn ready to play and I ain't played yet. Just constantly talking."[6]

Marshall then went on to tell the story of his initiation into the Arkestra in Chicago in 1958. "I was waiting to come into the band, but he told me 'to come over here tomorrow at twelve.' Be there at twelve, and he'd be sitting up there by himself, at the piano. And that was my [first] rehearsal, and it was taking not what he played, but it was creating something else with his music. And that's what I did. I never did play any music with the band, for a whole year. I was standing up there by him at the piano until he tell me, 'you play.' And it was something not that the band was playing."[7] Marshall's reflections remind us how Sun Ra built a comprehensive context around his music that never strayed far from his overarching mission nor ceased to be highly personal, even in a public setting. Majer's characterization of applied tone science (Sonny's music) as an affront to the integrity of both gravity and the earth-bound body are equally telling.

In the United States, the greatest performers are the ones who kill themselves. Elvis. Marilyn. Jimi. Kurt. Some say this is because we feel a tragic loss of love and profound regret for the creative potential that has been wasted, all the films and music that we will never have again. Maybe so. I think these performers are the greatest because we appreciate the fact that they did us a favor. They understood that in order to be truly loved, they needed to dispose of their limited physical bodies so that their unlimited virtual images could live forever, move freely about the world and be in a million places at once, and never have anything to compare to except other images.

Joe Scanlan[8]

Now finished with his work onstage, Sun Ra joins the ranks of cultural ephemera readily accessible through the mediated

network that has become the crucible of our cultural life. From these sundry fragments, the young are uniquely privileged to build their bricolage identities of ironic retroflection. A student gave me a bumper sticker a few years ago that had a small image of Sonny flanked by the words "What Would Sun Ra Do?" Caught up in the apparent whimsy of the gift, I put it on my office door, unaware that Sun Ra's name and image so affixed to my institutional cubby could function in much the same way as the muted post horn in Thomas Pynchon's novel *The Crying of Lot 49*. In Pynchon's work of surreal fiction, the post horn was the symbol of an ancient network of couriers, vehicles for submarginal communication that functioned over the years to clandestinely unite and energize society, beneath the surface and behind the scenes. Unlike Che Guevara's iconic visage, endlessly silk-screened and plastered on t-shirts and coffee mugs, Ra's likeness has not yet traded subversive functionality for recognition. The sticker on my door has been the starting point for many extraordinary conversations and the subsequent formation of crucial alliances with other like-spirited travelers. Under Sun Ra's mark, I have found my humble assistant professor's office discretely serving as a cosmic weigh station, a depot on a new underground railroad, conscripting me to do my small part to lead souls out of a prison made of meaning and its institutionalization (Death).

The question of *what would Sun Ra do* is not entirely the same as the question of what did Sun Ra say to do or even the question of doing what would be most consistent with the largest ideas extractable from Sun Ra's cosmic gumbo. That is to say, the catalytic Ra, the precise nature of the push that his body lends to reactions and processes within our bodies remains occult, at least somewhat mysterious, potentially magical. Had he been simply an ideologue, a fountain

of doctrine, we would have exhausted the discursive power of his rap during his lifetime, but Sun Ra's enabling of our evolutionary ascent is grounded in his powerfully prescient ability to employ myth as media. Myth — a prehistoric, i.e., preforensic tale of other than truth — that was Sun Ra's proper medium. Applying and deflecting what Andy Warhol observed in the transformative power of twentieth-century celebrity, Sonny kept *a low profile*, as he called it, and meticulously built a life of anti-celebrity — the greatest keyboardist, big bandleader, and recording artist that (almost) nobody ever heard of. Everything Sonny did contributed to our reception of Sun Ra as a creature of myth, a singularity, a living unicorn, or as he suggested, an angelic visitant among us. He becomes, through his understanding of the mythic sphere that scientific rationalism would claim to have forever deposed, a powerful attractor whose gravitational pull increases as we move forward in time, away from the point of expiration of his corporeal spacesuit. His body — which is his sound, his word, his art — is now condensed into the deepest kind of analog, antiauthoritarian skepticism and compressed into the ethereal code of a global network of curious seekers. In corporeal absence, the catalytic Ra, the Sun Ra of rare records and grainy YouTube clips, is turned on, activated, released.

OVER JORDAN

...from the streams that flow with movements of the air, clouds all joined together like strands making a skein of wool, from the spirits of the infidels, the ancient people that lurk in the earth in certain special places around here that Christians cannot or should not enter.

Sibundoy Valley Shaman as told to Michael Taussig[1]

I f Sun Ra were a political party, the first plank of his platform would be the eradication of Death*. He railed against the blanket condemnation of humanity (what he called a Death sentence hanging over the heads of all Earth's people) as if Death were a policy decision that could be rolled back, or an addiction that could be wrestled into submission. The fact that biological collapse flows without rancor or partiality, from application

RECOMMENDED LISTENING

Seductive Fantasy from *On Jupiter*

* In keeping with Sun Ra's admonition that Death is the domineering and jealous lord of human affairs, and is not to be fucked with, the author has chosen deferentially to capitalize all occurrences of the word *Death*, except where used in a context where this Lordship is to some extent diminished, e.g., *brain death.*

of the second law of thermodynamics to closed biological systems, didn't seem to blunt Ra's rejection of the inevitability of fatality:

> It's so ridiculous to say that everybody has to die — it's a waste of time — people with magnificent minds, magnificent talents, why can't they keep on going on? Because it doesn't even make sense that they shouldn't.
>
> Sun Ra[2]

Sun Ra was a distance runner by nature. Assuming that illness or accident could be averted, he saw Death's indiscriminate scythe as cutting down the human being at precisely the moment when she or he is finally starting to get it together. Reproductive instincts have been fulfilled, and certain distracting urges have been blunted. Competency has finally had a chance to ripen into mastery, and here comes that guy. Grim, all right, and a frustrating waste of precisely what Sun Ra valued most — development. Death is an equal opportunity destroyer — an indiscriminate conqueror, eventually taking out the best and the worst without distinction:

> The way to look at it, the way people die proves that something is killing them — something superior to them always wins — a superior force. So Death is a god, if nothing else, and all people are subject to it, so Death's their god. They aren't actually subject to the United States or Russia or anything; they're subject to their god — Death. That's very obvious. The point is, having reached that point, what to do about it? If they ever reach that point, should they be obedient to the god Death or should they be rebels? Because, if they're obedient to God and are righteous, then the most appropriate thing to do is to die. Then, when they're dead, they're holy and righteous.[3]

What is Death? Well, as you might expect, this depends very much on where in time and space the question is being

asked. That is, as universally problematic as the settled inevitability of the full stop waiting at the end of our sentence, its definition only coheres at the shifting intersections of culture, medical history, and religion. Perhaps it is the body's final developmental stage or, more poetically, it is the ship of life irretrievably run aground. It is a really bad day. It is the promise of no more bad days, ever again. It is the beginning of the end and the end of the beginning. A dead body is broken. It cannot be fixed.

For human (and most other animal) bodies, the risk of mortality conspicuously increases with time. Excluding the increased likelihood of Death by accident, this can be seen as the result in large part of an accumulation of damage at the cellular level caused largely by cumulative mutations in DNA (not unlike the changes that make evolution possible), and the decreasing ability of cells to rid themselves of dangerous free radicals, harmful proteins, and other metabolic byproducts. Some animals are gifted with *negligible senescence*. For a handful of identified species there is no significant increase in mortality with the passage of time. That is, for certain species of fish and turtles, for example, aging as a diminishing of health or increased vulnerability to disease is statistically absent. However, even these very long-lived animals, do appear to eventually mature and die. Marine biologists, however, have identified an animal that may be the only truly deathless animal. *Turritopsis nutricula* is a bell-shaped jellyfish-like hydrozoan, and has the unique ability to revert to a pre-mature state and resume its development from there. "All stages of the medusa *Turritopsis nutricula*, from newly liberated to fully mature individuals," writes the team of researchers, "can transform back into colonial hydroids, either directly or through a resting period, thus escaping Death and achieving potential immortality."[4] This would be

similar to you or me living to about sixty and then rewinding to puberty to do it all over again, which may or may not be such a good deal.

For most of humanity's time on earth, bad medicine and bad hygiene have kept our average life expectancy too low to allow for the onset of old age or senescence. People died from trauma and simple infections that would eventually be among the easiest disorders to repair. Only in the last century has human life expectancy crept beyond the half-century mark where it still stands in countries like Chad, Guinea-Bissau, and Afghanistan.[5] Of course, in the developed world, life is longer, not by years, but by decades with geriatric proliferation being a serious concern for policy makers. While Japan retains its title as home to the most centenarians in terms of absolute number, Cuba has recently surpassed it in the percentage of its citizens living to or beyond the century mark. With a population of 11 million Cubans, 1,551 people are over one hundred years young, roughly five times the proportion in Japan.[6]

For a human being, long life is still life truncated. In developed countries, including the United States, the redundancy of age is often warehoused and billed like forgotten goods in a storage locker. Many decay in virtual isolation, oblivious as direct debits pull their expenses (first living, then dying) from dwindling bank accounts and evaporating health benefits. Others are more "privileged" and can afford an equally marginalized Disneyland twilight of endless golf and martinis, still somehow saddened in their last chapter by the loss of friends and real social involvement. This isolation of the elderly is a particularly pointed problem in China where the math of an official one-child limit has severely diminished the odds of a call or visit from the kid(s). A growing crisis of geriatric abandonment spurred the Chinese government to enact legislation that allows parents to sue their children

for neglect.[7] Vedic scriptures exalt the 100-year life as a just adequate time span for achieving the difficult work of self-knowledge and self-realization, but in the Twitter Nation of perpetual youth, there is an appalling lack of appreciation for the precious asset that is age. Survivorship is in many ways the ultimate mothership, the essential vessel for arriving at the abundant good stuff that can unfold over time within a diligently lived human life. Should current trends continue, it is quite likely that there are infants being born now who will live to be 150. What will they do with themselves after their worldly work has ceased — sudoku and painkillers?

Had Sun Ra's body not disintegrated and collapsed, he would have continued to produce high quality musical per-formances, recordings, and compositions without abatement. Anyone who knew him will tell you, it took more than a series of cerebrovascular accidents to shut him up. At the time of his departure, Sun Ra still had plenty to say and do.

I saw Sonny shortly after his rehabilitation from the most serious of the strokes he had suffered. He was playing with a full Arkestra at the Knitting Factory in New York City when the popular jazz and progressive music club was upstairs on East Houston Street. It was a fairly narrow strip with a slightly raised stage and the mixing board at the back of the club. That night the injury to Sonny's brain and body was inescapably visible, painfully audible. The once nimbly masterful pianist, whose stylistic competencies could meld stride, the blues and microtonal extrapolations, struggled to bring hand to key. Even by a cosmo-standard that embraced weird intervals and blurred intonations, he did not sound very good. It was a hard night for everybody that loved Sun Ra — in the audience and on the bandstand. And it must have been hard for the engi-neer working the board who gradually pushed the volume of Sonny's piano down into the house mix. Playing close behind

Sonny was trumpeter Michael Ray who at first discretely and then emphatically gestured for the soundman to return Ra to his proper level in the foreground and every time, the piano mic gradually receded again. This back and forth — Ra down, Ray gestures, Ra up, repeat — went on for a couple of cycles until finally Mr. Ray shot a stare in the direction of that engineer that was so cold and so hard that it could be felt across the room and only interpreted as *if I have to come down off this stage, I will solve the problem*. Of course, Sun Ra's piano returned to prominence in the mix and remained there for the rest of the evening.

I have had many occasions to retell that story. It is very meaningful to me. It is a candid demonstration of the love and protective loyalty with which Arkestra members surrounded their leader. Sun Ra was a proud man. Beyond the hyperbolic hubris with which Ra inflated his myth-self, he was at his core a highly accomplished, self-demanding artist who was deservedly proud of exemplifying a consistently high level of musicianship. He did not have to play that night. He could have stayed home. The Arkestra could have performed without him and wheeled him out at the end of the set for a long and loving ovation. He had several options. The one he chose was to set down his pride and perform for us yet another crucial lesson as we each prepare to face our last night on stage. Fading and fighting, in the end, are indistinguishable. Life is stubborn. Death, relentless. Play. Why would you not, until the last curtain call, play?

Death is more a process than an end state. Presumably, Death is an unabashed bummer because at some point it is a process which cannot be reversed. If your condition improves, then no matter what else may be true, you were not dead, just really, really sick. Discerning when the process of Death has passed the point of no return has never been

a foolproof affair. For a diagnosis of Death, false positives have ghoulish consequences. In the era before embalming became routine, evidence of premature burial was common enough to justify the construction of *pre-morgues* to accompany many nineteenth-century hospitals where those believed dead would camp out together until the onset of decomposition could dispel any doubt. A string running from the pre-dead's finger to a little bell would signal an attendant (there's a job) who alerted medical staff that one of the opposing team's points could be taken off the board. Companies in the late 1800s offered expensive burial vaults with elaborate provisions for ample airflow and equipped with portals that opened from the inside to allay the fears of wealthy people that they might have parked their loved ones in Parklawn before their time.[†]

The beating heart was the definitive signature of human life for the longest of time. This sound-vibration is music that is always inherent in a healthy body. It is heard as a strongly syncopated duple rhythm and is governed by a distant regulator buried within the most primitive structures of the brain — a neuroelectrical metronome calling beats out of something like a fleshy water drum with its own unique tones and overtones. Check for the pulse to determine if the body is a person or a corpse. This music, this pulse, this wonderful rising and falling *binghi*[†] beat, must be there for the whole thing to work.

As Sonny put it in song, *things change; there's always change in the air.*[8] In the late '60s two factors collided that necessitated a rethinking and relitigating of the most

† The US Patent Office even had a standard application category for a "class of devices for indicating life in buried persons" including various types of coffins equipped with periscopes.

† From *Nyahbinghi Order*, a stalwart subdivision of the Rastafarian movement known, among other things, for the stirringly sparse percussion-based music that accompanies a celebratory liturgy (i.e., *I-ses*, from *praises*.)

time-honored definitions of dead. Machinery, which could do the job of heart and lungs, was in widespread use, and vital organ transplant was becoming a viable medical procedure. Cardiomuscular music could be replaced by the mechanical (but functional) thrusting of plastic pistons, and the presence or absence of that primal rhythm was no longer reliable as the clinical threshold separating life from Death. The truth of pulse was replaced by something of a myth called *brain death*. Transplant surgeons learned early on that replacement organs had to be "harvested" before the heart had stopped beating to ensure the likelihood of procedural success. It follows that if irreversible cardiac arrest (that is, the old gold standard of a stilled heart) remained the only official criterion of Death, the prospects for successful vital organ transplants would be far less promising. Enter *brain death*, a modern benchmark addressing both the desire to alleviate suffering (mostly of family members needing the validation of an external authority to make painful life support decisions) and the need to release those precious organs while they can still be used (essentially sold, although the family of the deceased will not be compensated for this valuable biological property.). A website for the California Organ Donor Registry assures us that, "Brain death is Death. When brain death has been declared, families are given the option of organ, eye, and tissue donation if the patient has the medical potential to be a donor."[9] In the United States, but not in all industrialized countries, brain death has been the appropriate medical and legally binding definition of Death since the Uniform Determination of Death Act (UDDA) was endorsed in 1981 by the American Medical Association, the American Bar Association, and the President's Commission for the Study of Ethical Problems in Medicine and Biomedical and Behavioral Research. UDDA is intended "to provide a

comprehensive and medically sound basis for determining Death in all situations."[10]

Apparently, since Dr. Christiaan Barnard performed the first human heart transplant on December 3, 1967, vital organ transplants have become *quite* viable. According to one source, a heart transplant now costs $997,700. While a single lung sets you back $561,200, a matched pair can be had for $797,300. If you need heart *and* lungs, come prepared to throw down a whopping $1,148,400. But topping out this list of estimated U.S. average billed charges per transplant for 2011[11], if you have the guts, or rather need some, is an intestinal swap, which is available for a stunning $1,206,800.[12] Even if the price for a fresh strand of guts can be prorated by the foot, that still seems like a lot of cold cash for literally some new shit. We are not surprised (or are we?) that there is a surfeit of profit to be found in the remarkable reusability of an individual once the medical and legal establishments have declared the person to be a cadaver.

A patient lying in deep coma, and presumed near brain death, will undergo periodic tests to assess the integrity of brainstem function. Mechanical means may or may not be needed to breathe or circulate blood for the patient. If the patient is in grave enough condition to warrant consideration for brain death, their pupils will already be dilated and unresponsive to light. The clinical examination of the brain will include testing of other brainstem reflexes, determination of the patient's ability to breathe spontaneously, and evaluations of the motor response to pain which might be as drastic as pushing a pin into the sensitive flesh under the nails of fingers and toes. The doctor will probably shout "wake up, wake up," suggesting that to the patient himself or herself this critical state may be something like sleep. Cold water will be poured into the patient's ear. In a person with a

living brain, this sudden change in ear temperature will trigger nystagmus (a violent twitching of the eyes). Though their blood continues to circulate, the brain-dead respond to none of these offenses.

In other words, there is an alignment between a clinical protocol for declaring Death and a bureaucratic checklist for releasing organs that reflects a broad scientific and social consensus within advanced cultures on when the human individual has become a bag of spare parts. Well, not exactly. You see, some advanced cultures have been a bit more skittish about institutional declarations of Death and have embraced neither vital organ transplant nor the criterion of brain death as regular features of critical care. If a Japanese person has benefited from an organ transplant (aside from those tissues like bone marrow, liver, or kidney that do not require a deceased donor) there is a high likelihood that the procedure was performed outside the country. The Chinese are also reluctant organ donors. In 2008, just thirty-six Chinese out of a population of 1.3 billion people voluntarily donated organs.[13] But in a totalitarian super state, contributions from executed criminals can satisfy some of the demand. In her examination of Death in technological times, medical anthropologist Margaret Lock explains the Japanese reticence to accept the cessation of brain stem activity as the threshold to Death. "Because it is *mienai shi* (Death which cannot be seen) it [brain death] represents a radical departure from a Death where the family participates fully in the recognition of the process."[14] In other words, the Japanese believe that the decision to take their family members off life support is sacred and integral to familial responsibility. It is the most difficult of decisions and should be made wholly within the family, not coached along by external forces who must also be responsive to a market demand for organs.

Lest you allow yourself to believe that this concern on the part of the Japanese that modern medicine is hasty to rush us off to the hereafter, consider the work of the head of Intensive Care at Stony Brook Medicine in New York. Dr. Sam Parnia is a British native and resuscitation specialist who, like Sun Ra and Black Herman, has been doing his part to undermine Death's conclusive authority. His innovative approach has extended by hours the time after cardiac arrest at which a patient being treated in a specially outfitted and trained emergency unit can be revived. Old-fashioned chest compression (CPR) is only the initial step in Parnia's upgrade of the last-ditch measures used to restart the heart and return the individual to full functioning. (Restarting the heart after the brain has melted from oxygen deprivation leads to unacceptable outcomes.) From there, however, Parnia's recalcitrant approach deviates radically from standard medical protocols and builds on the time-honored observation that individuals whose apparent demise involves extreme cooling — the classic case being patients who have drowned in frozen lakes or streams — can be reanimated after exceptionally lengthy periods without spontaneous cardiac activity. While continuing to receive chest compressions and defibrillator shocks, Parnia's lucky patients are immediately injected with iced saline solution. A heavy catheter tube is shoved into a femoral artery and a vein on the opposing thigh is similarly tapped. These are attached to an ECMO (Extracorporeal Membrane Oxygenation) machine, which oxygenates and further cools the blood. With the brain thereby protected from damage, Parnia-trained medical teams can extend their attempt to reestablish the heart's music with repeated applications of defibrillator blasts and adrenaline injections. Then, like an old Chevy that's a little stubborn to turn over on cold winter mornings, the heart usually does crank back up and resume its normal rhythm. "Most

doctors will do CPR for 20 minutes and then stop," he says. "The decision to stop is completely arbitrary but it is based on an instinct that after that time brain damage is very likely and you don't want to bring people back into a persistent vegetative state. But if you understand all the things that are going on in the brain in those minutes — as we now can — then you can minimize that possibility. There are numerous studies that show that if you implement all the various resuscitation steps together you not only get a doubling of your survival rates but the people who come back are not brain damaged".[15] Currently a Japanese girl holds the record at nine hours for the length of time after cardiac arrest that a patient has been revived to full functioning using this type of forced-cooling protocol.[16] Twenty minutes?

Death is usually an unwelcome visitor, no matter how his arrival is determined. But Death is also a project, something to do, a consciously undertaken act of human relationship. Ever since Set slaughtered his brother Osiris and cast him into the Nile (later remythologized as Cain smashing Abel's skull with a rock), the human capacity to kill has been a closely held individual and collective prerogative, with all human cultures drinking from the chalice of murder to a greater or lesser extent. In the world of the blind, eye-for-an-eye justice restores balance and reestablishes comity. Execution is the ultimate punishment for failure to comply (including compliance with norms prohibiting the taking of life). War (a sloppy, collectivized execution) remains the ultimate arbiter of inter-group conflict. Had it not been for the broad human propensity to treat Death and the threat of Death as an effective instrument of control, Sun Ra might have seen humankind as a hapless victim of mortality. As it was, he was especially annoyed with instrumental violence and its institutionalized expression, War. *SITP* uses court records and letters to

evocatively document a 27-year-old Herman Blount's refusal to be inducted into the US Army in 1941 and the punishment that he received for his conscientious objection.[17] Its victors have framed the Second World War as *the good war* and at the time of Sun Ra's decision to abstain from any war, treason was much better understood than pacifism. Sun Ra was jailed and sent away to a forestry camp for his refusal to answer Uncle Sam's call and Szwed informs us that he returned from his time away from Birmingham bitter and even further alienated from normative society, black or white.[18]

> In the first millionth of a second, the fireball is 500 feet across. Within 10 seconds, it would grow to over one mile. The temperature would rise to 20 million degrees Fahrenheit — hotter than the surface of the sun. The blast would generate winds in excess of 650 mph. Forces of that magnitude can destroy anything that people can build…. In the first 5-6 miles, virtually everyone in that five-mile radius is going to die.
>
> From the film *Countdown to Zero*[19]

Throughout his life he was consistent in his opposition to war and his art reflected this, perhaps most sharply in the space chant "Nuclear War"[20]. *It's a motherfucker, don't you know*, Sun Ra and Arkestra trombonist Tyrone Hill sing over a deceptively sparkly chromatic piano line played at a steady walking rhythm. It is worth noting that this spicy chunk of language is the only use of profanity that this author is aware of in Sonny's vast recorded song repertory.

Apes have something like war. Common chimpanzees (as distinguished from their close relatives, the far less aggressive bonobos) will occasionally form raiding parties to attack and kill members of rival groups. It is from extensions of comparative behavioral biology that some have assumed that war, as an organized social phenomenon, has always been a part of the human behavioral cabinet. Other voices on the subject,

however, point to archeological evidence that only documents the kind of mass carnage and projectile injuries that typify war within the sediments of the last 10-15,000 years[21]. What is clear is that once pursued as a program, propagated as a meme, war has been pernicious and contagious. It is real world game play where the winner must know what holds human individuals and human communities together materially and spiritually and (to win the game) how to undo that integrity. This undoing, this disintegration of the opposing (mirrored) human side is the objective of war. As such, War, absolved of any pretenses of propriety or legality, must always embrace the interruption of food and water as well as the deployment of rape, poison gas, and every manner of torture. The goal of war is control through destruction. Warriors are effective when they cause enough disintegration of the opposing human side to force capitulation.

> All of us are already civilian soldiers, without knowing it. And some of us know it. The great stroke of luck for the military class's terrorism is that no one recognizes it. People don't recognize the military part of their identity, of their consciousness.
>
> Paul Virilio, *Pure War*[22]

In the same year that Sun Ra released "Nuclear War," Paul Virilio developed a concept of *Pure War* to describe the pervasive and internalized militarism that was birthed during the Reagan regime, and which ultimately came to prevail in the Cold War. Virilio writes under the mushroom-shaped shadow of a doctrine of deterrence that continues to aim two earth-extinguishing arsenals at each other. He presciently warns of the permanence of pure war and how its societal preconditions include the colonization of science and the subjugation, if not obliteration, of nature by technology. The lyrics and

music of "Nuclear War" are Ra's way of rubbing our noses in the same putrid prognosis: *First comes the heat/then comes the blast!* Most of Sonny's lyric on this portentous tune catalog the aftermath of nuclear detonation through an understated, even relaxed call and response exchange, except for that line about the blast, the explosiveness of which is echoed in the barked delivery. It is the understatement, the casual, almost campy lounge feel of this piece that is the perfect musical counterpoint to war normalized into society's finest workings.

Collateral damage — a euphemism that now seems so unnecessary that it is hardly ever invoked — provides little moral cover for a war that is now waged on both sides with automatons. Each side in a pretentiously messianic conflict that one side casts as a war for security, the other as a war for god, is writing into the contemporary chapter of the long Book of War something like its perfection as moral and political act. This perfection is accomplished simply and entirely through mirror image enhancements to the terms on which each side has operationalized Death. Understandably, the ethical assessment of war by aerial robotic proxy (i.e., predator drone) has nothing to do with the lives of people in the targeted societies and everything to do with the gaping blind spot in the moral vision of Americans for the distant civilian victims of their exceptionalist wars. At the time of this writing, predator drones are the technological embodiment of a politically insulated means to an end and (for the time being) appear to be only available to one side in the conflict. As long as she or he can tax his populace enough to pay for the hardware, a US president can drone away their enemies without ever (directly) jeopardizing the safety of one American (although US citizens have been shown to be under cover of no such exemption while outside their country, as the predator drone executions of Anwar al-Awlaki and his 16-year-old son demonstrate.) For

a people whose sense of moral responsibility stops at the border, this is a perfect weapon. (Evidence of this moral blind spot is found in the response to efforts by the National Security Agency to track calls and Internet communications of US citizens. The outrage was explicitly and unapologetically limited to data collection on US nationals — never mind any right to privacy non-US citizens might claim to have.) But this perfection doesn't stop at its self-insulating political features. More importantly, the predator drone is a technology, which in its proper operation guarantees the perpetual regeneration of the thing it is sent to destroy and thereby offers the perfect insurance that the whiny electric drone of automated Death will always be "needed" somewhere.

On the other side, the quite queer fusion of anti-colonial rage and religious fundamentalism has manufactured software that effectively weaponizes individual humans. Where the Western powers have perfected their strategy by maximizing the distance between the individual human agent and the delivery of the expunging ordnance, the suicide bomb of the jihadi fuses its human delivery mechanism with the bomb itself and thereby perfects his war game by insulating not its politics, but its morality. For as surely as the predator drone effectively short-circuits political critique (Americans being only offended by the shedding of blood that flows red, white, and blue), a suicide bombing is by definition a self-punishing crime. What, after all, are we to do with the suicide-bomber once his deed is done? Scrape up his pieces from the pavement, separate them from those of his victims, and blow him up again? To the extent that punishment is defined by what can be done on this side of the great veil, his is capital and instantaneous — no long drawn out trial, no appeals. Any moral hesitancy or ambiguity attached to his act is immediately rinsed away by the act itself. The jihadi has learned that

only the law of what works need contain the instrumentality of violence. Asymmetrical warfare waged by scattered bands of zealots can, and perhaps eventually will, bring wealthy, well-armed democracies to their knees. In the end, the predator drone is defeated by the martyr's suicide vest simply because its software proves more difficult to hack.

Once purified, each side in the Last War seeks to perfect the way in which mass Death is organized. None of this purified perfection is in the interest of life or the living. The only humane war reduces conflict to a game of tag, to a Lakota ritual of counting coup. War is retired only after the cult of the war hero is abolished.

———————

Corpses stink. It is our custom to segregate the living from the dead. The social distance between the living and the dead, the etiquette of Death (and dying) is also subject to considerable cross-cultural variation. Many of Sun Ra's ideas on the matter are consistent with West African constructions of Death and the hereafter. Like Sonny, for the Akan, a prominent cultural community in Ghana, "Death is a concrete, tangible, and personified being." The Akan name for this being is *Egya Wu*, Father Death:

> Death, personified, is usually imagined as a skeleton with hollow eye sockets, blind but has ears to listen with. Thus Death may linger within reach of its victim and yet fail to claim him unless the person reveals his presence by speech. Although Death is capable of hearing, it is adamant and insensible to pleas for mercy."[23]

In Twi (principle language of the Akan), the act of dying is expressed by the verb *wu*, but this Ghanaian ethnic group has a wide range of politely poetic expressions that are preferred over simple constructions on this monosyllabic verb.

For example, *se nnyim owu a, hwe nda*, translates as "if you have no idea of Death, observe the phenomenon of sleep."[24] And the maxim "summoned by Death and by your mother-in-law, attend to Death first,"[25] in a matrilineal society is meant only to convey the inescapability of Death's lone commandment and echoes a warning with which Sun Ra repeatedly used to chide us: *When Death calls, you go.*

For the people of sub-Saharan Africa, spirituality is typically organized around a community of cosmic deities, nature spirits and ancestral intercessors. For these people, like Sun Ra, Death is seen as only a partial absence; for the African, the deceased are expected to continue to serve a pro-social role. About two hundred miles north of the Akan home territory, author Malidoma Somé was born in a traditional Dagara village in southern Burkina Faso. In a fantastic, first person memoir, Somé, who holds several advanced degrees, recounts the amazing events of his childhood including the unusual Death and last rites of his grandfather, a loved and venerated village chief. According to Somé, after being pronounced dead in a Jesuit clinic, his grandfather the Great Chief walked four miles (as a corpse) to the village over which he had reigned sovereign in life. "Why do the dead walk where I come from?" Somé asks rhetorically. "They walk because they are still as important to the living as they were before."[26] He recalls, in matter of fact detail, Dagara funerary rites no less incredible, including the preparation by occult initiates of an extraordinary meal for the dead chieftain:

> They had transformed Grandfather's room into a kitchen where everything was happening upside down...One of the men poured some flour into a basket of water yellowed by a mixture of herbs, stirred it carefully, and tossed its contents toward the boiling pot. Instead of falling down onto the floor, the contents obeyed another law. They landed in the boiling water, which splashed upward onto the wood of the ceiling.

> Everybody went about their tasks as if unmindful of how their activities appeared. It was as if they were operating in a circle that defied natural laws, involved in a strange conspiracy to challenge the Great Master of the Universe.[27]

Nullification of mortality is perhaps the oldest and most incontrovertible demonstration of supernatural ability. Raising the dead and returning from its terminal domain are unfailing ways to build one's reputation as a possessor of superpowers. Power over Death has certainly been a part of Jesus's grip on Christian believers, although Sun Ra saw the crucifix as a gruesome icon that only served to remind human beings of their subservience to Lord Death. The holographic tapestry of narrative and legend that establishes Sun Ra's mythic power also includes extraordinary challenges to the normal course of Death. Sun Ra had convinced many members of his organization that he had put himself beyond the reach of *Egya Wu.* He told the Hinds Brothers[§] of a drummer who paid dearly for his perceived disrespect of Sun Ra and the imprudent invocation of Father Death:

> One morning we was playing a breakfast and about 25 musicians [were] asking me questions after playing. I said something, and the drummer that was playing with us that was named James King said, "No, no it isn't like that". And then the other musicians said, "Man, you play with the band; that's your leader. You got a nerve saying he's not telling the truth and you're insulting our intelligence. You think all us fools; twenty-five of us, standing up here and you talking about no and we talking about yes. Your leader must be speaking the truth. You're in the band and if you don't understand what he's talking about, you must be dead and if you're dead, you need to be buried." I said, don't say that because I'm dealing with the kind of Creator he listening to what we saying. And the saxophone player named James

§ John and Peter Hinds founded Sun Ra Research in the mid '80s and recorded many hours of dialogue with Sun Ra and Arkestra members.

repeated, "If you don't believe what Sun Ra says, you must be dead, and if you're dead you need to be buried." In fifteen minutes he was dead, without any reason whatsoever. He got in the car and all the musicians got in there with him and he put his head back and they thought he was sleep and he was dead.[28]

As this passage implies, Sun Ra sometimes saw himself playing the role of double agent, appearing to partner with Death to serve the Creator's ultimate purposes:

We went to Nigeria, and they had this big festival, poets and intellectuals and everything; there were 5,000 people — beautiful auditorium. The poets and everyone wanted to appear in an auditorium, but the Nigerian government said, "We don't respect nobody from America but Sun Ra. This auditorium, only governments appear; we're going to have two governments presented each night, Sun Ra's going to be in there with the Zanzibar government, and y'all can't be in it." So, then they was very upset, but the Nigerian government said that only I would appear. So when these different governments would appear, the first thing they would do was bring out their flag. And here I was over there, in a sense being recognized as a government, and what flag was I going to use? So what I did is I brought my flag out there, and there was practically...a standing ovation. We're playing, and after we get through playing, we won't be back here. So now I came out with my flag, and the band wasn't...They weren't aware of what was happening. And I held my flag up. Standing ovation. Wasn't a United States flag, neither. It was not a Black Panther flag. It was the flag of Death. It was purple and black. I know what I'm doing. I had the flag of Death up there.

Sun Ra on his participation in FESTAC-77[29]

Jac Jacson told me that the band's FESTAC appearance attracted a lot of attention from local attendees because Sun Ra's dress and demeanor seemed to indicate a connection with *juju*. Jac (who also knew how to grow a good tale) told me that a contingent of Nigerian spiritualists and shrine priests had

seen Sun Ra and the Arkestra in performance and retreated from the auditorium early in the set, walking backward, heads bowed in deferential obeisance. Sun Ra was throwing too many sparks in the air. Szwed recounts the purple-black-banner story on page 342[30]. Danny Thompson and at least one other musician who was also present have no recollection of such an event. What can be gleaned from Sonny's flag of Death parable is that he felt that Death was a power to be respected and placated. We should give Him his due, since we must inevitably.

If sex is the pleasurable push back against the morose stank of Death, then perhaps Sun Ra had escaped sexuality, because he had no intention of dying. Trumpeter Art Hoyle worked with Sun Ra during the Chicago period and recalls that Sonny once showed him a formula in a notebook that Sun Ra claimed was the key to eternal life.[31] John Gilmore, senior band member in the Morton Street house, also made clear that Sun Ra had no intention of blinking out like that.[32] I am quite convinced that Sun Ra, if not fully convinced of his own immortality, was at least buoyed by the possibility that through the proper and sustained application of tone science he had inoculated himself against the bony claws of *Egya Wu*. There was in his last, crumbling days, frustration and a tinge of bitterness in Ra's usually sunny countenance. As his circulatory system and the body it nourished failed in the glare of the public eye, he could no longer feign immortality, and this exotic singularity would have to own a normal, mortal, old-black-man-with-busted-arteries Death. "Death is weak, not strong," interjects Szwed, "but weakness is powerful, the power which conquers people; you die because you get weaker and weaker until you are the equal of Death."[33]

Michael Taussig has studied the anthropology of Death as a social space, not of weakness or termination, but of power,

continuity, and transformation. "Prisons," he writes, "are the preeminent form of the modern death-space for the young men of the inner city in the U.S. today."[34]

> The colonized space of Death has a colonizing function, maintaining the hegemony or cultural stability of norms and desires which facilitate the way the rulers rule the ruled in the land of the living. Yet the space of Death is notoriously conflict-ridden and contradictory too; a privileged domain for transformation and metamorphosis, the space par excellence for uncertainty and terror to stun permanently, yet also revive and empower with new life.[35]

As I write I am reading that militants allegedly associated with the Boko Haram movement (*Jama'at ahl al-sunna li-da'wa wa-l-qital*) of northern Nigeria shot to Death some fifty boarding school students as they slept[¶]. This horror comes less than a week after gunmen loyal to the al Shabab Front in Somalia laid siege to a Kenyan shopping center and in the process killed some unknown number of people.[**] Here we have Africans killing Africans in the name of a time-war fought through the rhetoric of religion and the tactics of annihilation. We are to appreciate as unlawful in every way the indiscriminate destruction of the most innocent of non-combatants and are left by the subtexts of official analysis to ponder the cowardice and inhumanity of actors so enraged that they could kill with such cold-blooded and demonic abandon. There is no counter-narrative or set of accessible images that paints the opposing (mirrored) picture: predator drone operators (warriors?) reporting for duty, sitting down to gaming consoles with cute little joysticks, not unlike the latest home entertainment products from Sony or Nintendo. At the end of their "shift," the result of their work will be much like

¶ 29 September 2013.
** 21-25 September 2013.

that of the jihadis. Families and lives will be destroyed, not in front of the destroyers, but rather continents away, beyond the reach of retaliation or conscience, far beyond the reach of cries for help or mercy.

Guitarist On Ka'a Davis played with Sun Ra from '81 to '82. In a thoughtful and patiently developed response to the language I had chosen for my fundraising appeal to support this book, he reminded me of the need to speak of Sun Ra in a way that would not inaccurately imply that "his existence was like yours or mine, subjected to Death."[36] Davis also seemed certain that at the time of his departure, Sun Ra was on the road to recovering from his cardiovascular complications and left the planet mainly to escape the profound grief caused by the loss of June Tyson to breast cancer less than a year before Sun Ra lost his own battle with infirmity. What really struck me about the former Arkestra member's email was his mention of Sun Ra's disdain for the "necromancy" that he saw as coloring life in Western civilization. *Necromancy* — as opposed to *necrophilia* — implies more than an affinity for Death or even attempts to communicate with those in the hereafter. Necromancy implies a partnership with the dead in shaping the future. From the vantage point of the human being floating in the bubble of the now, there is no need to store up action against the day when you cannot act. That stored action, or more properly, action deferred, can be conditioned and guided by a last will and testament. What we call our *last will* is meant to bind the hands of survivors with manacles of love and loyalty, grief and mourning. Thus, do well-intentioned feelings of responsibility pull up the dead from the narrow trenches in which they rest, to release, if not their bodies, then certainly the last wishes enunciated by their tongues, out into the broad daylight of social life. This pact of necromancy is only fortified by our survivor's guilt and the

expectation that this privilege will be there for us when we give up the ghost.

There is nothing wrong with honoring our friends and family when they leave the stage before we do, but their lines should, in all fairness, afterwards be erased from the script. Otherwise they remain among us as zombies, uttering words that can no longer make sense as the storyline attempts to advance in spite of their absent presence. There is a diminishing of social space as the result of the accumulation of territory allotted to cemeteries. Our fear of Death is mitigated by the knowledge that a place will always be set for us at the table, but the dead do not eat and they certainly do not grow. The dearly departed can only find their way in the world of the living if that world is also prevented from growing. While I'm sure that Sun Ra wanted to free our bodies from their submission to Death, he was also keen to liberate our cultural present and future from its submission to an honorific spectacle of corpses.

Like Sun Ra, Taussig sees the inclusion of the dead in the affairs of the living as a conflicted inclusion, so conflicted

> that it amounts to a fundamental flaw running through the core of society like the San Andreas fault. It would be nice if the dead could be tucked away, far away, so there would be two worlds, one for the living and one for the dead. It would be almost as nice if they were given visiting privileges, say one or two days a year, like the Mexican Day of the Dead, candies and grinning skulls with picnics in the cemetery, and as a result of this liberal attitude they then promised to keep well out of the way for the remaining 364 days. But what if they're uncontainable, like illegal immigrants in California and Texas?[37]

It is the uncontained dead that spoil both the social and spiritual space of the living. In fact Sun Ra's response to Nietzsche was that "they should say, 'God is Death.' Not that

God is dead, but God is Death. In other words, that's what He is. So when people go out and they want to be like God, they went over into his Kingdom — of Death."[38] Religion, Taussig argues, begins in an attempt to appease a mob — that virtual "ur-crowd"[39] represented by all who have ever been, but are no longer alive. This zombie corps of literal has-beens is an invisible mass movement calling into existence both god and worship as the living's feeble attempts to arrive at some accommodation with this insatiable mass. Taussig calls for a "decisive alienation-effect that can whip us around the repressions Death fosters, letting us see anew the magical powers human societies have lodged therein."[40] Sun Ra's extremism on these matters is one of many misunderstood axes of his mythspace. Sun Ra's work in the arena of nonmortality can certainly be seen as a "decisive alienation effect" and if that allows us to tap into the magicality of *Egya Wu*, so be it.

NATURAL MYSTIC/NATIVE SKY

"The cleanest bones serve Wakan-Tanka and the Helpers the best, and medicine and holy people work the hardest to become clean. The cleaner the bone, the more water you can pour through it, and the faster it will run. It is this way with us and power, and the holy person is the one who becomes the cleanest of all."

Frank Fools Crow as told to Thomas E. Mails[1]

My home is always where I am. My home is in my head. My home is what I think about and how I try to set my mind in the thinking that I think. That is my home. My home is not a material home, or a somewhere or there. My home is in my head.

Bob Marley, from the film *Time Will Tell*[2]

sked, point blank, by WKCR radio host Phil Schaap[3], to name a few books that he might rec-ommend, Sun Ra immediately

RECOMMENDED LISTENING
Shadow World from *Nuits de la Fondation Maeght Nights*

cited two. The first, Sonny abbreviated as *X-ray and Searchlight of the Seventh Day*. He indicated that it was by a man who had been born a slave. That title is actually *Search Light on the Seventh Wonder: X-ray and Search Light on the Bible with Natural Science; Discoveries of the Twentieth Century*. It was published in 1903 by Boston Bonaparte Napoleon Boyd, Sr., as the first in a series of religious-themed polemics under similar names. Boyd was a once-slave from Pitt County, North Carolina, who became an influential landowner during Reconstruction. Boyd amassed a considerable fortune in real estate and was known for painting all of his rental properties a vibrant green. He won a case in the U.S. Supreme Court overturning a local ruling that had barred him from renting to white tenants. He was adamantly against the way Southerners had married the Bible to white supremacy and like Sun Ra, saw something nakedly hypocritical in a nation that was both ostensibly Christian and avowedly racist.[4]

The second of his recommendations, *God's Children* by Archibald Rutledge, Sun Ra describes to Schapp as an "interesting book"[5] in an understated manner that belies the mordant wit loaded into the suggestion. Interestingly, both Rutledge and Boyd write of the decisive era that immediately followed the termination of African enslavement in America. But if Boyd's perspective is that of the enslaved, then Rutledge is speaking from the other side of the coin. His inclusion on Sun Ra's reading list is another example of Sonny's contumacious refusal to toe the party line — in this case the party line of black power and black pride.

This author is certainly not the first to find it "interesting" how the discursive trope of the mythic melting pot so lithely converts African slaves and their descendents, through stipulation it would seem, into *Americans*. These people (there were millions of them) were certainly Africans when they were

abducted in their home continent either by other Africans or the few intrepid European slavers savvy and courageous enough to do their own kidnapping. They were certainly Africans when they arrived, and first set tortured foot to foreign shore. One could make an argument that they were certainly not Americans while working in the fields and homes of whites in a legal status that accorded them neither human-ity, nor the legal protections thereof. One could also challenge the presumption that the 14th Amendment of the United States Constitution could convert this stolen class of persons into Americans by imposing upon them a citizenship that they have to date never formally requested. Such an imposition (as opposed to an offer) could only extend their powerlessness, reinforcing the gross suspension of the right to choose which makes a slave a captive in the first place. Beyond whatever lib-erating grace was intended by Lincoln's emancipating words, the sons and daughters of African slavery certainly had politi-cal choices and only the systematic exercise of those choices could represent a truly self-determinative act. At a mini-mum, this notion that the once-slaves had as their common and human right a range of choices concerning their political destiny is the common thread among various strains of Afro-American (or black) nationalism.[6]

"My Negroes — I call them mine, for they are my people; but more truly, I am theirs..."[7] Rutledge speaks as an heir of a Southern plantocracy entitled to nostalgically look back at the antebellum South as the good old days. From any con-temporary perspective — especially any steeped in a rhetoric of black pride — *God's Children* is an embarrassingly rosy reconstruction of the life lived by black people as slave labor on the Rutledge family plantation in McClellanville, South Carolina. Rutledge was born two decades after emancipation, but he wants us to understand that after the war, many of *his*

Negroes stayed attached to the plantations in a status hovering between employees and wards. The pages of his memoir should therefore be taken as offering an unerring look at the secret life of black servitude from the jaded vantage point of those they served. From this premise, it is hard to understand what Sun Ra might have found redeeming in what seems only readable as a cloyingly one-sided apology for conduct that Frederick Douglass called "hideous and revolting."[8] From his own childhood memories, visits as an adult, and his father's recollections of the people he referred to as "his black henchmen"[9], Rutledge builds a gooey-eyed portrait of these mystifying black bondsmen that is as flattering as it is essentialist, and it is in these essentialisms that we can see how the book would have fit quite snugly into Sun Ra's library.

Rutledge first identifies the lineage of the captives on his father's land as Nubians imbued with a "mixture of Egyptian, Moorish, and Arab blood."[10] This is quite consistent with Sun Ra's identification with the Africans north and east of the Sahara. The lifelong hunting enthusiast and first poet laureate of South Carolina then unleashes his considerable powers as storyteller to genuflect *ad nauseum* about the "native intelligence"[11], "dusky wisdom"[12] and "eerie gifts"[13] of the black workers he knew as a child, many of whom had continued to perform the same roles that they had in the slave economy, only for a recompensory pittance understood to include their lodging on the plantation. For Rutledge, the black slave is a spiritual superbeing and consummate craftsman. His is a natural and pre-alienated genius that can only flourish under the imposed disciplines of his social caste.

> I understand very well what a missionary to Africa meant when he told me that the fundamental mistake he had made when he went to the Dark Continent to civilize the heathen was in supposing that he was spiritually superior to them. In

certain ways, intangible and having to do with spirit, I know
they surpass me.[14]

Underlying both Rutledge's and Sun Ra's concept of
Negritude is the idea of the black — as an essential primitive
— retaining some connection with a naturality of human exis-
tence that white people exchanged long ago for the fruits of
civilization. In this natural state, the black primitive (the one
who hasn't made it his business to copy white people) can par-
ticipate in a genuine cosmic consciousness that can only be
reduced to superstition by the civilized.

> When for the first time a plantation Negro baby is taken
> outdoors, the occasion calls for a religious ceremony. The
> mother walks toward the door with the child in her arms.
> Beside her walks another member of the family, talking to
> the baby's spirit, for fear that when it comes under its native
> sky, the soul may suddenly return home. The spirit is told
> what a beautiful, joyous and wonderful world this is, in order
> to reconcile it to its sojourn on earth.[15]

To be clear, for the black people who were born there, the
plantation was an open-air prison. Slaves were allowed to
travel beyond the confines of their master's domain only
with explicit written permission, usually to accomplish some
business for their owners. Because nothing like it would be
allowed to exist today, *and* because the survivors and perpe-
trators were equally motivated to conceal what had happened
between them, all stories of American history are necessarily
his story, with the elision of the truth of the cruel and capri-
cious nightmare that was the earliest African experience of
the American dream built into the very psychology of the
experience and its conflicted memory.

But, and this is where Sun Ra's unique and cavalier genius
is at its best, the energetic presence (i.e. soul) attached to the

slave's incarcerated body and his pre-literate (by force of law) mind are wholly outside of the only bondage that matters. The slave's naturality is his gift for escaping in his chattel-hood the heavy chains of civilization. Unlike his master, the slave is not a domesticated animal. Sun Ra loved his people.

As I sat there reading Rutledge's book in the main reading room of the Library of Congress, a setting which, of course, only served to amplify the absurdity of the information that Sun Ra had inflicted on me, I asked myself: What could it possibly mean for a slave to be *responsible*? Responsibility is a core concept for talking about both morality (of some ultimate type) as well as the finest ethical grain of daily life lived among people. It is a measure of maturity and personhood. Even slaves must have had some sense of what it meant to be responsible, but what could that idea of responsibility have meant in service to the system of servitude that had monetized their bodies and could sell apart their families abruptly and without recourse to appeal? Certainly, slave owners could be responsible *for* their slaves, but not in any sense *to* them. Could the black men and women of the antebellum South — among whom were my earliest ancestral participants in this American experiment — in any way be seen as responsible *to* their masters?

I visited a park on the Potomac River with my seven-year-old son and his mom. Like many state parks in the tobacco-producing, rural southern part of Maryland, Chapman State Park was once a plantation. It's so-called big house sits empty and restored, facing a cedar-lined driveway with the building's rear opening onto a sprawling treeless vista formed by park service-maintained grassy hills gently rolling to the shores of a river from which the local Indians (Piscataway, among others) once effortlessly speared striped bass a yard long, sturgeon as big as a car. The river bends and narrows a bit there and sparkles like a disco ball in the afternoon sun. It's

an impressive view, but how do you convince a child that it was the frustrating experience of spaciousness viewed from inside a box with no lid. I pointed to a similar "big house" on a distant hill across the river on the Virginia side. I explained to my son that if we had lived on old man Chapman's farm, he could have chosen at any time to sell my boy across that hopelessly broad river to any number of plantations on the other side. And more importantly, we could have lived out our lives apart from each other, just that far away, for the rest of our natural lives and there was nothing I could have effectively done to stop it. His eyes widened at my melodrama, but I could see that he got my point.

So, slavery as practiced in these United States — the system that colonized African people on American soil — was, like any system crafted by a dark-hearted gang of sadists, a thoroughly evil system. The rhetoric of self-righteous progressivism in which this country is steeped, boldly declares the responsibility of decent men and women to oppose with force any such great and monstrous evil, *wherever* it might be found. So, does slave responsibility take the form of Nat Turner and his raiders, who with the admonition that nits make lice, fell upon their white masters and their children as they slept neatly tucked in slave-laundered linen? Resistance is the responsibility of the oppressed. That axiom is so deeply encoded in my leftist DNA that I almost broke into a sweat as I struggled with the lesson that Sun Ra had led me to under the cavernous vaulted ceiling and eight towering marble pillars of the Jefferson Building's main reading room. What could I do as I read a caption accompanying a black and white photo of the house (quite like Chapman's) that Rutledge's father had built: "God's children love the Great House. It is not mine, but ours"?[16] Or, imagine if you can, the author choking on this choice morsel of revisionist word craft:

When he was born, all Negroes on the plantation came up to the Great House to get a sight of their future master. The numberless eager faces radiated only love and good will for the son and heir. And if all their wishes would have been known, they would have proved to be as generous as those of good fairies.[17]

Good fairies? Now imagine me sitting there reading a book full of such gratingly pro-slavery panegyric under the grand domed ceiling of Tommy Jefferson's library. All the while, the ghosts of Malcolm X, Kwame Toure (aka Stokely Carmichael), and George Jackson circle my head like a troika of angry falcons picking dreads and then flesh from my exploding scalp. Come on Sun Ra, such deep embarrassment seems like a lot to stomach even from the trickster that you always were and remain. How could he possibly have included such a book on a reading list passed out to a classroom of UC Berkeley undergraduates at the very height of the Black Power movement? Certainly Rutledge's rosy revisiting of the hell that was American Slavery does not stand unchallenged. There are ample first person accounts from the period that credibly paint a much different story.

When the slaves are whipped, either in public or private, they have their hands fastened by the wrists, with a rope or cord prepared for the purpose: this being thrown over a beam, a limb of a tree, or something else, the culprit is drawn up and stretched by the arms as high as possible, without raising his feet from the ground or floor: and sometimes they are made to stand on tip-toe; then the feet are made fast to something prepared for them. In this distorted posture the monster flies at them, sometimes in great rage, with his implements of torture, and cuts on with all his might, over the shoulders, under the arms, and sometimes over the head and ears, or on parts of the body where he can inflict the greatest torment. Occasionally the whipper, especially if his victim does not beg enough to suit him, while under the lash, will fly into a passion, uttering the most horrid oaths; while the victim of his rage is crying, at every stroke, "Lord have mercy! Lord have mercy!"[18]

More recently, reconstructive works of literature (e.g., Toni Morrison's *Beloved* — perhaps the most indispensable book ever written about America) have worked alongside probative works of scholarship to peel back the amnesic veneer that has for so long masked the insidious criminal depravity of America's *peculiar institution.*

> Whatever else slavery was, it was a system of sexual privilege. Owners could participate freely in the slave-breeding process, whether as actors or voyeurs. There is ample evidence that this privilege was extensively exercised by Southern slave owners. When the South went to war to defend the institution of slavery, it was, inescapably, defending the privilege of forced concubinage. Perhaps, beyond purely economic considerations, part of the irrational intensity of the South's defense of slavery came from the strength of slave owners' attachment to that privilege.[19]

So, Sun Ra, why not come at this slave thing like a true pan-Afrikan warrior? The Rutledge recommendation is the kind of move that may have led to whispers of *Uncle Tom* behind Sonny's back. In spite of all that Egypt talk and fancy garb, he could never be counted on to ride with the consensus. In Nigeria, Szwed tells us Sonny was omitted from the closing program for FESTAC, because he refused to join the other participants in a black power salute as a show of solidarity.[20] And then I saw it — in a lengthy passage describing a sophisticated system for controlling the drainage of soggy bottomland and converting otherwise useless parts of the Santee Swamp into valuable and fertile farmland, I saw it. A description of a slave-engineered system of complex baffles, levies and dikes that rested on a detailed understanding of hydrology and natural cycles gave me my first clue. Then I saw it again — ironsmiths working with basic tools and procedures to create metals of amazing strength and remarkable ductility. And here it was again — marksmen and hunters that could track game like

an Indian and shoot the eyes out of a gnat at thirty yards an hour before dawn. Mastery achieved through *precision-discipline*, Sun Ra's trademark term for the ability to buckle down within a challenging task until trial and error have transmuted effort into success. This was Sun Ra's most vaunted attribute. Rutledge's Negroes reeked of precision-discipline. In the course of grossly over-emphasizing their "natural freedom and happiness",[21] he had shown that the labors of these simple men, whose bodies had been purchased by money, had been released from the corruptions of money into works of great genius, talent, and certainly, in some measure, joy.

The slave is endowed with certainty of purpose that the freeman can never achieve. Any deferral of agency beyond the here and now was a dream in vain for the bondsmen. By dragging me to Rutledge, Sun Ra had shown me that the issue of "slave responsibility" could not be so easily settled in terms of power and resistance. These men and women were faced with an impossibly desperate situation and rather than committing what even Huey P. Newton called "revolutionary suicide",[22] had chosen instead to take the jobs that they were given and elevate these from banal chores to music. Sun Ra understood what it meant to work really hard to become really good at something that was apparently very valuable only to never see his just compensation. He was showing me through Rutledge that slave responsibility, like a photon in a quantum experiment, splits along a line of probability and can arrive at more than one state or form. On the one hand, the slave is always permitted his rebellion, but to date it has generally ended in Death. After he was caught and hung, a lampshade was made from the skin of Turner's belly. If sustained, slave victory has tended to be bitter, as best exemplified by the free black nation of Haiti, suffocated by its rich neighbor to the north, beginning in 1801, with a $300,000 grant by Thomas

Jefferson to help whites there suffering the indignity of being ruled by their once-slaves. Since then, *every* U.S. administration has done its share to suffocate the spirit and dignity of the Haitan people. (That's 213 years — Uncle Sam sure knows how to hold a grudge.) But Sun Ra knew in the end that precision-discipline is its own reward and that the opportunity to do something well, even under the most degrading of conditions was (paradoxically) still an essential component of human dignity. Excellence under duress was still excellence. And while he might have found something worthy of commendation in the semi-skilled labor that was the focus of Rutledge's reflections, he could only have seen as tragic waste the countless anonymous black bodies poured into Southern agricultural drudgery like fertilizer ploughed into the soil.

This is not an historical exercise. Like the shifting line between living and dead, modern life demands that we all take stock of the continually redrawn lines between liberty and servitude lest we unsuspectingly find ourselves on the dark side of niggerdom. Industrial Society's complex, self-cloaking class structure of various shades of have and have not is increasingly complicated by differing degrees of *do* and *do not*. As the divide grows between a skilled elite, whose privilege it is to populate the information age with its precious coded content, the rest of the population is lucky to find a job standing at a cash register funneling wealth in the direction of this creative vanguard and the corporate leech that multiplies the value of its work.

> When I first joined the band, I was concerned about what I'd learned in school, the rules of music in school, counterpoint, you know, and when I played with the band I was concerned whether they were going to be playing the right chord structure. He stopped me one day and told me that I should forget all of those rules; there were no rules in his band. The only rules are laws of nature. He said I had to study nature to

understand how to play his music. Well, that was quite different, you know. Here, I had come back from Vienna, Austria after studying all these rules in the conservatory and he said study nature, so I literally did that. I had a farm at that time up in Vermont near Dartmouth College. So, I spent a lot of time at that farm in the woods, listening, listening, listening, and meditating and seeing myself a part of nature, not an observer of nature, but being *a part of* nature. Relating to the animals and the birds and insects. Getting into trees and being able to hear the musicality in all of nature.

So, he was literally speaking the music of the World, the planet as a unit of nature, not of musicians, but musicians who are an extension of nature and who played natural music and the dancers had to do natural dances as the animals do. Everybody had to be a part of nature in that band. He broke down all my hesitation and instilled in me the fact that you had to play the jazz of nature.

Brother Ah (aka Robert Northern, French horn)[23]

There is in Sun Ra's scathing survey of the world and its affairs a soft spot reserved for Nature and the Natural:

Nature always sends answers to people, like herbs to heal them when they're sick. And nature has a way to help people now in all these difficulties, but the answers will come from, you might say, Nature's children, or Nature's naturals. They would know how to tell people what to do about this situation, because Nature does want people to live. The first law of Nature is self-preservation, so most certainly it wants people to live, so therefore it would have a way to protect them, of course it's got ways of destroying them, too.[24]

There are two songs in Sonny's catalog that exalt "Nature's God"[25] and while they are clearly two different compositions they resemble each other in content, structure, tone, and feel to a degree that makes it eerily difficult to tease them apart in memory. While these songs and their lyric can initially be read as fairly straightforward hymns of thanksgiving to the divine

hands that crafted and sustain nature, there is another way to interpret them, a way that is more consistent with Sun Ra's professed distinction between Creator and God. If a god is but an object of worship, then the Nature's God that *sometimes we should think about* (to quote one song) would be the object of Nature's worship as Nature might conceive of the Divine. Follow Sun Ra down this way of thinking and enjoy a subtle undercutting of the anthropocentricisms of human religion in a way that reignites the quest for spiritual truth, setting the fires of discovery to the pages of doctrine, in a conflagration that is every bit as dangerous as it sounds.

In Sun Ra's estimation, black people existed in a default state of naturality, although he conceded that integration, urbanization, and the church were rapidly herding his people in the direction of white folk. This coveted sense of naturality is the obverse of domestication. It is the human mind and spirit reposing in its place within nature. It encompasses mastery, but eschews dominion. It is self-love without narcissism, although you might hardly think so from Sun Ra's garish braggadocio.

This natural self stands conceptually, if not neurologically, before the self of personal identity. (How do I know that I am me, and not you?) This self, which might be seen as a distillation of Agamben's Genius or a conflation of the twin spirits of *ba* (soul) and *ka* (ethereal body double) that grounded the ontology of the ancient Kemites (Egyptians). As David Abram so pointedly reminds us, human consciousness is only sensible in a world understood to be animated. "Shall we prolong the painful split between mind and body by continuing to neglect our carnal entanglement with this immense Presence," he writes, "or shall we finally heal that age-old wound by acknowledging Earth's implicit involvement in all our experience — as the solid ground that supports all our certainties,

and the distant horizon that provokes all our dreams?"[26] The natural self stands in a mystical province, as does all activity that precedes the censoring and normalizing pressures of social intercourse. Whether supported by strong music, strong herb, or an equally strong devotion to Almighty Jah, this is what Bob Marley felt blowing in the wind, when he sang of "Natural Mystic." It is simple. Before we have run our experience through the sieve of language, it is all mystical and quite richly so. Before we have scissored apart our experiential plenum with valuating sheers, placed in our hands shortly after birth, we are free to enter into and out of this primary fascination without regret or consequence. How to live without the sheers, how to radically reframe our togetherness outside of standards and standardization, how to release the value of the mundane, like pulling zero point energy out of vacant space. These are the noetic* challenges our species has been backed into by the highly adaptive pressures of psychedelic gnosis and post-apocalyptic jazz. There's no way out, other than to become the kind of creature that can slide through the slim fissure left between our rock and its hard place.

That creature — the winner, the successor — is no longer a human being as anyone has known the human being at any point in earth history. The gross body — opposable thumbs, short arms, large cranium, wide pelvic girdle, and absence of penis bone (morphological features that distinguish humans from other apes) — all remain. What has changed is occult, hidden at the most advanced levels of brain physiology, embedded within the symbolizing function of our body, its highest and presumably most advanced capacity. The complex of metamorphosed organs that constitute this recondite change, are common, mutable, and hereditable in the same

* *Noetic*, from Greek terms referring to intellect and perception. A *noetic revolution* is a revolution in how perception is organized into knowledge.

way and to a similar extent as the capacity for natural languages that human infants acquire rather effortlessly all over the world. That new being may reflect in its sinewy new morphology certain archaic residues of value or form, but this critter (that trained itself to jump into the grinding gears of history rather than push with futility against the gravitational pull of its DNA) is a cryptid[†]. It is a hypothetical organism whose existence has yet to be conclusively established, except as this *Execution* maintains, in the oddly prototypical personage of Sun Ra.

What might be called *Homo Sapiens Saltus* succeeds and replaces *Homo Sapiens Sapiens*. Sun Ra's laws of negation would have the two Sapiens (Latin for *wise*) cross each other out. *Saltus* means leap as in *Natura non facit saltus* (Nature does not make jumps). This jumping wise man leaps into existence through a process similar to the permutation that Sun Ra performed upon himself, his operation. You see, he had to mutilate his earth body. His obese, one-balled, Bama-born, black body had to be virtually dismantled to construct the thing that is made of and in Myth. Severed organs had to be teased apart from their delicate connective tissue to form new points of attachment, thus recreating from Herman Blount, who was small and weak, Sun Ra who is as invincible and large as his solar emblem.

This is the new body that Sun Ra performs for us. It is ill equipped to make either money or sameness — the principle activities of modern man. Look carefully at the declining fertility of Europeans and citizens of other societies that view themselves as advanced. Reproductive rates hover at or

† While in Liberia, physician Thomas Savage obtained several bones, including a skull, of a massive, previously uncatalogued ape. Until Dr. Savage published his findings in 1847, the gorilla was also a *cryptid* — a creature suggested by legend, rumor, or folklore, whose existence has not yet been confirmed by science. Similarly, the post-human is a cryptid primate awaiting confirmation.

below replacement levels for the so-called developed world where people whose bodies are no longer very good at making babies excel at making money and making more of "the same," i.e., the homogenizing terraforming of a global market which takes its most painfully visible form in the evaporation of geography into an ever densifying grid of strip malls and the compression of all human interaction into some form of screen time. Those operations, tasks, agendas are inerrant, consistent. "Making normal" is given to us in Brian Massumi's excellent anti-Oedipal redux of Deleuze and Guattari as one of two fundamental activities confronting the human being in society: *becoming other* or *becoming the same*.[27] Human intention is channeled (not always cleanly) along the fault line separating retention from annihilation.

On a species-wide level, this transformation, this ontological upgrade, should not and cannot be conceived as a "construction project." Where voices on the right and left cry out for drastic action, and those down the middle craft apologies for apathy masked as moderation, the emergence of the new body is not helped along by any such heaving and pushing. We cannot collectively set about to do on a mass level what Sun Ra modeled through his stunningly unique presence. It would look funny; the end result of such an attempt could only leave us with old bodies dressed in new clothes. Yuck, that was the downside of the '60s — stylistic excess as counterculture. This activity is grounded just outside of culture. While drastic and complex agendas of retention, revival, and revolution are roundly and vigorously debated, we can add little more to our evolutionary unfolding than something like permission.

While complex activities and interactivities might be the order of the day, this permission manifests itself at the level of our perpetually changing bodies as a simple gesture, a component of action that can be transported to and inserted among

the sundry protocols and activities that constitute the quilted gestalt of our complex lives. This is a gesture familiar to every woman who has ever undergone natural childbirth, even familiar to the men who have accompanied these women through their heroic passage. Baby must come out and this is clear, but if mother pushes, bears down with all her might before the opening in her womb has dilated to 10 cm, the results will be a painful disaster, not a joyous advent. For most women, hormonal processes stoked by the same ancient brainstem physiology that governs breathing, heart rate and body temperature make this uterine expansion a fairly automatic process. Cervix will open and the baby with its fresh, unused body will come. If the opening is delayed, the clinical team will administer a drug to accelerate the opening, something like a catalyst for dilation.

Something like a catalyst for dilation — an enabler of release. This is how we find Sun Ra when we encounter the truth of his reconstructed body. But what passes through our middles and out our bottoms is not the inchoate corpus of our posthumanity. No, the thing that must be passed, the thing that must eventually be released (that we may be released) is a monstrosity built of money and sustained by war (picture Geena Davis's character and the birth scene in *The Fly*). This worm hanging between our legs in a most ignominious way is what is left of the civilized world. It is long past time to do something else with ourselves. Let it go.

> Most persons do not see the sun. At least they have a very superficial seeing. The sun illuminates only the eye of the man, but shines into the eye and the heart of the child. The lover of nature is he whose inward and outward senses are still truly adjusted to each other; who has retained the spirit of infancy even into the era of manhood. His intercourse with heaven and earth becomes part of his daily food.
>
> Ralph Waldo Emerson, *Nature*[28]

The world of man, the world of downtown Singapore as equally as the world of downstate Illinois, is built of money. This money-built cosmos is packed with the divine sheen that makes mere perception a cherished miracle, but this miracle is buried beneath a varnish of transactional logic accumulated over time and through the normalizations inherent in commerce. In the case of the great glass and steel metropolises — ugly gray barnacles on the blue-green skin of our magic spaceship — the abolition of natural order and the alienation from its secrets is obvious, but only city folk could ever see anything "natural" in the crisply placed rows of GMO corn and soybeans that constitute industrial agriculture in the American Heartland. If our civilized order retains any magic or mystery at all, it is only because that order is still fashioned out of the class of objects and actions occurring within the world — what Emerson called "the integrity of impression made by manifold natural objects."[29] But this real magic is all but lost in a spectacular haze of faux enchantment that always points back to the deities of design, those who have delivered the shiny surfaces and rounded corners that hem in the muddled details of modern lives.

Only Nature's God still knows how to get us off. As proof of this, even the most incorrigible of us will (when we notice) stop to allow a rainbow or a sunset to steal our breath and inhabit our soul. Those of us who can afford to, might spend a small fortune to jet ourselves to the farthest unchewed selvage of the Garden that the urban engine (great giver of money) is a parasite upon. There we will pay a trusted brown man or woman to share their folklore and show us how to adjust our safety harness before we zip-line through the rainforest canopy. This will not be cheap.

The new body reestablishes political and economic balance on the terrain of mutual fascination. We avert ecological

crisis as a being so enraptured by the handiwork of Nature's God that we can no longer harm Mother Earth (or each other). While dancing with our reflection in Her cosmic waters, we retire war and enter into a new politics of mutual respect, too enthralled by the nomadic interplay of different compartments of identity to pledge our blood fealty to any single camp. Patriotism dies with war heroes and war. Nobody looks back. It's developmental. The conditions that necessitate some critical number (but not necessarily all) of us to develop these new bodies (the partial loss of opposable thumbs, that is, the emergence of bodies which can no longer effectively grip either weapons or money) must involve some degree of force potent enough to stimulate something like the life-extending tricks of the immortal hydra. If adulthood is that phase of development in which socialization has maximally run its course, then we must find a way to throw the mature human being backwards to allow the crystallization of our new ontology.

Jacson told me that Sun Ra's unique ability to connect with people rested in his ability to approach life and its challenges in a very child-like way. The last angel of history carries neoteny† in its wings.

† *Neoteny* is the retention of juvenile characteristics by the adults of a species.

TWINS

In this country as children, we learn that there is a founding principle, that men and women are created equal. And we want this equality, because this is a founding principle.

Chris Perry, Plaintiff in Proposition 8 case
before US Supreme Court[1]

Symmetry is an invariable characteristic of both growth and form, whether in simple or complex, living or non-living, systems.

David Wade, *Symmetry: The Ordering Principle*[2]

A t first there was nothing, *Nu*, in the form of a watery void. This fluid was darkness in very rapid motion. The moving waters were everywhere and they were formless and smooth. Light without brightness. Tremendous heat with nothing at all to burn. Textureless and featureless, from this ceaseless fluid wheeling, Atum gave form to himself in a shaft

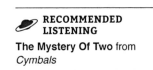

RECOMMENDED
LISTENING

The Mystery Of Two from *Cymbals*

of pure time. He was of and by himself. Self-formed and complete, Atum's existence manifested and the universe manifested. Atum was always there. As a bubble floating in the midst of the vast waters, a universe manifested as a living sphere and Atum made this orb to expand. As it grew, a mound of black mud rose up beneath Atum's feet to form the first earth.

> The big bang was an explosive instability in the "pre-space" of the universe, a fluctuating sea of virtual energies known by the misleading term vacuum.
>
> Ervin Laszlo, *Science and the Akashic Field*[3]

Usually translated as the Black Land, *Kemet* is preferred over *Egypt* (from the Greek *Aigyptos*) as the term that these ancient people used to refer to their home. The Nile valley civilization followed the concourse of the great river and its people were sustained by the rich black deposits left in the wake of the Nile's annual floods (as opposed to the red sand of the Sahara which defined the inhospitable desert). Writers who wish to emphasize the racial origins of the early Kemites tend to translate Kemet as "Land of the Blacks". According to Cheikh Anta Diop: "The interpretation according to which Kemit designates the black soil of Egypt, rather than the black man and, by extension, the black race of the country of the Blacks, stems from a gratuitous distortion by minds aware of what an exact interpretation of this word would imply."[4]

The focal point of veneration at the worship center that the people of Kemet called *Iunu* and that the Greeks would later call *Heliopolis* (City of the Sun) was a squat roughly pyramidal point of unusual (meteoritic?) dark stone resting on a single granite column — an architectural form that the Egyptians invented. This *benben,* as the people of ancient Kemet would have called it, was understood to be a relic of

that first materialization under the feet of the prime god Atum, as such it represented the first nodule drawn out of the inchoate void by a self-formed Creative Agency and was symbolically recreated throughout Kemetic art and architecture. In anchoring his ideas in the mythological bedrock of Dynastic Egypt, Sun Ra was invoking both a longstanding and deeply anchored Western fascination with ancient Egypt as the setting for several significant Biblical events, and as a bit of a time riddle possessing in its technology and culture an anachronistic level of sophistication and development. So, out-of-place in the Western mind has this realization of ancient African sophistication been (Sun Ra might have called them the *Antique Blacks*[5]) that everyone and everything from aliens to Atlanteans have been offered as causative agents for the extraordinary success and duration of Kemetic civilization. Sun Ra was also acting within a tradition of deconstructing racist colonial historiographies, and he was well aware that for his people, ancient Egypt was proudly (and obviously) emblematic of civilization's black foundation. While the racial identity of these ancient Africans* remains a flashpoint of controversy, Sun Ra belonged to a generation of black scholars who might have cited the post-colonial Senegalese anthropologist Cheik Anta Diop or even the nineteenth-century British orientalist E.A. Wallis Budge to document an Egyptian civilization whose core scientific, organizational, and religious principles flowed up the Nile, as the cultural products of people who were phenotypically indistinguishable from the inhabitants of what was then Nubia, now Sudan, home to some of the darkest human faces on the face of the planet. Sun

* Of course, one really can't take Egypt out of Africa without being geographically dishonest. Or as one author has observed, "The manipulation of African history has been so thorough that many people now mistakenly believe Egypt is not in Africa. It is as if Egypt has mysteriously detached itself from the continent and floated off to a nebulous place called the 'Middle East.'" (Browder, 1992: 36)

Ra's Egyptian connection energized his work with the symbolic attraction of these ancient archetypes of black myth as stony and stoic substance, as transcendence of time and as mystery, both mute and teeming.

> As the sum of all matter this first appearance of the sun god is named Atum, meaning "the All", but as the sun, source of life and energy, he could be named more specifically as Ra, the main word in the Egyptian language for "sun."
>
> Stephen Quirke, *Cult of Ra*[6]

This *benben* is repeated at the top of obelisks and pyramids in the form of the geometrically precise *benbenets* (or pyramidions) that typically topped both classes of monuments, and that, in the case of the Great Pyramids, were probably plated in gold. It's likely that the religious center *Iunu* was already in ruins when the Caesar declared Egypt a Roman Province in 30 B.C.E., bringing a permanent end to the Dynastic era. The Arabs of the Islamic expansion would use the Sun Temple's remaining blocks as part of the Great Mosque in Cairo. Today what's left of the site mingles with the working class neighborhoods of Ain Shams, Matariya and Tel Al-Hisn, an area engulfed in the popular rebellion that defeated Hosni Mubarak, but has thus far been unable to unseat the military junta that banned the Muslim Brotherhood and nullified the Egyptian revolution. Because Atum became the sun (Ra) as he pulled the earth, planets, and celestial bodies out of nothingness and into actuality, this *benben* stood with its column perhaps for centuries as the holiest remnant of the Egyptian big bang, the place where Ra's life-giving rays first touched Earth.

Sun Ra visited Egypt three times. The last was in 1983. At the end of his 1977 trip to Nigeria he stopped in Egypt before returning to the States. The first visit was a hastily organized pilgrimage tacked onto the end of a successful European tour

in 1971. "We was in Denmark and it was the last day on the tour," recalls Arkestra member Danny Ray Thompson (baritone sax, flute, percussion):

> We had been a month out on the road and Sun Ra said, "we going to Egypt," and the next thing I know we gone to Egypt. When we got there, it was 5 o'clock in the morning and we're staying at the Mena House Hotel, very famous hotel…it was near the pyramids. I didn't want to go to sleep. I went to put my stuff in the room and me and a couple of the guys we came back outside. From the front porch, the sun came up and you could see the pyramids and boy, oh boy, that was amazing. God, that was amazing. Oh man, something you'll never forget.
>
> We stayed there two weeks….We was just going exploring and stuff, we was like tourists. So, we had this filmmaker with us, Tommy Hunter, "Bugs", and we had to get a permit to dance and film on the Sphinx, so we got the permit. There was an office not too far from there, near the pyramids, of the Minister of Antiquities, his name is Hawass[†]. He's real famous now; I see him all the time on TV. He's everywhere, but he's really an amazing man. Sun Ra said, "you know what," he told me and another fella Eloe, "take this music." I was telling the minister that the music was good for the vibes. So, he took me and Eloe into an almost unopened tomb. It was open, but not to the public; the public hadn't seen it. It was near the pyramid at Cheops [Khufu], the great pyramid and this was the keeper of the secrets, Cheops. So, I had this tape recorder and I had this song called "Along Came Ra". So, we played the song on the tape recorder. It was from something we had recorded somewhere. And then somewhere on the tape, towards the end of the tape we heard a *mmmmmmmmm*.

The throaty murmur is frightening over the phone, and the retelling of the story seems to get Danny's adrenalin pumping.

> I looked at Eloe, I said, "you heard that shit?" He said, "yeah." So, I stopped the tape; played it back to make sure it wasn't on the tape. That went past; we didn't hear nothing

† Zahi Hawass is currently secretary general of the Supreme Council of Antiquities (SCA).

and toward the end of the tape, *mmmmmmm, mmmmmmm.* The minister wouldn't come in. He was standing at the door because he said there was a vibe there or something. Where we was at, it still had the mummy in there and it still had the hieroglyphics; they was really clear, you know.

And, then me and Sun Ra — there was about four of us went into the Great Pyramid. There was a guide — looked like he was about 100,000 years old, boy had wrinkles on him. We went in there and when we was in there and you had to climb up. There was a rail, but you had to climb up these slats. It's dark in there. There was a light, but you could see a little bit, but you was inside the pyramids and once you got up this little thing and then you had to crawl because you couldn't walk inside to the king's chamber. So we all got in there and Sun Ra said, "you know, the name Ra hasn't been spoken in here in thousands of years." So, we said the name Ra nine times and the lights went out. And you have never seen a darkness like this. Never before have I been in darkness like this. I ain't never even seen dark-ness like this. It was so dark in there. So, the guide lit a match and if you wasn't a foot near him, you couldn't see. That's how dark it was. So, we were like, "ooh, shit."

One of the guys, Tommy Hunter, he had climbed out before the lights went out. He was stuck on the ledge right outside the little tunnel. He had his hands folded because he didn't want to move, because if he had fell, it was about 150 feet and if he had fell, he would have been dead or something. It wasn't no bullshit. We didn't have no flashlights or nothing. So, the guide said, "okay, we better go out." So the guide started leading us out and we was holding hands. Before we got out, the guide was the first one out, and he saw Bugs [laughter]. The guide jumped up about six feet. He said, "Oh Lord. It's the end. The pharaoh done come and got me." He's holding his hands; he's afraid to move. Well, he was a little concerned. I guess he had been in there when the lights went out before. I think he was a little freaked out, yeah. So we had to climb down backwards in the dark. We got to the bottom and we getting ready to go out, and the guide grabbed Sun Ra and said, "Sun Ra, you have to see the queen's chamber." Sun Ra [said], "well, you know, maybe tomorrow." He said, "Now!" So he grabbed Sun Ra and here

we go through this other tunnel. It wasn't too bad on this other tunnel. And we came to the queen's chamber. As soon as we got in the queen's chamber, the lights went back on. Later on, somebody was telling us that the queen's chamber was the chamber of life; the king's chamber was the chamber of darkness. That was something. So we was telling the guys that didn't go later that day what happened and boom — the lights went out in the hotel.

From hieroglyphic texts carved into architectural surfaces erected 5,000 years ago, we learn that as Atum stood on the mound, becoming Ra, shining on the freshly born continents bursting muddy and fertile from the receding cosmic waters, he masturbated and from this issue sprang forth the first beings having true gender — Shu, the god of air, and his sister Tefnut, the goddess of moisture. These two joined and gave birth to Geb, the earth deity and Nut the sky goddess. Incest being the order of the day, Brother Earth and Sister Sky joined to create two pairs of gender-paired siblings, who, while possessing entirely human bodies, were nonetheless gods: Osiris and Isis and Set and Nepthys. *Ennead* is a Greek word for a set of nine and the early students of Kemetic culture attached this term to Atum and his first three generations of progeny. Among this group, Osiris was central to the activities of mortal men and women and the "belief in his divinity, Death, resurrection, and absolute control of the destinies of the bodies and souls of men"[7] were core tenets of Kemet's earliest organized belief system, even as a diverse panoply of other gods were also woven into the ritual life of their society. According to Budge, the tenets of the cult of Osiris "weaned the primitive Egyptians from cannibalism and from cruel and barbarous customs, it taught them to respect human life and to regard Man as the image of God, and his dead body as a sacred thing, it induced them to devote themselves to agriculture, and it improved their morality."[8] Consistent with Sun Ra's concept of the human condition being

John Gilmore

largely a case of faulty delegation, Budge also would like us to understand that "the management of the physical world and of the affairs of men was deputed by God (Neter) to the *gods, goddesses*, and spirits of whom some were supposed to view man and his affairs benevolently and others malevolently."[9]

Like the Olympians of the Greeks or the Orishas of the Yoruba, this *Ennead* is a rather rough neighborhood of god-sized personalities among whom all manner of intrigue and machination form the basis of mythological narrative. As such, jealous Set (later syncretized with Satan) kills his brother, dismembering and scattering his lifeless body around Kemet. Distraught, Osiris's sister-wife Isis gathers the scattered god-parts and reanimates them with her breath in the first historical account of a resurrection. Before departing from the earthly plane to rule the Egyptian underworld, or *Duat*, the reborn Osiris and his mate conceive a single child, Horus, often iconized as having the head of a hawk. Horus avenges his father's Death by replacing his uncle on the throne, notably in most versions without killing Set, who retreats into the margins of filth as a lowly black swine. According to the third-century-BCE historian Manetho, upon whose work all succeeding pre-Christian Egyptian chronologies have been based, Horus stands at the head of a lineage of god-men who were understood by the Egyptians to have been actual, concrete beings who wisely ruled the lands of Kemet for thousands of years before the dynasties of mortal kings commenced from about 3150 BCE. The fully human rulers of the periods of political stability that Manetho identified as dynasties were the central actors in a system of rituals intended to ensure each leader's personal immortality and the continuity and prosperity of the Kemetic collective. The fully human kings of the Egyptian Dynastic era personified Ra or Horus-Ra on Earth and these leaders were measured against

the standard of the Christ-like Osiris who would await them in the *Duat* to weigh their hearts against a feather representing truth on the sensitive scales of *Ma'at,* their eternal fate resting on the results of this moral measure. Writer Tony Browder reminds us:

> From its earliest beginnings, Christianity was embraced more readily in Egypt than anywhere else worldwide, primarily because of its similarity to the ancient religion of Kemet. Coptic, which became the official language of the early Christians, is essentially nothing more than the language of Kemet hieroglyphs written in Greek letters.[10]

Ma'at was at once a moral code emphasizing standards of personal and interpersonal conduct that would be familiar to a contemporary reader and a metaphysical concept implying the delicate balance of complementary pairs that the Egyptians saw as the key to cosmic cohesion and orderly motion, as opposed to stagnation, disintegration, or chaos. A core of duality was thus the epistemological foundation of the dialectic of Kemet.

> Harmony starts with a duo. [he's writing on the board] Duo. [as he writes] See there, you got that number *two* again. Time starts with the seconds…In cards, the lowest card is the deuce. That *two* is being used as a foundation for something, rather than the *one*. The *one* is being used as a foundation for something, too. [writing] Like Monday, [writing] you got the one again. Two-day. Two-morrow. So you got the present over in the *two*, and you got the future over in the *two*. You got the past over in the *one*. Now this *two* is phonetically T-W-O, so you have two-day, two-morrow. One for the past. So, that makes it very simple. One equals past. Two equals present and future. To have equations like this is very relevant to everybody.
>
> Sun Ra, UC-Berkeley, May 1972[11]

Sun Ra was born on the twenty-second day of the month. He was born under Gemini — the sign of the Twins.

TIME REBEL

These times and spaces are not continuous or consecutive; they do not formulate a narrative path but produce a multiplicity of places within which to hear the stories. These places vibrate time and resonate space not as a series of absences and presences but as a network of concrete inventions expanding from my body as fantastic interpretations.

Salomé Voegelin, *Listening to Noise and Silence*[1]

His scope is so big in that it brings together swing, an early bebop space thing, avant-space music, electronica, new age futurism, free jazz and mid-eastern types of tone poems together in a stew that makes it difficult to see him as a proponent for any particular school or stylistic brand.

Matthew Shipp, pianist and composer[2]

At our best, and most perceptive, we are time rebels. Time, or rather our perceptions of its rate and direction, is minted centrally and distributed widely. Not time, like *duration* into which one could actually launch events, but

rather the ardently defended assumptions of where we are going and about how fast. That time dogma, which is really a prognostic flavor and a nostalgic aroma, shapes our individual and collective life plans and both justifies and delimits our activity within those plans. I couldn't recommend Babylon-time, official time, because among other problems, it is still willing to predict that we might sail into the future on a magic carpet made of microchips. Within the bounds of the temporal currency of a Western world obsessed with notions of forward motion, all dogmatic dictums of time collapse into the stubborn faith that the same reductively aberrant thought process that spawned this hell will soon put out the fire and give us all glasses of ice water. In other words, social graces about time and its flow require us to be like very small (or very stupid) children waiting by a fireplace (and it is now, not Christmas morning, but quite late in the afternoon) staring up into that blackened void of a chimney, looking for our gifts, only to be rewarded with a faceful of soot.

> **RECOMMENDED LISTENING**
>
> **Space Probe** from *Space Probe*

Time, like money, is vulnerable to inflation. Babylon time might spend very well for about six months, but is nominally worthless within about 6 years. Inflation: I'll give you a million dollars for your car — Zimbabwean dollars. Same with the Time minted by the Bank of American Exceptionalism — it is a fool's investment. Microwave-oven consciousness of Western consumption inculcates a false sense of speed enjoyed by a people frozen in mid-dance by a machine that can only converse with them while they stand poised in this uncomfortable position. Our official sense of time shares little with the intimate rhythms of human biology or the undulating bulges of human history. Up until 1993, Sonny's body did a pretty good job of staying anchored in what has been called "real time...the time of unfettered musical communion, the natural time of

feeling, conversing, and being"[3], while somehow extending its insistent rhythm into our molasses-like technotime (remember, humans used technology to arrest temporal flow and create something God-like within the temporal scale of human mortality). In his performance of an *ancient future* Sun Ra set an example of life lived within a more homeorhetic* temporal economy, that is, a practical appreciation of our natural (and therefore) optimal pace of ontic flow (or rate of being) founded in Myth Science and capable of adroitly reconciling the endless now with the yawning aeons.

> The end of history is the end of money and the end of artificial time.

<div align="center">José Argüelles, Time & the Technosphere[4]</div>

After I had returned from the audio archive maintained by musicologist and Sun Ra scholar John Corbett at a recording studio in Chicago, there was a terrifying moment where it seemed as if the task at hand (and I knew from very early on that I might be in well over my head) seemed to have quadrupled in size. There is an embarrassingly refreshing moment when you clear your eyes after looking at a thing for a very long time and ask yourself, *what is this, really?*

> What a task: the amount of material is staggering. Nothing that I need to do requires listening to all of this amazing music. What I need, what I came for are the jewels of spoken wisdom that were captured on tape, but these are often interleaved with the music that is the bulk of this collection, so to locate what I need, I must fast forward past what I love. Ouch. I think I could live here.

<div align="center">Author's note to self shortly after arriving at ESS</div>

* In a social world where life and its meaning circulate through a number of complexly interpenetrating networks, *homeorhesis* (from Greek for similar flow) as opposed to homeostasis (similar state), best describes the achievement of dynamic equilibrium within this flow.

Within my primary domain of study (the ethnomusicology of radical music), Sun Ra stands as a titan among titans. His is a deeply rooted tree with many fruitful branches, each erupting from the trunk to somehow fully envelope and transcend the musical zeitgeist of its particular time. Just prior to Sun Ra's return to wherever he came from, there was among collectors, something of a false sense of closure. Many of us assumed that Evidence Records would gather, and release as clean CDs, a more comprehensive subset of those priceless micro-run Saturn LPs. They did not. Robert Cambell's well-sourced and investigated Sun Ra discography[5] simplified what at times had devolved into a scavenger hunt of chutes and ladders in the search for legendary tablets of vinyl documenting some of the rarest sessions in the rich history of jazz. A few of the scarcer, most hopelessly out-of-print records were circulating as fairly clean cassettes, and these were being digitized as users settled into the advantages and limitations of emerging media. Now, as digital technologies for salvaging and arresting the deterioration of analog audio media have become more robust, there is a pharaoh's ransom of potential future releases hidden in the miles and miles of tape that Sun wrapped around our planet like the copper wire in an electric guitar pick-up. Arkestra members heard on these tapes have told me that commercial opportunism only further alienates them from the fruits of their labor and increases the likelihood of releases bearing Sun Ra's name that do not meet the master's artistic standards. What *is* clear is that Sun Ra's earthly trace eclipses by several-fold that of artists like Hendrix or Marley (in all fairness, much younger men) who have seen their vaults emptied for a seemingly endless succession of posthumous recording releases.

> "I'm one of the few people alive who's listened to all of his things. It's just overwhelming."
>
> John Szwed, Sun Ra biographer[6]

But there's more, a lot more than volume, to account for the scale of Ra's half century of laying down tracks. When the Great Sphinx (*Her-em-akhet*) at Giza was rediscovered by Europe in the nineteenth century, it's leonine body was buried under sand; only its broken-nosed head was visible. There is a sense with Sun Ra that his abundance is not measured in numbers of sessions committed to tape. What has been captured and buried for rediscovery in this potential archive of indeterminate extent is documentation of a unique form of jazz practice where composition was geared as much towards a thick and demanding rehearsal repertory as an audience-satisfying product. These men played Sun Ra's rehearsal tunes in the front room of whatever apartment Sun Ra happened to be staying in at the time, and while some of these works may have had pedagogical value, it may be closer to the truth to say that they document an underground gift economy of black love and immortality — invaluable assets in North Philly and, presumably, throughout the world.

Until they realized the futility of their protests, most Arkestra members were initially bewildered by Sun Ra's habit of investing their most intense rehearsal time into material that they would never perform in front of an audience. I've seen Marshall Allen, a pair of spectacles hanging from his nose, pull cassettes from a large plastic bag full of similar, hastily labeled, recordings made, I presume, during the hundreds (thousands?) of hours of rehearsals in the Philly rowhouse. There is more than one large bag like this. With a pencil in his hand, he grumbles a little, suppressing a wry smile trying to crack through his wizened face. As he complains about the tasks acquired with leadership, it is clear that he derives great joy from the insights into Sun Ra's musical intelligence that come with the "burden" of transcribing the compositions and arrangements secreted in these black bags

of lost treasures. There are, as a result of the dual habits of recording everything and thoroughly rehearsing material that never was performed or recorded, an untold number of "new" Sun Ra compositions spread between what's retrievable from tapes and the reams of sheet music he left with his men. This is quite different from the situation with Hendrix and Marley, whose musical afterlives have for the most part been populated by earlier or alternate takes of familiar music. In other words, quite bluntly, as Mr. Allen brings more of these lost crystals out of the bags and onto the bandstand, you can still hear new Sun Ra music as performed by *his* Arkestra. (So, don't sleep, dig?)

> One of his favorite things to say in the last ten years, he said, "the people are the Arkestra. So, people got to do this". When Sonny cut out, I tried to ensure that all this wonderful art that he produced, just didn't get lost and stuff, you know, because I knew, well I felt that the musical community kind of celebrated Sonny leaving, because he was a nemesis to them. He was the thorn in the side of the American music industry, because he transcended all of the artists that were front line. He could make musical statements that they didn't have a clue [about]. And then I realized what Sonny was talking about when he said, "You got to forego the money, Jacson. It ain't about the money. Money can't make you play" …All of these people are giving me instructions on how to hook up grants and stuff, but I'm not gung ho about it…Money can get in your way. Though it's a great tool, it's too easily misused and people will do a lot of things for money that they won't do for their spirit. And that was the thing with the Arkestra. There was no money to speak of, because when we made it, we spent it right away, buying new stuff to expand the impact of the Arkestra.
>
> Jac Jacson

Sun Ra and the music that he made with a band of poorly paid, but richly rewarded, disciples is now collectible product in a way that will ultimately leave few stones unturned in bringing

to the surface the many diverse listening opportunities forged by a range of creative activity that spans many parsecs. The norm for a pop or a jazz (when jazz was pop) record has always been for a tune to break first as a single and then to be reiterated in a variety of forms (instances defined relative to the studio original as versions of the instrumental-, acoustic-, live-, dub-, etc.- type). As others have noted, Sun Ra's established and emerging discography is a variegated mix of his own standards ("Enlightenment," "Discipline 27," "Space is the Place," "Fate in a Pleasant Mood," "Outer Spaceways Incorporated," "Satellites are Spinning," "Interstellar Low Ways") re-arranged and re-presented in a blizzard of variants that blurs any notion of an "original." This is a way of listening to music that few other artists have afforded their listeners. There are other Sun Ra compositions that were less frequently performed or recorded, and some, like "Sea of Darkness,"[7] which, when they did find their way onto record, became timeless.

Sun Ra recorded *Disco 3000* in 1978, during a residency in Milan, Italy. Taking an uncharacteristic break from his full Arkestra-format, Sun Ra opted for a small group featuring John Gilmore on tenor sax, Luqman Ali on drums, and Michael Ray on trumpet. Ray, was an established R&B player (Kool & the Gang) who had just met Sun Ra and was still in awe of the amount of music that went with the job. "The cat was always writing," recalls Ray, "so we always had new music to play all the time. We really never played the real music in concert — Sun Ra had so much stuff that we would rehearse but didn't even play live, because he'd say, 'I'm just putting this out for people to steal stuff from,' and he'd keep a lot of it from even being played in public at all. Suitcases full."[8]

I think Sun Ra was just too cocky at a time when jazz was enjoying a golden era of brilliant and courageous musicians, many of whom had far more name recognition than Sonny,

for most in the mainstream critical community of his day to dare meet him halfway in his self-aggrandizements as *master of earth music*. There's also the likelihood that Ra's thick space pageantry and Black Power occultism diluted and distracted any attention that might otherwise have been given to his music alone. Conceived as therapeutic tone science, rather than entertainment, his output must be understood as never having been aimed at critical acclaim, or commercial success but always at the inner life (soul-destiny) of listeners and the cosmic ear of creation. Among musicians in many genres, however, Sun Ra's name has become synonymous with something essentially creative and transcendent in musical history. In addition to legions of black jazz artists, his work has famously inspired a number of musicians of other nationalities working across many genres. Trey Anastasio of Phish and Thurston Moore of Sonic Youth are both famous (infamous, if you're bidding against them) Sun Ra collectors. Bay Area polymath Jason Berry's under-appreciated, but amply recorded, Vacuum Tree Head can almost be heard as a post-rock Sun Ra tribute band. The late Fred Wei-han Houn (another Californian polymath and baritone saxophonist) whose creativity and activism were in part inspired by Sonny's work with large ensembles partnered with librettist Quincy Troupe to produce an opera called *Mr. Mystery* in which Sonny returns to our planet on a rescue mission and is cast by Ho and Troupe as "the ultimate Hero against Hype. The Messiah against Mass Media Mindlessness and Muzak. The Warrior Wizard against World Wickedness. The Trickster to top all tricksters."[9] And, in a way that would have probably quite pleased Sonny, his deep cultural shock wave has made him something of an ultimate hero among a bold generation of black musicians working to add a Cosmo-Kemetic dimension to hip hop's urban renewal program. Among this cadre, two L.A. musicians stand out,

Flying Lotus (Steve Ellison) and Ras G (Gregory Shorter, Jr.), as well as the Afro-Asiatic, Seattle-based Shabazz Palaces (Ismael Butler and Tendai Maraire).

> There is no way to codify someone like him, he almost bypasses description, and carved such a unique niche for himself that it is almost impossible to be influenced by him except maybe in an overall philosophical way. First, as is said about Ellington, his big band is his main instrument and his keyboard playing has to be seen in the context of his overall conception for the Arkestra, which makes it difficult to access him as a "keyboard player" in and of itself. Hence, he is seen as an orchestrator at the piano and someone who feeds the Arkestra seed material — a painter of pictures of infinity at the keyboard — and that description does not sound like something that can be taught at Berklee School of Music.
>
> Matthew Shipp, pianist, composer[10]

Writer and musician Greg Tate, as a visiting professor of Africana Studies at Brown University, teaches a course entitled The History of Afro-Futurism and Black Science Fiction. Tate thought enough of Sun Ra's large ensemble concept to name his modern music tune-tribe "Burnt Sugar The Arkestra Chamber." There is a growing sense that Sun Ra's artistic influence has oozed like warm caramel out of the twentieth century and into the twenty-first, sticking itself to most everything at all musically relevant in the process. This delayed effect is no doubt what Sun Ra was talking about when he said that he was about thirty years ahead of his time, but Sonny's prevenient grace — leapfrogging forward, building in the present, only to lie in wait in the future — is only a small part of what it means to be a *time rebel*.

Sun Ra found in electronic keyboards and synthesizers a way of translating his prodigious abilities as pianist (abilities of ear, head, heart, and hand) through a class of instruments

flexible enough to sculpt his sonic vision of impossibility. He found a real match in the synthesis platforms developed by Robert Moog, and his live performances of ensemble jazz were often interrupted by what could only be considered as (more or less) solo presentations of electronic sound art. These spiky, swooshy forays into electronica could be demandingly physical (for the listener and for Sonny). Robert Mugge's documentary film *A Joyful Noise*[11] shows us Sonny twirling dervish-like (or maybe more like Thelonious Monk) as he rakes the keys of his synthesizer with the knuckles of both hands as each spin brings him back around. It is an erroneous gloss, however, to reduce anything Sun Ra did at the piano or any of his keyboards to showmanship, filler or acrobatics. Nor is it accurate to see his work within the electronic domain as a signification on futurism, technology, or related concepts. Sonny liked to stay current with the latest toys, but he was hardly a technofetishist. Pieces that emphasize his synthesizer work, or feature lengthy solo electronic passages, are perhaps the least-recorded side of Sun Ra's musical topography, but I have always found this work to tower over anything "similar" that was done at the time and the overwhelming preponderance of anything done since. Sun Ra was, in these moments away from jazz, not evoking the future through the logic or symbolism of its tools. "Truly," we are told of Sonny's Moog work, "no one had ever gotten sounds like this out of an instrument of any kind."[12] What it actually *sounded* like, *felt* like was an ingression from our Alter Destiny of a fully endowed sensibility, a historicized sound world that hasn't been born yet and can't quite be got to from here. This is, of course, impossible given that no one lives there, yet. But it is an impossibility fully consistent with a heliocentric conspiracy of fugitive time travel.

His life and set list jumbled time, ignored rules of sequentiality, and enforced no discernible logic to what had to be

dealt with in which order. Sun Ra, in effect, "integrated" time, *bussed in*† chunks of unheard fractal electromagnetic sonic spontaneity and made them sit next to fully assimilated exemplars of jazz classicism with all of its decorous trappings of sonority and tradition, and (here one really sees the mark of a formidable genius), once he got them there, he made them all play nice together. This is a social and aesthetic feat that has no precedent in North American popular music. It is a temporal insurgency that should be repeated again and again. Through art we can sensualize the coexistence of yesterday and tomorrow, perhaps feeling less intimidated by the ongoing transformation that this art is presently involved in. Sun Ra heard those sprawling, dripping, synthesized, sometimes angular, sometimes globular, sound(e)scapes with the same ear that he brought to well-tested big band anthems. There was from within his time zone, no contradiction or incompatibility. These were simply equipotent, but differentially indicated prescriptions. They were both, however, medicine — one palliative, one purgative.

† Readers who are younger than the author will need a reminder that this term is borrowed from a time when American public schools were achieving their first taste of racial integration by delivering black students by bus to white schools or districts.

DARK MATTER

Birmingham is probably the most thoroughly segregated city in the United States. Its ugly record of brutality is widely known. Negroes have experienced grossly unjust treatment in the courts. There have been more unsolved bombings of Negro homes and churches in Birmingham than in any other city in the nation. These are the hard, brutal facts of the case.

Dr. Martin Luther King,
Letter from a Birmingham Jail[1]

Northside Community Weed and Seed seeks to prevent, control, and reduce violent crime, drug abuse, and gang activity in targeted high-crime neighborhoods. The Weed and Seed neighborhood sites of the city of Birmingham are Central City, Druid Hills, and Norwood.

City of Birmingham,
Alabama, Official Website[2]

The research team explored the idea that the ancestor of Neanderthals left Africa and had to adapt to the longer, darker nights and murkier days of Europe. The result was that Neanderthals evolved larger eyes and a much larger visual processing area at the backs of their brains. The humans that stayed in Africa, on the other hand, continued to enjoy bright and beautiful days and so had no need for such an adaptation. Instead, these people, our ancestors, evolved their frontal lobes, associated with higher-level thinking, before they spread across the globe.

BBC Science Report[3]

Sun Ra fondly remembers his childhood in the Central City section of Birmingham as a time lived mostly in the absence of white people. We can, in an age eager to declare itself post-racial, understandably be surprised that such a condition was possible, even though there are still many pockets of black, red, brown, and white where people will only experience others like themselves. We shouldn't be surprised then, that when force of law is used to keep people apart, the resulting segregation can be near total. African Americans in the Magic City of young Herman Blount could function within an autonomous,

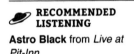

RECOMMENDED LISTENING

Astro Black from *Live at Pit-Inn*

authentic, and perhaps comfortable sense of black homogeneity as long as black political and economic power either served, or left unthreatened, white hegemony.

The dialectical trajectory of Sun Ra on race is at some points stridently clear and at other times less than predictable. Sun Ra seemed nostalgic in some ways for a racial world that fostered that old school level of communal autonomy, although he was certainly no fan of Southern apartheid. He could espouse and support pro-Black solidarity, while at the same time verbally scalding large segments of the rank and file of his race for their failure (among other things) to recognize his importance.

It was widely understood that he would not play with white people, although I definitely saw him play while poetry was recited by Trudy Morse — the late Jewish grandmother and advocate general of several "advanced" jazz musicians, including Cecil Taylor whom she introduced this author to.

He advanced the preservation of what he called "ethnic structures"[4] as indispensable cultural glue for group cohesion. At the same time, he chided other musicians, especially black ones, for criticizing his direction as an artistic trailblazer, for not recognizing his contributions to an authentically black musical tradition.

> The black artist must construct models which correspond to his own reality. The models must be non-white. Our models must be consistent with a black style, our natural aesthetic styles, and our moral and spiritual styles. In doing so, we will be merely following the natural demands of our culture. These demands are suppressed in the larger (white) culture, but, nonetheless , are found in our music and in our spiritual and moral philosophy. Particularly in music, which happens to be the purest expression of the black man in America.
>
> James T. Stewart in *Black Fire*[5]

Then still working and writing as LeRoi Jones, the late Imamu Amiri Baraka brought his pen and revolution to Harlem after Malcolm X's assassination. It was in the midst of the culturally self-determinative maelstrom that had gathered around Baraka's Black Arts Repertory Theatre that Marvin X Jackmon met Sun Ra in 1968. Jackmon had chosen Canada over Vietnam in 1967, but not before working with Ed Bullins in Oakland to establish Black Art West Theater. Jackmon studied at Merrit Community College with Huey P. Newton and Bobby Seale, the founders of the Black Panther Party for Self Defense. At Merritt, Jackmon, wrote and directed plays that incorporated the future Panther leadership into its cast. "The

Panthers had come through the Black Arts Movement. Bobby Seale was in my play before he joined the Black Panther Party," explains the dramaturge. "He played a young black man trying to find his self and join the revolution."[6] When Eldridge Cleaver was released from Prison in 1966, he joined Marvin X in establishing The Black House, a political cultural center. Jackmon promptly introduced Cleaver to Seale, and the rest, as they say, is history. Hungry for the struggle, Jackmon slipped back into the country by way of Chicago where he connected with artists (Phil Cohran, Art Ensemble of Chicago) and writers (Haki Madhubuti, Gwendolyn Brooks) like himself who were working to assemble a set of New World African ethnic structures. Still a fugitive, from Chicago he made his way to Harlem.

"As far as I'm concerned, Sun Ra was the essence of the Black Arts Theater. He was an expression of the essence of the theater in its totality. He expressed everything, more than anybody else, including Amiri Baraka."[7]

In New York Jackmon performed his *afro-agitprop* poetry behind Sun Ra and his *astro-black* band. When Sun Ra accepted a residency at UC Berkeley in 1972, Jackmon had just finished a short stint behind bars for refusing to kill in Vietnam. Sun Ra did music for Jackmon's theater and Marvin X enthusiastically adopted Sun Ra as a mentor. Explaining that he was still "under that Muslim, puritanism moral bullshit," Jackmon explains how Sun Ra responded to his removal of a sex scene from one of his plays. "'Why in the hell would you do some stupid shit like that? That's the best part of the play.' He said, 'the people don't want the truth. They want the lowdown dirty truth.'*

* The low down dirty truth: An Iranian man named Amoo Hadji has broken the world record for the number of years spent without bathing. His cracked and grime-encrusted skin looks diseased after spending 60 years without any form of bathing. The 80 year-old Amoo lives in the village of Dezhgah in the Dehram district of Fars province. There he eats scavenged road kill and sleeps in a shallow ditch that resembles a grave. His most prized possession is a heavy metal smoking pipe with a 3-inch bowl that he uses for smoking animal dung. (Al-Sharq, Islamic Republic News Agency, January, 2014.)

He said, 'the righteous man is the laughing stock.' That really rocked my world because I had to consider what I was doing."[8]

Jackmon took Sun Ra at his word and threw his unconditional support behind Sonny's acceleration of the global slide through history, towards Alter Destiny. "Everything he said was accurate. I don't know of any inaccuracies."[9] The support was mutual. When Sonny found out that he had secured the residency at UC Berkeley, he called Jackmon and predicted that Marvin would also be hired to teach at Berkeley. "I said, 'Sun Ra you're crazy,' because Ronald Reagan had just threw me out of UC-Fresno, because I was a Black Muslim, just as he kicked Angela Davis out of UCLA for being a Black Communist. So, he kicked me out at the same time...but the next thing I knew, I was invited to lecture in black studies. So anyway, he was staying with John Handy and John Handy was charging him a lot of money. So at the time, I had three or four different apartments. So I ended up putting up his whole band in these different apartments, including my own house. Yup, they was staying with me, too."[10]

The partnership wasn't without some bumps in the road. "I sent one of my young musicians, a talented, multi-talented flute player, a singer, I sent him on tour with Sun Ra. Sun Ra had to send him back from Europe. They were up in Sweden somewhere and he said the nigger wanted to come out on stage shaking a stick at the white people. He said, 'Marvin what we gonna do with this nigger shaking a stick at these white people. These white people coming after us. Ain't nothing *but* white folks here.'"

All artists, poets, writers, musicians, theatre persons, must learn the Sun Ra method of creative discipline, a holistic approach to life in the arts, how to bring all the genres together into a whole mythological order through creative ritual. And this includes a melting of art and audience, what

we called Ritual Theatre. Sun Ra taught us all how to ritual-ize theatre by breaking down that wall and destroying the comfort of the audience, yet making them one with the myth/ritual moment in time and space.

First Poet's Church of the Latter Day
Egyptian Revisionists[11]

"The point is that we have arrived at the level of conscious-ness that Sun Ra was on. The whole planet is moving towards that high spiritual consciousness — those who are awake. They're falling right into Sun Ra's hands."[12] Jackmon blogs under the banner of the First Poet's Church of the Latter Day Egyptian Revisionists, where Sun Ra is Pope and Baraka is beati-fied. Visitors can find Jackmon's call to turn away from religion and towards what he calls the Creator God. "He [the Papal Ra] would basically say, 'if you're not serving the Creator, you're not going to be around.' He talked about the Creator God. You can't serve halfway. He said you got to give everything to the Creator."[13] We have already clarified the distinction Sun Ra drew between *god* and *creator*, but Jackmon's webpage can be seen as situating Sonny's Solar Myth Approach far closer to the racial absolutism of Elijah Muhammad than a holistic reading of Sun Ra could ever support, going so far as to recount an adap-tation of the NOI's Adamic creation myth in which Caucasians are concocted by the evil scientist Yacoub in an ancient genetic engineering project.† Jackmon even lists among his Latter Day "saints" the late Khalid Muhammad, an NOI minister whose divisive and incendiary rhetoric put him at odds with not just white power, but his superior Louis Farrakhan.

There is something of a racial tug-of-war in the community of earthlings who would claim to be Sonny's *friends* (as he liked to call his enthusiastic loyalists). If this *Execution* were able to

† Of course, from a mythological vantage point, the notion that black people are responsible for creating their own monsters has some validity.

offer a bridge to connect the two sides, (or at least a discursive arena in which the two sides could fight over which values Sun Ra's work the most) it might serve our common interest in Sonny's mission to end the reign of Death. Some of the most loyal Sun Ra supporters I've ever met have been white folks, and yet, I probably could have stayed on the phone with Marvin X Jackmon for hours as he ignited my imagination with his memories of "hours and hours" spent at Sun Ra's feet.

Sonny's own racial positions are typically complex and unerringly serve a purpose much higher than race itself. People in the black arts Ra camp are justified in their concerns that Sun Ra might become another black star co-opted by the mainstream entertainment-media complex. (*Sun Ra ain't never gonna sell out.*) It is hard, and a bit humorous, however, to imagine Sonny deracialized in the same way that the mainstream media buffed the black off of Hendrix and (to a lesser extent) Marley. But you still cannot reduce Sonny to some "nigger shaking a stick at the white people".

Yes, Sonny might have told his Berkeley students that "the white race has a record of opposing progress"[14], but he often held his own people in contempt for being oblivious to his art and agenda:

> Something gonna happen to these black folks, because all the people who really have been holding them together, gonna pull back, and you'll see something you never dreamed. When they pull back, all these black folks that you thought was makin' it, gonna hit the dirt. You gonna see some tears and some gnashing of teeth. They gonna know they through. This is the end for them. Because they been up there for a long time, all evil and taking advantage of the good at heart black ones. Not the white ones. These black ones been hiding behind, talking about the white man this, that, and the other. It's them; you'll see them change. It's them and they will see the light, but it's gonna be a big fire burning them. And they'll see the light then, but it's gonna be

the kind of light they ain't gonna want. They will be enlight-
ened by themselves, burning in the fire. If I have anything to
do with it, I will be the keeper of the pitchfork. And I'm gonna
have me a nice time. [Band members can be heard laugh-
ing.] I'm gonna get even with them for everything they ever
said to me, everything they ever did. I'm gonna have me a
nice time and the fire is busy; just get my brothers to get the
fire ready. Because I know they gonna fall, just as sure as I'm
sitting here, black folks gonna fall right over into my hands.
I'm telling you what's going to happen fellas. They just as
sure to fall over into my hands as I'm sitting here and I am
sitting here. They gonna fall into my hands *totally*.[15]

While it is comforting to view the iconoclastic Ra as uncom-
promising on all matters, it is more accurate to say that he
was as precisely complex and mysteriously nuanced on race
as he was on everything else. In the best of all possible dying
worlds, all people would find their self-interest best served by
blowing on the ember of Alter Destiny. Jac Jacson opined that
largely because of their deep-seated recalcitrance towards
their own avant-garde, black folk had "missed the boat"
on Sun Ra. In the unique history of blacks in the West, Sun
Ra saw a built-in escape clause that should elevate African
Americans to the vanguard of his proposed space world, a
zone of fluid possibilities:

They got to have a sense of humor and they have to use it.
They'll make it, if they use it. First, they got to prove they're
not man. Then the laws of man cannot affect them. They
didn't come here as man. They didn't come here as a human
being. So, they didn't have no status to say [anything] about
equal rights. They came in the commerce department. They
came here as items of commerce. So, therefore if they want
anything, they have to get it from the Commerce Department.
They most certainly can't get it from the State Department.
Well, I'm dealing with mathematics. So, if they came here as
items, things, then they'll see do the Constitution have any-
thing mentioning things; do things have any rights in America?
Of course not. Then they'll have to go to Congress and get a

law passed for things. And say they're things — of course, it's a different story. Things would have to be added onto the constitution so that you have some rights. What rights do things have? Well, things don't have no ten commandments. They could eat of the tree of knowledge of good and evil, because God didn't say they couldn't eat it, he told man that. Now, what they have to do is to prove they're not man.[16]

Sun Ra preached that instead of trying to compete with the white race for equal leadership in and of the world, African Americans should embrace their status as *number two*. Whoever was responsible for erecting this civilization, he taught, would soon have hell to pay and how close do you really want to be standing to them when they do? Sonny's di-chromatic race talk offers little as a harmonizing agent for a global battleground of competing shades of skin and culture and is often more a metaphorical arena for the ubiquity of black holes and other singularities than any assumed mysticism of melanin. Referring to the iris at the center of our pupils, Sun Ra said that everybody had a black part and declared that to be the part he was interested in redeeming from planetary doom.

Instead of waving a stick and shouting "Hands off Sonny!" (it's a little late for that), the black community would be better off undergoing some internal reflection and rebuke for its blanking out of black musical innovators including, but not limited to, Sun Ra and artists of his generation, as well as a virtually unknown field of dedicated creative musicians that have come and gone since.

Thomas Stanley: Music beyond belief. Where are you trying to take us?

David S. Ware: Man, I want to, I want to merge into the absolute, man. I just want to merge into the absolute and stay there.

[laughs] Just go back to the absolute and stay there; before creation, you know, go to the perfect state and stay there. You know, that's what I'd like to do. [much more laughter]

Stanley: How does it feel to be gifted with such a powerful team (William Parker: bass, Matthew Shipp: piano, Susie Ibarra: drums) to pursue this journey into the absolute?

Ware: It's a blessed thing, you know. It's really a blessing. I'm trying to find wisdom in life. I'm seeking wisdom, you know. All these myriad experiences that people go through, I'm trying to extract wisdom from it, you know what I'm sayin'; that's the only thing that really matters. So to hurry up and get back to the absolute.

Stanley: You know, today is the fourth anniversary of Sun Ra's transition.

Ware: Four years, yeah?

Stanley: Exactly four years ago today, yes sir, and I wondered if maybe you could talk about Sun Ra.

Ware: Well, you know, he was a great human being, you know what I'm saying. He was great because he had the spirituality, you see? Because he sought spiritual things. That's what made him great. That's what made the difference. And you seek spiritual things and you incorporate it into your life, you know what I'm saying, and you walk with that. And that's what makes you great. That's what makes anybody great. Life is empty without that, you see. Without the spiritual essence life is empty and that's what he was about, through his music that's what he was about, you know what I'm sayin', preachin', teaching the ancient teachings...through music. He taught the truth through music like we all try to do, you know, but he had it going pretty well.

Stanley: Can I ask a frightening question: How far can you take this thing, man?

Ware: As far as the body will allow. As far as the body will allow. As much as the body can take. As much of that vibration

that we can take on this physical plane, you know what I'm saying. I'll go for it. I'm not afraid. As much as the body want to take. I'll go for it.[17]

David S. Ware completed using his body on October 18, 2012.

Danny Thompson

© Yusef Jones

MEDIA DREAMS

What therefore more easy than now to take his servant on a second journey into the blessed region of the Fourth Dimension, where I shall look down with him once more upon this land of Three dimensions, and the inside of every three-dimensional house, the secrets of the solid earth, the treasures of the mines in Spaceland, and the intestines of every solid living creature, even of the noble and adorable Spheres.

Edwin Abbott, Flatland[1]

When the black American reads Frederick Jackson Turner's The Frontier in American History, he feels no regret over the end of the Western frontier. To black America, "frontier" is an alien word; for, in essence, all frontiers established by the white psyche have been closed to the black man.

Houston A. Baker[2]

un Ra is what in literature is termed a *nonce word* — a chunk of language cobbled together for a single, specialized use to solve an immediate problem of communication. In security engineering, a nonce is an arbitrary number used only once in an encrypted communication. *Sun Ra* was also a singularly unusual stage name and the stage was life performed publicly before audiences of hundreds, dozens, or

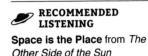

RECOMMENDED LISTENING

Space is the Place from *The Other Side of the Sun*

one. It rises above all of his mystery names as the one around which he built a splendid thing of music and words, sights and sounds, pretense and performance. Finding a way to talk about the thing he built as a device, implement, nutrient, vehicle, or dwelling (as something recognizably useful) is indispensable to the task of talking about what Sonny was trying to do as well as what he accomplished, and what he might be accomplishing now, a pair of decades after his departure from the planet.

I've got some damned significant info for you re: your interest in the analogy between Sun Ra and Ricky Wagner. A month ago late at night I was listening to and watching video footage online of a bunch of lectures presented at the Wagner Worldwide 2013 symposium down at the Univ. of South Carolina, which took place in late Jan/early Feb this year. One of the lecturers, Alex Ross, Music Critic of *The New Yorker*, was entirely dedicated to Wagnerism in the black community. It turns out (and I was amazed to learn this) that W.E.B Dubois considered himself a Wagnerian, who wished to apply Wagner's notion of restoring the lost mythos of the Germanic peoples through art, to his own movement to stir the black community to establish its own identity, and a new identity, vis-a-vis white America. It turns out that he studied in Germany. I knew nothing of this. But that's not the end of it: Herzel, who was a key figure in establishing Zionism (of course, the Jewish movement to return to the homeland), was also a Wagnerian, in spite of Wagner's anti-Semitism,

because he considered Wagnerism a model for the rebirth of the Jewish nation. Who knew?

Paul Heise, Wagner Historian and Scholar[3]

Like Richard Wagner, Sun Ra had an appreciation for the ability of the performing arts to aid and abet the historical maturation of a people, not merely provide an artistic chronicle of where that people have been. Which is to say, artistic practice can reflect what has happened as well as what is happening, but expressive praxis can also throw itself forward and determine, not just respond. Journalism is often seen to be at its most dysfunctional when reporting becomes the news. Art is at its strongest, its most alchemical mode, in those rare instances where it is able to craft historical reality, not just emote about it after the fact.

He called his mission and its method most broadly and consistently Myth Science and identified its objective as the happiness of others. His was, as he never failed to remind us, a thankless task of many sacrifices and slim rewards.

> Since this planet for thousands of years has been up under that law of Death and destruction, it's moving over into something else, which I choose to call MYTH, a MYTH-SCIENCE, because it's something that people don't know anything about. That's why I'm using the name MYTH-SCIENCE ARKESTRA, because I'm interested in happiness for people, which is just a myth, because they're not happy.[4]

Myth as a medium erupts from the sap that binds history to time, meaning to the movement of bodies. I'm not sure that Sun Ra's repeated and specialized use of that term aligns well with either the vernacular use of *myth* to refer to almost anything false, or any of the more specific conceptual domains implied in the way that Myth was central to the work of Joseph Campbell, or was captured by Carl Jung's archetypes,

although it might be closer to the latter. Jac Jacson was an invaluable companion mind in finding the sense lurking in Sonny's parabolic pronouncements. We talked at length about myth and he told me that Sun Ra defined his myth as anything that could not be proven true or false and as such, in this bizarrely suspended state of quantum epistemology, myths necessarily have a potent effect on the more definite facts of social history:

> The myth is the seemingly false and the seemingly impossible. The borders of the rim of myth are vast and nonexistent because there are no limits to the imagined realm ideas of myth. It is a challenging frontier.[5]

Where the myth and the virtual converge, we find Sun Ra as ontological frontiersman offering his body as a time-stretched filament of possibility connecting here and now into some preferable sub-region of the greater omniverse. As Brian Massumi writes in *Parables of the Virtual*:

> [t]he appearance of the virtual is in the twists and folds of formed content, in the movement from one sample to another. It is in the ins and outs of imaging. This applies whether the image is verbal, as an example or parable, or whether it is visual or aural. No one kind of image, let alone any one image can render the virtual. Since the virtual is in the ins and outs, the only way an image can approach it alone is to twist and fold on itself, to multiply itself internally.[6]

Essentially, for Sun Ra, the apparent polarity between a human order and a natural order is a figure-ground reversal (another inversion) dependent on reversing the usual hierarchy between the real and the myth. In Sonny's Myth Science, the natural domain, usually constructed as the wild margin surrounding the affairs of man, is a lot like a tent surrounding the circus performers inside. Sun Ra, however, was ready

to dispense with the clowns, recognizing that the show was the Big Top itself: *Space is the Place,* and in a virtual world, space need not be Cartesian, or even physical. Space is never only real estate (terrestrial or otherwise). It is the most basic precondition (after agency, volition, or intent) for any order of construction.

On a daily basis, the greatest epistemological challenge any human must face is distinguishing between what he or she knows from what they think they know, that is, how to discriminate between science and nescience, *vidya* and *avidya. Avidya* is ignorance and like the Upanishads, Sun Ra taught that it was our common inheritance as individuated/embodied consciousness. Ignorance is not sin, or sloth, just non-knowledge. Sun Ra accepted that we were all equal in our ignorance and that if the energy of that informational dearth could be harnessed, it would be a renewable source of ideational novelty. Sun Ra's myth was meant first to make us aware of the high walls of certainty that shade our noetic potential. And then, with Sonny's push, to breach the event horizon of our ignorance behind which exists as pure potential (*myth splendor*) all that has not been settled or discovered.

Sun Ra's encoded energy of externality refreshes the pregnant junction between doubt and belief, skepticism and faith, and gives us, in other words, much more to make up our minds about. This prerequisite emptying of *avidya* stands between us and a renewal of the covenant integrating human and planetary destinies. "There's no place for you to go except in or out," Sonny counseled in song. "Try the out".[7] Or as the sun dancer in me is forced to ask: How can you possibly win a fight with your Mother? If you kill (transcend) her, how will you ever be happy? If you just beat her badly, how can you continue to look at her?

Dominion is a nonce word planted in the first book of the Holy Bible* as bait to solve an immediate problem — to lure us into thinking we've been given diven license for matricide.

The big band is the first thing built wholly off the plantation by the African once-slaves who poured out of the nightmare of the smoldering Reconstructed South and its more or less successful effort to reclaim the Confederacy, not from the Union, but from the blacks. "They still got that flag up—when a nation is defeated, they take their flag down," Sonny observes. "Confederate flag is still the flag of Alabama, so Alabama's the center and the capital of the Confederacy."[8] The big band was ebullient and precise. It went to work on time, because it could, not because it had to. Regal in their bearing, these jazz orchestras, beginning with Ra's mentor Henderson, effectively colonized Edison's new mass technology for recording and disseminating sound, guaranteeing that at least for the duration of the twentieth century, records as art and industry would be dominated by the productivity of the sons and daughters of the transatlantic slave trade. As tall ships are reminiscent of the European scheme to expand beyond the cramped western tip of the Eurasian peninsula, the big band as sound and structure would be repeatedly revived and redeployed in Sun Ra's music as a similar holy icon of the communal and continuing exodus out of the ontological bracket of nonhuman

* King James Bible, Genesis 1:28: "And God blessed them, and God said unto them, be fruitful, and multiply, and replenish the earth, and subdue it: and have *dominion* over the fish of the sea, and over the fowl of the air, and over every living thing that moveth upon the earth." Dominion is understood here to refer to the power to direct, control, use and dispose of at one's pleasure and implies the right to possess and use without accountability. *Aho Mitakuye Oyasin*, on the other hand, opens and closes most Lakota prayers, means *all my relations*, and is a declaration of cosmic holism that is antithetical to Judeo-Christian dominion. While much has been made of the clash between Islamic sharia and western democracy as competing conceptions of law and order, the truly determinative conflict of our time is obviously best characterized as a war between *All My Relations* and *Dominion*, holistic immediacy and reductive abstraction. The Children of the Sun stand with their Mother, an army of innocents arrayed against Modern Babylon and its Death machine.

chattel. The big band was a highly disciplined expression of what is most valuable about freedom — slaves should know — choosing that which binds the individual. While there are several significant small ensemble recordings and some solo work, Sun Ra chose to mount most of his futuristic ideas on the familiar chassis of the jazz big band.

Marshall McLuhan saw the work of artists "as an early warn-ing system, as it were, enabling us to discover social and psychic targets in lots of time to prepare to cope with them. This con-cept of the arts as prophetic, contrasts with the popular idea of them as mere self-expression.... Art as a radar environment takes on the function of indispensable perceptual training rather than the role of a privileged diet for the elite."[9]

> Progressive music is music that is keeping ahead of the times you might say. In America they call it avant-garde music. It's supposed to stimulate people to think over in the sort of modern trend, or keep ahead of the times. Well, we actually are bringing in this sort of ultra form. It's not just keeping ahead of time. It's dealing with ancient things and eternal things, which the ancient Egyptians were dealing with through cosmology.
>
> Sun Ra[10]

There was a cassette[11] made of Sun Ra in attendance at a west coast organizational and recruitment workshop for FESTAC[†] hosted by a representative of the Nigerian Government. It starts with the official extending a politely bureaucratic, scripted, and rather banal invitation and is followed by a com-parably officious and unruffled explanation of the selection process. We learn that the hundreds of cultural contributors will be divided into seven regions and that "Nigeria as host

[†] The Second World Festival of Black Arts or the Black and African Festival of Arts and Culture was held in Lagos, Nigeria in the early part of 1977. FESTAC still stands as the largest cultural event ever hosted on the African continent.

country will coordinate the arrangements of participation by the black liberation movements of countries still under colonial domination." The speaker then graciously closes out his formal presentation with an appeal to the African American artists assembled:

> It is evident that a great impact will be expected from the participation of black Americans because of the distinctiveness of their art and the technical and financial means which they and their country can put at the disposal of the organizers. The artistic experience of black people will be highly prized by black peoples everywhere for it constitutes a peculiar dimension of the artistic genius of black civilization. [Applause]

Then it's time for questions and answers. After a couple of tame procedural questions, an unidentified man, who it becomes clear, came with Sun Ra, asks how the conference organizers will identify the "true" black artists. The speaker seems just a touch put off by the question but recovers with some more polite embassy pabulum and then Sun Ra jumps in:

> Well, one difficulty is that in America, you've got about five different streams of music and one stream of music is completely neglected by black people themselves. So if you had a committee that was selecting music, they would leave out the avant-garde stream of musicians who are doing something advanced, because black people in America in a sense are bogged down to tradition on a lot of scores and they haven't paid any attention to a lot of musicians who are recognized by the rest of the world; unfortunately they haven't done that. Well, then if it's up under NAACP or the Urban League or some of the people over in there, they wouldn't know anything about the music.

> Like take the music that we playing. It never gets mentioned in *Ebony* or *Jet* or any of the black publications, never. But over in the European publications, in Japan, and every other country, well, my band is considered as tops. So you see

you have a case where black people have utterly ignored me, completely. So then, the only way we went to Europe this time, an African from Nigeria brought us there, because he said we should be heard. So, you see, I didn't get any recognition from black people. It took an African from Nigeria to bring us there. He also said that I should be known to the world and he was the one who publicized me and wrote all the articles in all the leading white publications, because he felt that black people in America neglected me. So the last two tours we made in Europe was done by a Nigerian who said that this music is the bridge between black people here and Africans, and since he's from Africa, he knows that this is the music.

The embassy official attempts to regain control with a courteous interjection — something about committee formation. Sun Ra bowls him over:

You have many different groups of musicians in the black race that are doing some things that the whole world recognize, but then as I said, black people here haven't paid any attention to [these] musicians. A lot of them have gone to Europe to stay. Some of them are in Alaska. They just left here because they couldn't get anywhere to play or they were doing something advanced that some of them were even threatened by black people over here. Like Cecil Taylor who's a black musician, plays piano, he went to Brooklyn, a black district in New York, and black people gave him ten minutes to pack up and get out when he played. And Ornette Coleman, another black musician, some black people took his horn and threw it down the mountainside and gave him a few minutes to get out of town.

So now you see the world is changing and some people who are black also resist change, but the musicians in this country haven't stopped. In fact, when black people were in slavery, when they were in a worse condition than they are now, it was the black musician who always been in the forefront of any kind of civil rights or anything else. They held up the banner for black businessmen when black people couldn't do it. At this point black people are neglecting black musicians who are still holding up the banner for avant-gardeness

143

and advanced thinking, so a lot of black people are talking about revolution and they're leaving out the black musician and that's why they haven't gotten any further in America because they left out the music. And everything that's ever happened on this planet, the musicians were in the forefront. Like in Africa, music is always very important there. In Russia when they had their revolutions, also the music was important and every country on the face of the earth always used their culture. Black people in this country have neglected culture. Now they speaking a lot of other things, but unfortunately another African came from Nigeria, one time in New York, and LeRoi Jones said the only thing that Africans know about black Americans is what they hear in the music. And I tried to tell them then that the music hadn't been — the whole gambit of different phases of black music — hadn't been heard by Africans. Like we've been all over Europe, but we haven't been to Africa, yet. You have a lot of festivals in Africa. We've never been invited. We went to Egypt the last time, and the Egyptians did recognize what we were, but we still haven't been down into Africa, because no one has invited us.

There's another sheepish response, referring to the work of previous organizing committees, and an assurance that he will pass Sun Ra's message onto the selection committee in New York. Do you think Sun Ra was finished?

We're also doing something in art. We were the leaders of the movement for a new type of art among black people in LeRoi Jones' Black Theatre. In fact, the whole Black [Arts] Movement started with LeRoi Jones. And we were there playing out in the streets of Harlem, and still no attention was paid to us. Now here in this district, we're making a science fiction film [the film is Coney's *Space is the Place*, filmed in Oakland in 1972] about outer space, and black people in this district don't even know it. It's going to be in Cinerama‡, and it's going to be a full-length film. It's going to be in color. It's about somebody black landing from outer space to get black

† A widescreen process that simultaneously projects images from three synchronized 35 mm projectors onto a huge deeply curved screen. I've seen no evidence that this technology was ever used to present *Space is the Place*.

people interested in outer space and Africa's in it, too. At the end of the film, Africa's in there. So you see, they aren't alert to a lot of things that's relevant to them.

A response with a little irritation in it begins. Sun Ra cuts him off.

I would like for you to have a specialty department for the advanced musicians different from just the others, because black people don't know anything about the advanced musicians in the black race and therefore you need a special department so that they will be represented in Africa, too.

Now, after Sun Ra has completed his full court press, the Nigerian representative is heard to turn to a female assistant with a whispered attempt to explain the demands of this odd-looking, long-talking man. Sun Ra can be simultaneously heard turning to his associate, and declaring, in an equally hushed, off-mic voice: "We're out of here."

Solar Myth Approach, a Summary:

1. Embed an utterly profound Darwin/Marx/Einstein/Gandhi-scaled idea in a vessel of such self-compromised credibility (the minstrel jazzman version of a Trojan horse) that this insurrectionary cultural anti-particle glides (neutrino-like) right past normality's most aggressive early warning systems.
2. Translate that idea into an embodied holistic ontological contagion through music, choreography, and the childlike magnetism of a parade. (Our mirror neurons are firing wildly as we vicariously dance along with June, Vertamae and Teddy.)§

§ Along with June Tyson, Vertamae Smart-Grosvenor and Thadeus Theodor Thomas were perhaps the most frequent dance contributors to Sonny's work.

3. Use Myth as an effective antidote to the mind-freezing effects of Faith. After all, both are remarkably and stubbornly resistant to contravening evidence.

4. As this contagion is handled for quarantine, for containment within the ideological loony bin of laughable one-offs, this amazing truth about the human condition and its ride along the temporal shock wave will inevitably rub off on the handler. Any mind virus that you can tap your foot to is bound to win.

Sun Ra © William Brower

NOTHING IS

And when they found them not, they drew Jason and certain brethren unto the rulers of the city, crying. These that have turned the world upside down are come hither also.

Acts 17:16

A solar "blob" is coming, but this show won't be scary. It might sound scary to hear that a giant blob of solar plasma is heading straight for us, but don't panic: Space weather forecasters say this solar outburst should deliver nothing more than a spectacular show up north.

NBC News[1]

Eventually a stage may be reached at which the decisions necessary to keep the system running will be so complex that human beings will be incapable of making them intelligently. At that stage the machines will be in effective control. People won't be able to just turn the machine off, because people will be so dependent on them that turning them off would amount to suicide.

Theodore Kaczynski, *Industrial Society and Its Future*[2]

How *about* a spectacular show *up North?* Sun Ra's scouring skepticism eats at all notions of the permanence of the order that we have been taught is civilized. He was not an anarchist or a nihilist, but he did unambiguously uncouple his objectives from any notion of the survival of a Western World. If anything, he saw in the manifest failure of the current order an opportunity for the resurgence of the ancient black order that he claimed to represent.

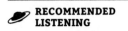 **RECOMMENDED LISTENING**

Space Loneliness No. 2 from *Nidhamu*

> I have to be talking to people, but they will be changed, and everything they think is right, that will be nullified, and that's kind of hard: to come to a planet and nullify everything, but everything has to be nullified for them, or else they're going to die.
>
> Sun Ra[3]

The daily news delivers social dissolution, which when reinterpreted through messianic myth-speak, becomes an energy gradient down which our current condition can more readily flow towards a field of alternative courses of action and outcomes, existing in a radical condition adjacent to sanity, but by any consensual measure, other than sane. This condition is implied by Sun Ra's way of being in the world, but is by no means synonymous with it. In other words, it should go without saying that Sun Ra is not a style of identity to emulate. There's no payoff for a generation of copycat Ra's with sparkly hats and cosmic raps. Charisma is contagious. Rather than a lifestyle, Sun Ra was modeling a mode of existence that deftly renegotiated the pressures of normative society in such a way that, against all odds, something novel, even miraculous, certainly something legendary, if not entirely mythic, was able to take place.

Michael Taussig passionately reminds us that the oft-cited father of cultural critique, Walter Benjamin, noted early that the left is slow to embrace the messianic nature of their methods and objectives. In fact, both the *Communist Manifesto* and the *New Testament* represent activist documents intended to prepare for the advent of a new heaven and earth. In the words of psychedelic prognostician Terrence McKenna:

> There is very little political light on the horizon. So, I believe it's reasonable, looking at this situation, to say that history failed, and that the grand dream of western civilization has in fact failed. And now we are attempting — with basically a carved wooden oar — to turn a battleship around. And it's a very frustrating situation. The momentum for catastrophe is enormous in this situation.[4]

The information age represents an intermediate phase between an economy of *stuffs and thangs*[5] and one of feelings and ideas. Clean energy is the refusal of greed. The machine can take care of us; there's nothing wrong with the engineering involved. It is the product of good ideas based on fairly accurate understandings of physical and social science. It is the fuel that's corrupt. The mechanisms are clogged and gunked-up with the tarry excess of the very fuel that established them — *dolla bills, y'all*[6]. Money as a symbolic system (actually, a cancer upon language) may be calorically rich, but it is ultimately too dirty and unstable a fuel source for a modern machine. We must rid ourselves of the cash and do so fast. As fast as we once scurried around (like ants on a hunt for crumbs) to make it, we must divorce ourselves from money and its pornographic contempt for us. You can't pour hay into a Lamborghini, either, right? Clean energy is the refusal of greed as a valid reason for doing anything, as the great lean forward that pulls each of us out of bed and

pushes us out the door into a world made of and (now, in the end) *for* money. Leave things as they are, and only money will be able to survive in this brave new world order of rampant privatization, predatory loans and drones, and other neoliberal infatuations.

Why cast money as a malignancy feeding on language? It is composed at a cellular level of pretty much the same stuff as language and similarly serves as a kind of connective tissue around which all other social realities cohere. Money, however, is a weird frankenfusion of a verbal materiality that allows it to function within and as language and a mathematical aspect from which money derives its pernicious, metastatic threat. As word, money is like poetry, a communicative tool for the expression and clarification of matters of value. But where poetic power rests in metaphor, money's ability to instantly and "objectively" resolve controversies of value rests in the authority of its math. That is after all what numbers are for — to render our world object(ive). Equivalence is established between a decontextualized abstraction of value and a fixed standard of exchange — a norm, controlled (somewhat) by the Central Bank and enshrined in a system of tokens (the body of money), which themselves become a highly sought end goal, but are not the same as money; it is an immaterial abstraction in the same way that the splashes of ink on this page represent, but are not identical to, the words that you are reading.

Science fiction is the ladder upon which today's dreams climb into tomorrow's realities. Alter Destiny is at the top of the ladder. Case in point, I watched Jim Kirk chat up Lieutenant Uhura on a cell phone in 1967, but I never saw either of them reach into their pocket and pull out a coin or a credit card. Money has no place in an authentic (that is, survivable) future and solving the problem of Clean Energy means on every level,

the abolition of moneyed economy as the material basis and motivational framework for our relationship to each other and to our planetary home.

> I ain't about no money. Money doesn't interest me.
>
> Sun Ra[7]

We live in an inverted and insane world in which marketing interests have thoroughly infiltrated our use of language, thus leaving melted and thinly diluted, in one catastrophic fall from grace, both the miracle and meaning of human words. All is profanity now. The words *Mountain Top Removal* should be meaningless gibberish except when uttered in some cartoon world of infinite absurdities. Once explained, the term *Fracking* should only bring to mind an image of something like a kneeling addict carefully, if futiley, fingering through carpet fibers for some stray fragment of bliss. (Frack? Crack? Frack equals fragments of crack; okay, that's clear.) Now, some few thousand years after its invention, after "discovering" continents, clearing their trees, otherwise emptying their riches, and raising great cities on their lands, Money reveals itself to be a potent neurotoxin. Its debilitating effects are uniquely cumulative across generations. At the current rate of atrophy, those of us who have not yet, will soon be reduced to a condition somewhere between mercury poisoning and nodding disease. Words are profane. Words are impotent. Everyone can "like" everything. (Thanks, Zuckerberg.) No one can be convinced of anything: every narrative that violates the quasi-official version of things is laughed off as a "conspiracy theory" and has probably been seen tens of thousands of times on YouTube. The only apparent effect of all this high tech propagandizing seems only to be more online video, more conspiracy. No matter how

THE EXECUTION OF SUN RA

shocking or seemingly consequential, the truth, apparently is as banal as it is easy to access.

———————————

"Ain't no way you push a plane dat big through a hole dat small," said Br'er Rabbit, staring at the burning gash in the side of the funny-shaped building. "Dat dere Boeing 757 is supposed to be a big ol' thing, and dat little hole dere ain't no bigger than the door to my briar patch."

"Well, sho' dere is cuzzin," said Tar Baby, scratching his head in that annoyingly moronic gesture that seemed to have been designed just for him. "You shouldn't ought be so seeni-cal," said Tar Baby. "Youse gots to remember dose terr-o-ist fellas, days smart and days tricky. Day got dems a way to shrink a big ol' airy-plane, a panel truck, or any ol' thing, and den make it grow back up no'mal size, just een time to blow it all up t'hell. Sheet — dem fellas is tricky an' don't you forget Rabbit, days evil, too"

But while Tar Baby was scratching his head, Br'er Rabbit had hopped away.

———————————

Sun Ra repeatedly disavowed money as the driving force for music. Any so-called musician who was consciously try-ing to use money to profit financially was degrading a priestly art. And yet, a properly oriented society would have to hold "sincere" musicians and artists in high regard, subsidizing their needs and financing their work. Can we, on behalf of Le Sony'ra declare war, a fully nonviolent, unconditional war on the Myth of Money, the pedestrian tentacles of faith with which money permeates human life, and all its wasting eco-logical, cultural, and social implications? A completely, even militantly, nonviolent war, waged primarily through art?

"I am the brother of the Wind," he sang and I thought I understood what he meant as an allegory for his affinity with the forces of nature. And he might have meant that, but he also said that he is Sun, which is also *Son*, which is sound in the French language. Sun Ra was saying that he is Sound, which like the wind, is moving air, a movement so subtle, that its pressures are made perceptible only by the triggering of microscopically fine whip-like cochlear hairs. The frequency-specific undulations of these, our shortest hairs, form the bodily starting point of all audio perception. While the wind, when intense enough, can easily deform, destroy and transport the exteriors of bodies, even taking down the structures that surround them, sound excels at in-forming and transporting the energetic facts of awareness — effects (affects) that we habitually assign to the charged gap between body and world, but it, too, can destructure the space around bodies, like a hurricane.

Nicholas Ridout and Rebecca Schneider describe temporal dimensions of the cognitive and affective timbre of life lived in the eye, wake or onslaught of overlapping storm systems:

> Precarity is life lived in relation to a future that cannot be propped securely upon the past. Precarity undoes a linear streamline of temporal progression and challenges "progress" and "development" narratives on all levels. Precarity has become a byword for life in late and later capitalism — or, some argue, life in capitalism as usual.[8]

Precarity versus Precision-Discipline. Opposed to *freedom*, Sun Ra saw *discipline*. It was his mantra. The hyphenated construct *precision-discipline* underscored that discipline is about hitting a target, bringing body and world into the closest possible alignment. Shooting jump shots and hitting high notes are of the same order of challenge for the embodied mind. If he was a perfectionist, it was of a very particular kind, however. Many of the works that make up Sun Ra's oeuvre are live

shows or rehearsal sessions edited from reel-to-reel record-
ings made in Sonny's living room/rehearsal hall. Sun Ra's
discipline never seemed forced. Rather, he was a persistent
push in a particular direction, relentless and unrushed like
running water and equally resolved to see his gesture through
to completion. Sun Ra was aware of the liberating power of
being able to do something really, really well. George Clinton,
the barber turned rhythm & blues revolutionary, still brags
about the precision of the finger roll waves he used to press
into his client's fried hair.[9] Sun Ra's embodiment of excel-
lence reflected an alloy of effort and ease, intuition and
premeditation.

> Nothing is inherently political: politicization requires a politi-
> cal agent which can transform the taken for granted into the
> up-for-grabs.
>
> Mark Fisher, *Capitalist Realism*[10]

With Sonny, everything but music, love, and discipline
were up for grabs. I think Sun Ra understood that a civiliza-
tion allowed to periodically (let's say every 12,000 years, or
so) go back into solution would eventually settle out into new
cultural forms that allow for the realization of fresh human
stories and positive achievements that are (from the lightless
dungeon of the old order) as valuable as they are invisible. His
push is a push out, out the door of a burning house, through
the open gates of a disintegrating plantation. It's over, he says
with music and a smile that should only threaten those who
are clinging desperately to the keys of a rusted gate. Those
on the top floor of the mansion, in its comfy cozy penthouse,
are just beginning to smell the smoke. Soon, they will try to
escape, but to no avail. The stairwell is blocked by a bunch of
jazz musicians, blowing and swinging their asses off.

I dare them to take the elevator.

Marshall Allen © Yusef Jones

TRANSMOLECULARIZATION

The "schizophrenia" Deleuze and Guattari embrace is not a pathological condition. For them, the clinical schizophrenic's debilitating detachment from the world is a quelled attempt to engage it in unimagined ways. Schizophrenia as a positive process is inventive connection, expansion rather than withdrawal. Its twoness is a relay to a multiplicity.... Not aimlessly. Experimentally. The relay in ideas is only effectively expansive if at every step it is also a relay away from ideas into action. Schizophrenia is the enlargement of life's limits through the pragmatic proliferation of concepts. Schizophrenia, like those "suffering" from it, goes by many names.

Brian Massumi, *A User's Guide to
Capitalism and Schizophrenia*[1]

*And it's all symbolic — everything is symbolic; nothing
is real.*

Sun Ra[2]

In 1942 the efforts of the United States to construct the first nuclear weapon began secretly under the auspices of the University of Chicago. In the winter of that year, in what was then innocuously called the "Metallurgical Laboratory," Enrico Fermi led a team of scientists in building the world's first nuclear reactor in a squash court under the school's football stadium. The so-called Manhattan Project was actually launched in Chicago. In 1946, the year that Sun Ra relocated from Birmingham to Chicago, the lab was renamed the Argonne National Laboratory. It was located roughly thirty minutes driving time from the South Prairie Avenue apartment that Sun Ra called home. While in Chicago, Herman "Sonny" Blount found his solar name and prototyped his ideas about music, performance, and history through an ensemble concept called Arkestra. It has been said that Sun Ra fell into that name through the accident of his thick, black southern pronunciation — what was intended as "orchestra" came out of Sonny's mouth as *ar-chestra*. Uh, maybe, but the serendipities of locale, however, force us to explore a functional polarity uniting the two projects that adds another interpretative vector for this symbolically pregnant project name. If Fermi, and the rest of Bob Oppenheimer's brilliant team were tasked with rushing to production an instrument of ultimate destruction, then Sun Ra, with his relocation to the windy city and organization of the musical specialists who would form the core of his workgroup, can be seen as commencing an opposing long term effort to create a vehicle of ultimate creation — cosmogenesis — through artistic activity having a largely sonic base. In effect, like Noah's very large boat, Sun Ra offered his Arkestra as a hedge against the large-scale annihilation that would be the standard of success for Oppenheimer's team and

RECOMMENDED LISTENING

Untitled Synthesizer Solo
from *The Paris Tapes*

their diabolic employers. The A-bomb was ready in a hasty three years. The Ra-bomb is only now armed and primed for detonation.

> Sound and aether are thus the very first manifestations of objective consciousness — not the first in time, necessarily, but the first in the hierarchy of being...One who works with sound is therefore manipulating the source of all we touch and see, taste and smell. But just as the alchemists say, "Our Mercury is not the common Mercury", so this sound is not the common sound.
>
> Joscelyn Godwin, *Harmonies of Heaven and Earth*[3]

It is not at all incidental that the construction material for Sun Ra's anti-Manhattan Project would be sound or that he would generate so much of it.

> In either the propagating or standing form, wave processes enjoy a number of capabilities that are not available to discrete particles. Most basic is that the information and energy they carry may be widely diffused over broad regions of space and time, rather than sharply localized in a well-defined geometrical region.
>
> Robert Jahn and Brenda Dunne, *Margins of Reality*[4]

In 1967, Hans Jenny coined the term *cymatics*[5] to describe the elaborate visual representations of sonic phenomena that he had coaxed out of a fairly straightforward experimental design. Using resonators and viscous fluids or certain fine powders able to behave like fluids, he documented unique, complex structures that emerged from the interference patterns generated by his application of periodic vibratory energy. The patterns that resulted from the application of simple sine waves were often aesthetically elegant, highly complex three-dimensional structures that appeared in response to the sound in unpredictable ways. What became

clear was that Jenny's protocol provided visual evidence that energy propagated as invisible waves could have very specific structuring effects on the matter within its reach.

Sonny might have seen or read Jenny's book (especially given the Swiss doctor's connection to Rudolf Steiner) but he certainly was aware that matter was structured by sound:

> Sound itself is music. Music is our sound department. So what if the sound department just refused to cooperate. If you hear wind rustle in the trees, that's music. You hear the grass rustling, that's music. Everything you hear, if you hear the wind in any kind of way, it's music. You can go on the Sahara Dessert, near Egypt and, uh, you hear the wind playing all kind of symphonies. You can look at the sands and see it also doing its dances — dancing symphonies. So, you see it's music everywhere. It's music when you look up at a cloud, because music is symmetry, too, you know. Anytime you see some symmetry, you're seeing music. Symmetry moves over to be harmony, too. Why not? That's what harmony is. Harmony is over in sounds equations things, when you're dealing with harmony. So harmony, [inaudible] harmonious surroundings, it could be symmetrical, that's music, too. If you read a poem, that's music. If you look at something rigid and it holds a place together in a certain way, it's music, if you look at it.
>
> Everything is music. If you really stand back and look at yourself, you're still songs. You've got all kinds of rhythms going on. You've got a rhythm to hold your eye in place. You've got rhythms that hold the joints of your fingers in place. Everything is a rhythm about you. That's what holds you in place.[6]

"How tall were you? How tall would you like to be?" These are the questions asked by the prosthetician as he prepares your new legs. Function can be restored (your old height) or maybe extended beyond your wildest dreams. (You've always wanted to be able to dunk a basketball.) Damned *jihadis* and their IEDs; your old legs are gone, they have been deleted. If

you are to ever stand again, walk, run, dance again, you will need the prosthetician to work carefully and expeditiously. Thankfully, things have come a long way since pirate pegs and plastic mannequin legs. They may not look at all like the flesh and bone originals, but thanks to the methodical application of a thoroughly integrative science, your replacement limbs will help you realize all your ambulatory needs and then some. Yes, if you really want to make the investment, the prosthetician can put you out on the court in an NBA jersey and with the height to fill it out. The cyborg — whether projected fully blown in fiction or incipiently in the market place — is born from the prosthetic replacement or extension of the body through microprocessors implanted within or grafted onto our organic structure.

What would a prosthetic for mental functioning look like? Is Adderall® (amphetamine and dextroamphetamine salts) prosthetic attention, Ambien® (zolpidem tartrate) prosthetic sleep? Are there chemicals (nano-prosthetics operable at the neurosynaptic level) or other "implements" that might be used to compensate for all the functionality blown out of our heads by the terrorists (i.e., the institutional actors, the bankers, cops, soldiers, teachers, and priests, responsible for immolating our innocence and mangling our futures with doctrines of fear and control)?

Both music and brain activity are phenomena constituted by and conceptualized as waves. Listening is the experience of acoustic mechanical waves through neuro-electrical waves. Awareness of sound *is* that translation and the portal to dimensions of experience that are also vibratory. Systematic manipulation of these waves, constructing, and delivering them to real humans as an agent of change is what Sun Ra called tone science. It was his method of communication and his primary means of healing.

> The sensory motor reflexes of the body are centuries ahead of minds still locked in the dead traditions. The body is a distributed brain, a big brain whose zones are nonetheless separated by centuries, inherited habits.
>
> Kodwo Eshun, *More Brilliant than the Sun*[7]

At its first level of clinical priority, tone science is a stimulant, a shout in the ear of the brain dead — *wake up*. One can't do much of anything until he or she wakes up. Sun Ra's alarm clock is effective because it can coordinate and activate an outrageous level of novelty. In a social complex that can so handily regularize away difference, extreme self-determination (madness) is the equivalent of acoustic decibels. Sun Ra's delicate dance along the border between sanity and otherwise is even louder. After awakening, the body can act, but here Sun Ra's tone science offers no template of specific possibilities (a program), only an enabling energetic vibratory field. The purpose of these waves is to make our old bodies quite malleable. Rearranging their organs and limbs into a functional and handsome new morphology is our responsibility. It will be a pre-social act of pure creation and it will be the most consequential hominid act since the erection of the elaborate megalithic ceremonial circles at Göbekli Tepe* in Turkey. These ruins, parts of which were uncovered by a Kurdish farmer in 1994, have been dated to nearly 12,000 years ago, or nearly 8 millennia older than Khufu's Great Pyramids. (Perhaps because these concentric rings of intricately carved T-shaped limestone pillars were *not* unearthed in Africa, no one seems quite ready, yet, to suggest that extraterrestrials or the lost children of Atlantis erected *them*.)

* Guh-behk-LEE TEH-peh

Göbekli Tepe qualifies as the ultimate out-of-place arti-fact (OOPArt), that is, an archeological object that when combined with the context in which it was found, appears to radically upend established scholarly orthodoxy concerning the development of humankind across the broad canvas of time and geography.

The stones found at Göbekli Tepe have a status as OOPArt that is unrivaled among megalithic monuments. Even if we accept as "compelling," research that uses evidence of erosion from rainfall to push the construction of the Great Sphinx at Giza back by thousands of years, Göbekli Tepe was dated with a high degree of reliability, and that date voids a longstand-ing chronology for the emergence of history from prehistory. The stone Ts look considerably more "finished" than the ruins at Stonehenge, which are younger, again, by thousands of years. Animals, many of which no longer exist in that part of Eurasia, are depicted in scrupulously representative relief. The problem with these structures and their construction date is that they could have only been built by people who had not developed any of the other standard rudiments of civilization. No permanent settlements. No pottery, metal or agriculture. No domestic animals. Certainly no writing or money, just the sudden compulsion to gather *en masse* at the top of what is known locally as "Potbelly Hill" and create a circular stone chapel and engage in something like "church."

Until that time, it has been believed that people everywhere on the planet lived as small bands and found their sustenance and shelter in much the same way as the animals with which they shared the end of the last ice age. They lived free and rel-atively healthy on a rich diet provided by a temperate climate and the diverse wild flora and fauna on the fertile plains left by retreating glaciers. Mother's bosom was still intact and she gifted us abundantly. We can only attempt to imagine what

their daily lives were like, but we can be fairly certain that the size and intimacy of these bands (and the relative glut of food sources) buffered and dissipated intragroup conflict and limited the scale of conflict between collectives. There were no nations, no flags, no tribes, no holy books or dirty looks — just little clusters of friends/family willing to hang out and share food and life together. It's possible that every day was predicated on a collective effort to spend as much time as was necessary, to eat enough, love enough, dance enough, sing, hum, look, laugh, explore enough, discover enough, that when our ancestors finally retired under those unobstructed starry skies (in simple dwellings that were extensions of their organic surroundings and moved where they moved, or maybe they just collapsed around their fires in the open air) assured that they had just had one great fucking day and that tomorrow had a pretty good chance of being just as good, maybe a little better. This sounds very primitive and very happy, even if it is happiness devoid of dental plans, deodorant, or public libraries.

What is a bit shocking and quite germane is the reason some scientists believe these stone crosses were erected and the unexpectedly enormous impact of their use on the unfolding of human history, culture, and spirit. Arguably, Klaus Schmidt knows more about Göbekli Tepe, than anyone alive. He has proposed that the people who built the site congregated there with paleoreligious intent. Understood in this context, the site reverses the causative relation that has long been held by archeologists to exist between settled agricultural life and the origins of religion and the other abstract symbolic systems that are the germ stock of civilized life. Schmidt argues that the stones on Potbelly Hill and the activity that they supported drew large numbers of these hunter gatherers to the area where they quickly exhausted the ability of

the surrounding terrain to support such numbers by running around in the bush and spearing rabbits. So, as this religious community became a multigenerational enterprise of carving stones and doing with them whatever they did, the indigenous grasses were selectively pushed in the direction of our first cereal crops. Similarly, they realized that if there was going to be any meat to go with the grass seed, animal husbandry would have to be developed. This occasioned the "need" for the first real blood sin against nature — stones and bramble pushed into linear filaments across our Mother's face to keep their domestic animals from going feral and, by the way, the critters on this side of the *fence* are "mine" and the critters on that side of the fence are "yours." Oh, oh. What the reader must understand, is that at this point, still many thousands of years before the first "real" civilizations emerge a bit further south in Kemet, Sumeria, and Mesopotamia, we are only a few critical, but inevitable steps away from air pollution, traffic jams, cell phones, stock exchanges, internet porn and standing armies.

Inversion: Early worship *creates* the necessity for agriculture. NOT the other way around and while the general public may find the difference obscure, it is this difference that most thoroughly explains the who and why of the subject of this *Execution*.

You see, just as the first perfidious steps of any misadventure often seem innocent enough, you must understand that Göbekli Tepe is, in fact, anything but a place of innocence. It is a scene of a most bizarre and singularly consequential crime. And the formidable circles formed by concentric rings of these imposing vertical stone bodies are in fact tools used in the commission of that colossal crime. What we see in the forensic evidence of Göbekli Tepe is proof supporting an absolutely Sun Ra-like permutation on the familiar story of

Adam and Eve and their alleged expulsion from the Garden of Eden. We don't know all the facts, but here is the scenario as we at the Outerspaceways Detective Agency believe it went down: What a life that was lived by those pre-agricultural people before they stopped to build. Naked, free, and fit — you couldn't ask for anything else, could you? The pre-Tepe people lived in alignment with Nature's God. In other words, we might speculate that there was no special word for God. No rituals, no prayers, no holy water or fetish shrines. Making babies was ritual, laughing was liturgy, simply drawing breath in this pranic-paradise was both eucharist and oblation. No religion, no clergy, just an open heart and a natural walk. This was the blissful, pre-literate and authentic relationship with the energetic presence of the cosmos. And then somebody got an idea.

What if this God-thing that was in nature, this ineluctable power that suffused and surrounded everything and everyone, could be consolidated, contained, regularized? Maybe Paradise could be just that much better, if Humanity could only get this God-thing just a little bit more *under control*. So, these Paleolithic felons devised a plan to kidnap God. To abstract It[†] from the biosphere and its living rhythms, to steal It from the open sky, to snatch It out of the sun's golden glow. With a snare of symbols, the God of Nature (which until that time could only be engaged as the mystical, non-denominational, gnostic film connecting the interiority of personal experience to the boundless cosmos) was grabbed and their quarry contained somewhere in the center of the earliest stone structure ever erected on the face of the Earth. We can't quite figure out how they got the jump on an omniscient being, but sure enough it starts right there. And for the last 12,000 years, our

† Nature's God is necessarily omni-gendered (like Obatalla, Atum, and Sun Ra).

situation has been analogous to the pitiful town folk cowering and coping, while the lineal descendents of those primeval thugs drive around with God tied up, mouth duct-taped shut, bouncing around in the trunk of their late model car, fucking shit up and in the process, intimidating and victimizing everyone bold enough to resist these cheap hoodlums.

The looming tau[†] crosses at Pot Belly Hill, with their fixed iconic representations of the sacred animals with whom their builders shared the plateau, are mirrored across 10,000 years and roughly 1,000 kilometers in three similarly-shaped structures on another hill — this one is called Golgotha and its God-punishing crosses were hewn from wood. I am suggesting that the inescapable meta-theological implication of Schmidt's audacious theory (that organized religion sparked civilization, not the other way around) is that the first thing of any complexity and difficulty that was ever built by humans might in fact have been a site of worship, but it was also surely a God-jail. It all starts there: Church as an excision out of nature, God as the absentee CEO of this (in) corporation. Society as a coordinated gang rape of Mother Earth. Man, effectively evicts *himself* from paradise when he gets it in his vane little head to socialize the God of nature, into the poly-headed serpent of religious order. As agriculture supplanted the natural economy, Schmidt notes, there was initially a reduction in health and height. Where we are right now, is the perfectly predictable result of the kidnapping of God, the regularization of mystery. The astute reader will understand that this move was also a time-jacking, that is by taking God hostage, mankind was also able to achieve a temporal deceleration that allowed civilized humans the

† Tau, the Greek letter T, was the shape of the wooden structures originally used for crucifying prisoners and is the type of cross seen in the earliest artistic depictions of the Passion Play. The more conventional Roman cross (like a lower case t) did not become a familiar icon until much later.

fatuous conceit that they might also be able "to Create". Manifest Destiny begins on Potbelly Hill.

Alter Destiny reverses a 12,000-year-old mugging.

Here comes Black Herman as Dolemite and Billy Jack. In the original German, *Hermann* means *soldier*. Michael Lackey's work on the political dimensions of black atheism includes an analysis of how writers Frantz Fanon and J. Saunders Redding justified their rejection of the God concept. Lackey seeks to address the apparent contradiction of these and other writers who "consistently portray God, a being that does not exist for them, as a hideous entity."[8] I had never considered the possibility, that under all the interwoven layers of his god talk, Sun Ra might in fact be an atheist. Outside of his references to Nature's God, which are unanimously favorable, Sun Ra has consistently painted the God of faith and worship as a less than flattering figure, a capricious subcontractor who long ago delegated away the affairs of earth to a subordinate crew of mixed competency. He has equated God with Death and otherwise found him, well, *hideous*. Is Sun Ra hinting that in addition to refusing the military and marriage, he had, like Fanon and Redding, bailed on the whole idea of theology?

Fanon saw theology as serving the colonial division of humanity into those worthy of leading and those whose distance from the God of the colonizer made them fit only to be led. Decolonization was for Fanon the creation of a new man and woman, but a creation that could only be legitimate when conceived as occurring outside of divine agency. While Redding (a professor of history who was the first black to teach in the Ivy League) saw the existence of the God concept as the very source of all racial and other forms of oppression and therefore rejected it outright. Both thinkers, according to Lackey, were subscribers to a similar brand of *liberation*

atheism§ that saw the idea of a Supreme Being invalidated by something Lackey identified as the "epistemological/ontological recursive loop of theology."⁹ That recursive loop refers to the troubling implications of the *chosen people* mentality that is built into all theologies. That is, the authentic knowledge of God that comes to the enlightened is specifically inaccessible to the umber infidel, making the former a being of spirit — who like God is entitled to autonomy of agency — and the latter a being of flesh to be lorded over (naturally) by the man of spirit. Historically, the church/mosque idea, whose embryonic architecture is seen at Potbelly Hill, is a power of magic symbols that has always grown, morphed, and moved with political power in a mutually beneficial symbiosis. "For both writers," Lackey writes, "killing God is an intellectual must in order to set into motion an entirely new system of creating humans."¹⁰

If Sun Ra, the warrior, was sent to create new humans, was he also sent to *kill* God? Does Alter Destiny (as a posthuman reification) require a deicide? Lackey argues that the oppressed learns through bitter experience that "it is by *controlling* the God concept that one can experience intellectual agency."¹¹ [italics added] Sun Ra's Myth effectively brings the God concept under control, by alleging a partnership with God where it is often not easy to tell who is working for whom, but more importantly, the distinctions Sonny draws between the Creator, Nature's God, and the God of the various human worship systems reveal an ulterior motive that takes us back to the kidnapping and confinement of God by Paleolithic ancestors who may not have been particularly sinister, just bored. (The ritual pomp that lends form to worship has always provided damned good entertainment.) Understand Sun Ra

§ This is the author's construct, not Lackey's.

and his Arkestra as the nonviolent equivalent of a Navy Seal team, tone science commandoes on a dangerous, clandestine mission, not to assassinate, but to decarcerate God. Yes, if *liberation atheism* seeks to free man from God, Sun Ra's Myth Science conceals a timely plot to free God from man.

———————————

When was Evolution only about bodily structure and systems of genes? We don't need more thumbs or less hair. Evolution will show its persistent hold on the destiny of Earthly hominids (even after we have left the earth in some substantial way) by changes to a body that is now thoroughly saturated by and co-produced with intricately ordered and circulated systems of meaning. Sun Ra, who performed the transcendence of the souls of black folk, struggled to give us the means of transposing ourselves across several octaves at least, still phenotypically human, yet able to accomplish and express behaviors consistent within this higher range of vibratory frequency.

Only love can pave the way towards the technoparadise that is only implied by our present myth order of microchip-empowered modernity.

Sun Ra was first to use electronic instruments in jazz or what would be considered popular music. Before his experiments with an array of early keyboards, electrons might have been used to amplify music, but had not yet been widely employed to form the expressive tissues of music itself. Sun Ra challenged the Christian church's obliviousness to the powerful value of the new machines and new media that were growing with him out of the period of reconstruction and into the space age. But, I don't think it's fair to call Sun Ra a technologist, and the frequently-applied designation of *Afro-Futurist* has never proven to this author to be a

particularly valuable construct in approaching Sun Ra. "It is science-fact that Sun-Ra is interested in, not science-fiction," writes Baraka in *Black Music*. "It is evolution itself, and its fruits. God as evolution. The flow of is."[12] If Sun Ra was a man, he was a natural man (in the same way that Aretha Franklin sung about feeling like a "Natural Woman"[13]). His oddity as a being of flesh, blood, and biography is the signature of his emancipation. Sun Ra departed in the middle of the Digital Revolution, so there are many things about his response to the way that the Internet and related tools have rearranged our lives about which we can only speculate. The image of Sun Ra endlessly peering into his smart phone, however, while checking his Facebook status is as bizarre and unsightly as the idea of Colin Powell breakdancing.

OUTERSPACE AND SPACEMEN

Well in the first place, Planet Earth is hanging out here in outer space. It's just sitting out here doing nothing. A real liability if you take an inventory of what's been happening here all along. So when I say outer space, it's a space that's further out than the immediate surrounding territory. They already out in outer space furthermore this planet is a spaceship, too.

Sun Ra[1]

I felt the DMT release my soul's energy and push it through the DNA. It's what happened when I lost my body. There were spirals that reminded me of things I've seen at Chaco Canyon. Maybe that was DNA. Maybe the ancients knew that. The DNA is backed into the universe like space travel. One needs to travel without the body. It's ridiculous to think of space travel in little ships.

Sara, subject in studies of the hallucinogen
dimethyl tryptamine.[2]

"Sun-Ra is spiritually oriented. He understands 'the future' as an ever widening comprehension of what space is," declared Amiri Baraka.[3] Space is fundamental and its reimagining away from a cold energetic dead zone to a timeless holographic memory cache of cosmic possibility is the trajectory of a new science that is straining to reconcile immaterial consciousness with the physical laws used to predict the behavior of what we commonly hold to be the firmest stuff of reality. But

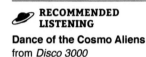

RECOMMENDED LISTENING

Dance of the Cosmo Aliens
from *Disco 3000*

there has been something generative about the gaze since Heisenberg, and Sonny's work parallels that of the quantum revolutionaries in reminding us that *looking* in the box to assess the condition of Schrödinger's cat is insufficient, we must *listen* to know if it is purring, as well.

> I went in outer space. So, I know its possible, but not in a spaceship, in an energy corridor. You don't need a spaceship if you've got an energy corridor. I call it transmoleculariza-tion. It changes the substances of you and you become like light and you go up with the speed of light.[4]

"Hello, my name is Sun Ra, and furthermore I'm an ambassador sent from the Creator of the Cosmos. I was taken to Saturn by aliens and intend to change the entire course of earth history with my music." With the very first handshake and exchange of business cards, Sun Ra confirms that, if nothing else, his sense of social identity is jarringly other. "Some sense a mischievous, deceptive, and coy intelligence lurking behind the stage of the UFO's theater of the absurd," writes Erik Davis, "an intelligence whose message seems almost intentionally tangled in a briar patch of rumor and report, pop archetype and con job, evidence and hoax."[5] As you come to grips with the fact that his character is his character, that is, that there is nothing behind his mask but more

illusion, we start to edge back in the direction of diagnostic questions. Mad, wouldn't you have to call someone mad who would submerge their entire life into nonstop delusion and invention? Sun Ra baptizes us in a sea of doubt, an ocean of skepticism, not faith. Is this guy for real? What does he *really* mean. Is seeing believing, when you can't really believe what you see?

I stood with Pedro Bell in the basement of his mother's South Side Chicago home, a short ride on the L from the apartment where Ra had first rehearsed the Arkestra as a trio. Surrounded by the large originals of the felt-tip marker gatefold album covers that Bell is famous for (visual art that served as propulsion units for another chapter in the Afrodelic space program) he told the story of his first chance encounter with Sun Ra. "Sonny had a beetle, a live beetle, like a scarab, attached to a long chain that was pinned to his clothes," recalled Bell, still incredulous across the years. "He wasn't paying no attention to it. It was just crawling around. That sort of tripped me out. I mean that really tripped me out."[6]

Anti-faith. Disbelief. Doubt. Sun Ra's power over people and the time around them had something to do with his ability to communicate so much, even after he had given you every reason to dismiss him as a nut job. He gives himself over to us as a thing of doubt, not faith. He reminds us that thousands of years ago and even today, faith and skepticism, belief and disbelief are always in rapid oscillation in the mythic gesture (Ras-I's beckoning finger from the wings of the stage), the perpetually perplexing call of the thing that is too real to be true, and is therefore in its jarring salience, superior to mere truth in its consequences, its suggested range of responses. The motion of Myth keeps Bigfoot crashing through the woods without leaving evidence of a body and UFOs forever aloft and aloof. To touch him is to doubt him, but it is also to touch him.

Sun Ra is the antichrist, and the way to be saved by him is to doubt him *and* to touch him.

> The one incident that really made me think seriously about Sun Ra's outer space talk was when we rehearsed, there was a contraption. I'll call it a contraption, that Sun Ra himself created that was in the middle of the room in which we rehearsed. We all rehearsed with this thing. [Contraption?] Yeah, it was made of copper and these wires and stuff, looked weird and it always evolved [sic]. As we were playing, this was spinning and no one expressed anything about it, but it was there. It evolved as we were performing. Yeah, as the band was playing. It just [r]evolve, [r]evolve, [r]evolve. One day it just stopped. He said, "there's a spaceship outside; go outside and check it out." I said, "oh man," you know, "spaceship, yeah, yeah — right, right, right." We went outside and looked up and man, there was this thing up in the sky, hovering over his building, pulsating, white light, just pulsating. Wow, this is what? It just stood there and it pulsated and then it took off. Those who had been with Sun Ra for a long time were not surprised at it, but those of us who were novices in the band, like myself, we just couldn't believe this. We went back inside again and it [Sonny's contraption] started revolving again. From then on, I was a believer. I believe now; I saw it with my own eyes.

> Brother Ah

We got outside and we looked up and more toward the east, looking over towards Brooklyn, looking down third street looking east and it looked like it was hovering over the East River....and then when it lifted up, it went straight up and stopped and then went sideways. I mean it got so that nobody could say that satellites could do that, helicopters couldn't do that, 'cause we didn't hear no sound.

The same thing happened when we were on a train going to Seattle, Washington on the Northern Pacific. We had done a jazz showcase in Chicago and we went on down to the train station the morning after the gig, we got on this Northern Pacific and it's got these observation cars and we were on the observation car 99% of the time, because the night sky

174

is amazing once you leave Chicago. It looked like you could spit on your finger, reach out and touch a star and put it out. We were all sitting in the observation car one evening and there were a lot of other people in the same car, but mostly it was the band members. And everybody in the car's looking at us, because we are strangers in a strange land. They can't figure out where we're coming from or where we're going, or why. I think we were the only blacks on the whole train. And the people asked, "well, what are you looking for", because we're all looking up through this dome on the top of the train and Sun Ra says, "we're looking for UFOs" and this guy who was there, he just busted out laughing. Suddenly, John said, "look Sonny, there's one. There's one". This particular point of light is moving with the train. And then another one showed up, and then three or four more. And then they started some gymnastic shit. They made some motions down by the horizon and then came at the train. Most of the folks jumped up and were stumbling down the stairs; they wanted to get up out of that observation car. It looked like they were attacking the train. They were so big that they lit up the whole observation thing and then it looked like they must have went up straight up over the train and went back out over the flatlands again. This went on every bit of, well, it was almost morning time before they disappeared.

Jac Jacson

SLEEPING BEAUTY/FALSE PROFIT

The light from which all life comes exists in three aspects, namely the aspect which manifests as intelligence, the light of the abstract and the light of the sun.

Hazra Inayat Khan, *Mysticism of Sound* [1]

The imaginings of quasi-neo-gnostic New Age spirituality, that by putting oneself into vibrational harmony with the harmony of the universe, new spiritual (and materialist) vistas open up, is a thin veneer disguising the dominant ultra-cynical stance of dominant late capitalist post-modernity. Becoming cosmic is not some vaguely spiritual mystical thing. It is a harnessing of material forces.

Peter Price, *Resonance: Philosophy for Sonic Art* [2]

I'm gonna get even with them for everything they ever said to me, everything they ever did. I'm gonna have me a nice time and the fire is busy, just get my brothers to get the fire ready, Because I know they gonna fall, just as sure as I'm sitting here, black folks gonna fall right over into my hands. I'm telling you what's going to happen fellas. They just as

sure to fall over into my hands as I'm sitting here and I am sitting here. They gonna fall into my hands totally. And it'll be my word as to whether they live or die. And I'm telling you, I will have powers ain't nobody ain't never had. Not even the devil has had the powers I got. And the Christ ain't got the powers I got.

Sun Ra to band members during rehearsal[3]

Betty Carter smelled it on him. My methodology for dealing with the voluminous, idiosyncratic (and at least occasionally) self-contradictory, literal Ra, the Sun Ra, who for all the cosmos can sometimes only be read as slinging it wide and deep, is perhaps no methodology at all, but a selective redaction, an edit, whose cut is guided by my particular ideological biases and admitted adoration of the man. Having become acquainted with the visible tip and submerged bulk of Sun Ra's early writings and teachings, for example, I find it relatively costless

> **RECOMMENDED LISTENING**
> Love In Outer Space from *Somewhere Else*

to de-emphasize the amount of time he invested in his own unique dissection of the problem of race (in ancient and modern times). I can, in a sense, allow his claim that most African Americans "are actually ancient Egyptians"[4] or that whites represent "a different order of being,"[5] or any of a number of other dubious, indelicate pronouncements to be heard as a kind of rhetorical noise competing with the signal (Sun Ra's broader statements about time and human development within time), but that's not to say that you must (or should). His binary, broad stroke proclamations on the fated dynamic of *the white man* versus *the black man* are not, for this author, disqualifications of either Sun Ra's integrity or of his value as postcultural catalyst. What, however, can the reader be offered in the way of a sieve that will allow you to walk away from this interaction with Sun Ra (and this *Execution*) without

feeling that you have been forced to swallow any reactionary fat with what I have suggested is a more nourishing and considerably "leaner" meal?

First, it helps to paint Sun Ra into his context, aligning him with some of the great race men and women of his generation. Black leaders like Booker T. Washington, Nannie Helen Burroughs, and, of course, Elijah Muhammad and Noble Drew Ali, made it a point to underscore black responsibility to and for self in recovering from the state of exception known as slavery/reconstruction. Washington provisionally accepted segregation and white domination as temporary conditions under which African Americans could develop their own societal infrastructure and pursue the knowledge and skills necessary for participation in greater American society. Burroughs fought the double tax of race and sex. She worked within the National Baptist Women's Convention to improve the leadership opportunities for women within the church and (like Booker Washington) bring practical education in the industrial and homemaking arts to young black women. Her motto, *We Specialize in the Wholly Impossible*, was a sentiment that Sun Ra might have tried to fit onto the vanity plates of his starship. Of course, Muhammad and Ali (both shared the streets of black Chicago with Sonny) had each spun arcane counter-theologies that deified the Asiatic Black and explained their people's suffering as a rite of passage leading to elevation and redemption. With the exception, perhaps, of Washington, none of these voices spent much time directing arguments towards white society and were therefore unencumbered by the discursive ground rules and sensibilities that went along with participating in a broader conversation.

Along with Elijah Muhammad (The Messenger) and (Prophet) Noble Drew Ali, Sun Ra would have been familiar with the charismatic black Christian evangelists Father Divine

Jac Jacson

and Daddy Grace with whom his life also overlapped. All built economic empires around cults of faith and personality that were legitimized by their claims of a unique connection to (and at times, identity with) Almighty God.

James "Jac" Jacson was my tutor. The man who built and stood tall behind the Ancient Infinity Lightning Wood Drum, playing it with a heavy pair of curved sticks (that he also made) was my friend. He was easy to approach, probably because under his sometimes gruff exterior, he was actually reaching out, seeing himself as something of an emissary for Sun Ra's ideas and work. At the time he met Sun Ra in the early '60s, he was working with his hands, restoring antiques and making jewelry. Jacson made the sign for the Pharoah's Den corner store that was owned and operated by Danny Thompson.* Like Sun Ra, Jacson was an articulate student of life and books, but Jacson, having heard Sonny's parables in so many different forms, could repack Sun Ra's cosmo-speak in a way that was intelligible and powerful. While I have heard some minor grumbling about the pretensions involved in Jac assuming this role, at the particular time of my intersection with the Arkestra, Jac seemed like the best positioned of Sonny's three top men (with Marshall Allen and John Gilmore) to serve as something of a translator.

Sun Ra asked Jac to remove the "k" from his name because of the way Sonny read the numerology of the original spelling. Jacson helped me navigate through the tangled undergrowth of Ra's copious body of lessons and wring from the cosmic light show, enough sense to make me feel like I wasn't wasting my time. "Sun Ra knocked me on my ass," he told me. "I always thought that Sun Ra was trying to show me that I wasn't as stupid as I thought I was. We used to talk to

* Thompson and the sign can be seen in the film *Joyful Noise* (Robert Mugge, 1980).

one another for hours on end using nothing but parables to explain circumstances and situations."[6] Jacson stayed at my house twice, including the time he introduced a pair of Sun Ra films at the Library of Congress, something he was very proud of.

Vidya versus *avidya* (knowledge over its pretensions) according to Jac Jacson: "He put me in a position where I had to make a decision — I had to chose between what I *thought* was real and what *might* be real."

Sun Ra's devotion to Myth as construct and substance, as dwelling and vehicle, reveals his suspicion of the Truth as ultimate epistemological ground of reality. He often challenged his audiences to choose between the "bad" truth they had and the "good" fiction he offered. "Take a gamble," he said. "I am the magic lie."[7] The Magic Lie — a string of language having power precisely because it evades the narrow straitjacket of veracity, a human musician who is simultaneously much more and less than he claims to be. Yes, I think that Sun Ra made it all up, but so did Einstein. That is, Sun Ra created the perfect (most profitable) prophet for modern times, a *virtual* prophet, spinning a *virtual* revelation in search of a *virtual* promised land (Alter Destiny). Not a falsehood in the conventional sense, but a model, a (co)creation between the cosmos and a star-crossed black boy born into one of the darkest zones of Jim Crow oppression and global conflagration. A thing built of humor and outrage to perform perfectly the messianic function of Revelation (always a negation) while simultaneously disarming and deactivating the moldy meme of Jeudo-Christian prophetic judgment that his life was a freestyle, unending vamp upon.

> Well, actually what I represent is totally impossible. It affects every nation on the planet — on this planet. It affects government, it affects schools, it affects churches; the whole thing

has got to be turned to another way of thought. A blueprint
for another kind of world.[8]

Sun Ra's change was spoken in unequivocal, but global, generalities. His Magic Lie is a call to change that is as sweeping as it is less than specific. Sun Ra never named the mysterious force that he claimed sent him. His only commandment was Change. And while he was quick to point out our excesses and deficiencies, he really didn't tell us what to do to once we got there or how to enact the transition. Vaguely, but with a strong arm, he drags our past into our future as he affirms that the future of possibility must ultimately be consistent with ancient Egyptian ideals of cosmic balance (Ma'at), just as surely as his music requires that his advanced (if idiosyncratic) approach to electronic synthesis sits in the lap of the most doggerel expressions of big band primitivism. Time rebels resist not the authority of the now or the past, but rather the assumed linearity and directionality of temporal progression.

"Sun Ra had a spirit on him," Danny Thompson tells us, "and he used to say that he was an angel. He was an angel."[9] Sun Ra might have been an angel or perhaps a representative of the hybrid of divinity and humanity that the ancient Egyptians held their Ra-kings to be. He saw leadership, even when it manifested under conditions tainted by injustice, as having a legitimacy and practical necessity that were undermined by the rhetoric of equality. On the bandstand, he was an unremitting authoritarian. He was not, however, a fascist.

> As there is a land of joy, so also there is a world where diversity is not, where there is unity alone. It is higher than the land of joy, for joy is the land of universal ideas, and unity is behind ideas.
>
> Geoffrey Hodson, *The Brotherhood of Angels and Men* [10]

Sun Ra was silly, but he was silly standing in the same clothes as our most serious professions: teachers, preachers, scientists, and other leaders. He knew exactly what he was doing, except for the parts that he didn't.

Sun Ra © Lee Santa

SOMEWHERE THERE

Behold this mystery: Iniquity. The word was executed by the law called sin. Execute not only means to kill. It means to put into action — word of strange duplicity. It is written in an ancient, so-called fable: The troubles were hidden in a forbidden box, Pandora's nemesis.

Sun Ra[1]

Some artists try to cross the borders of what can be thought and of what is possible so that we may wake up, that we can open ourselves to another world.

Karlheinz Stockhausen[2]

Utter chaos, then ultra chaos. The Kemetic system, the procession of Ra-Kings on Earth, monarchs whose regency made them (as dead people) central actors in complex funerary rites conceived less as worship than as the technological achievement of the impossible — deathlessness. The point of this elaborate pursuit of immortality as conferred

on the innocent by Lord Osiris acting on the basis of Ma'at was intended to maintain continuity of order (cosmic and social) which these folks achieved to a degree and for a duration that no other (known) civilization ever had or has since. Is it possible that the arrow points towards pointlessness? That is, that they're on the right road, but going in the wrong direction? The Solar Myth Approach as modeled, discussed, propagated (i.e., preached) and activated by the sound artist/jazzman known as Sun Ra is a mode of being most consistent with a planetary realization of Alter

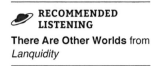

RECOMMENDED LISTENING

There Are Other Worlds from *Lanquidity*

Destiny. It is a self-conscious, disciplined, intellectual and soulful embrace of the necessity of discontinuity, and yet, it is crucial to note it is not chaos, and it is certainly not anarchy, but it is a disturbance, a discontinuity on the order of what Nassim Nicholas Taleb termed a *black swan* event[3] — a rare, but highly consequential, occurrence beyond the realm of normal expectations.

Sun Ra's life, his myth-science, his dream media, encompassed and was greater than his music, his writing, his teaching, his circus; it was shared with us as a seed-crystal for a (re)creation of order, another large play of human intelligence, creativity, and love worked out through a reshuffling, refreshing, and reimagining of the possibilities inherent in human bodies in time and a place (space) to act. We have excelled at the building, rearrangement and destruction (but not disposal) of things, and the vanguard medium of Myth Science is sound. This sound is a real, vibrational, *psychocymatic* force, the individual and collective result of which may well be such radical departures in human economy, politics, identity, and communication that if we envision such large changes in what we do (agenda) as being acted out by the current version of what we are, we'll retard our transformation.

So, we see in Alter Destiny a time frame within which our newly birthed ontologies, our Alter Us (*homo saltus?*) will have space to do new stuff. Sun Ra exposes the present stage of hominid evolution as just another beta version, in need of supplanting by software (foundational cultural archetypes) more suited to the tasks at hand. As we occupy our Alter Destiny, we save the world (Mother Earth) by allowing our current form to be crossed out, deprecated. No one wants the old model anymore; we can't even respect it ourselves. We stand where our ancestors stood after outperforming the necessity of hunter-gatherer archetypes as the logic/Logos underpinning what to do with what we are. We now, nomadic and naked once again, must come up with something as profoundly untested as the ideas that trapped God at Göbekli Tepe, settled city-states in Mesopotamia, and raised pyramids on the flood plains of the Nile. We have bled history of its reason and now stand squarely in the realm of the myth, which is, of course, both a garden of fecund abundance and a starkly arid desert. Our problems are beyond the reach of mere restructurings of policy, or cosmetic enhancements to what we are or imagine ourselves to be. What must be reconstructed is before ideology or policy. Myth Science is not directly concerned with the belief systems that order personal psychology and social space, but rather with "what moves people without their knowing quite why or how, with what makes the real real and the normal normal".[4] The opportunity enveloped in an existential crisis is no less than the necessity of total (re)invention of the real, an exhaustive (re)interpretation of the norm. This is a difficult task, as any addict could tell you. Yet, we must ponder the logistics of impossibility as though our lives (and the lives of our children and the life that surrounds them) depended on such an arcane task, because in the end, they do.

Millions and millions of people are part of what I'm doing.
Although in a sense they don't realize it, but they are.

Sun Ra[5]

With a blaring siren called jazz, Sun Ra summoned vibra-
tions that rattle worlds and loosen the postural habits
embedded in their ecologies with cymatic resonances that
are melting the mortar of consensual reality. It is this melted
goo (Nu?) that is (alter)destined to recrystallize into fresh con-
figurations of motion and position. For this recrystallization
to actually occur at the level of our core being and not mere
ideological froth, we must surrender any presumptions of
being able *to control* this process. We cannot. Such pretenses
of control would make us (again) despotic Dr. Frankensteins.
All we can offer to this final effort to resuscitate the great
project that we carried with us out of Africa and into the stars
is a form of dilation. Our primary evolutionary responsibility
in the precarious gap between perma-war and biosystemic
Death is a kind of gentle releasing of all conditioned loyalty to
the project once-called *Civilization*. Whatever that means (the
C-word), it will no longer and can never constitute or justify
our work. We will let it go, allow it to drop out of us, back into
the void from whence all ideas emerge. And if we can accept
the challenge of our small role in this becoming, this dilation,
we will be like Sun Ra — time rebel and angelic warrior against
Death, midwife to the chapter that follows this history. Now
would be a good time to turn that page. Nullification? Sun Ra
is not a nihilist, but rather an abolitionist. Clear away that
under which lies ossified and atrophied a rare and timeless
truth, discover among the weeds of pre-cultural natural-
ity the cure to our disease. Sun Ra as abolitionist physician.
Sustainability is cut off at its root: how much of this activity
must we really sustain? Social order is maintained as much

by entrainment as coercion. It is hard to predict what is left standing in the wake of Sun Ra's spaceship.

> "He was speaking to me. I put on the first tape and the first word he said was *Tod**. That's my name."
>
> Todd Carter, Engineer at ESS tasked with digitizing the Sun Ra tape archive.[6]

The cosmic cosmo tomorrow. Is Sonny the antichrist? Religion is an easily sprung trap. Whatever good has come of doctrinal faith and its stranglehold on the god concept is outweighed by its sustained debilitation of both psychology and politics. Yeshua Ben Yosef (historical Jesus), fiery-tongued irritant to the political and religious authority under which he was born, can (from outside religion) be fairly easily separated and sanitized from Christ the Redeemer, purported sponsor of a continuing European project of global domination, cultural eradication, and ecological subjugation. That "Christ" is not the revolutionary anti-establishment spiritualist, but his bloodied ghost grafted onto works of war and usury that the Nazarene never would have lent his name to. As such, it sounds like an anti-Christ, a reversal or undoing of the hell that has been falsely wrought in the name of a beautiful starchild[7] martyred for his nonviolent commitment to justice, might in fact be in order. Sun medicine may be just the right antidote for Son poisoning!

> Once they turn around and see that that's really it and they look, and see an exit, they're all going to run to the exit, because they have to. It's not because they want to.
>
> Sun Ra[8]

I've always thought that Sun Ra with all his bombast, ideological fluidity, and human foibles was never quite suited to

* *Tod* is Death in German.

be the cultic object of worship that so many latter-day, self-made prophets have become or sought to be. While I wish Marvin X all the success in the world, I do not currently plan on joining or forming a Sun Ra-themed church. If Sonny ran a cult of personality, it certainly didn't make him rich as it arguably did Daddy Grace, Father Divine and Malachi Z. York, the founder of the government-targeted Nuwaubian movement, which also drew inspiration from ancient Egypt and UFOs. The author has labored to be fully candid in disclosing his own devotion and loyalty to Sun Ra, while struggling to build something like a "rational" case for bringing Sonny's Myth Science fully into play as we quickly try to figure out how to respond to what money and war have made of our world and our selves. Sun Ra's virus is delivered into the matrix as an enabling stimulus, not another sacred text to be recited from memory, nor another crease-worn map receding from its territory. His functional beauty lies in the fact that his continued action turns on and accelerates activity that is already virtually implicated, if not vigorously underway. What matters is building enough momentum to break cleanly, but please abandon any hope of avoiding the break. Sun Ra as a person, as another celebrity to honor with t-shirts and posters, as another cultural hero of the African Diaspora, Sonny as a gentle, rotund black man with a disarming smile and razor sharp wit, that Sun Ra (except, perhaps, to those who knew him) doesn't really matter at all.

> You should grab hold of something that makes absolutely no sense to you and recognize that it's a treasure, and you can't sell a treasure nor can you trade it. You can only give it away, and it takes a lot of heart and a lot of spirit to give away something that you really want to keep.
>
> James Jac Jacson[9]

Shortly before his earthly form slipped below the horizon of entropy, I saw Sun Ra dance with June Tyson at a place called Freedom Plaza, their presences wondrously and innocently entwined, the perfect yin and yang of a pure flame whose warmth I wanted you to feel on your holy face. Were you there? Did you not see? Was he not Osiris, Lord of Everlastingness? Was she not Isis, the Sparer? Did you see their garments blowing in a solar wind, regal and splendid like a Sun Dance tree in dawn's first light? There was a power there and I witnessed it. I felt that you needed to witness it, too.

Aho mitakuye oyasin
Em hotep nefer weret
Thomas Taylor Stanley, 2014

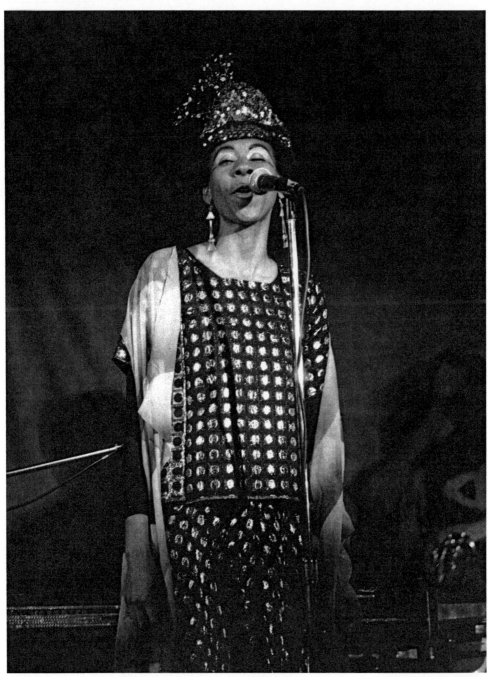

June Tyson

CODA ONE/SOLVING FOR X

C edar announced on the way to basketball practice that he could do algebra. I gave him the simplest addition problem, something that I thought he could work out in his head or on his fingers. "It's all about solving for X," he declared. And then he announced from his booster seat that he first had "to get everything on one side, except the X," using something called the *inverse property*, and then the answer could be counted on to expose itself quite naturally as a result of this reversal of function.

Sun Ra has been interpreted in this *Execution*, primarily through a series of inversions. It makes sense that a musician who had made so much out of the spirit-appropriating potency of polarized current would be able to travel so far via this simple idea of reversal and

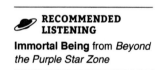

RECOMMENDED LISTENING

Immortal Being from *Beyond the Purple Star Zone*

inversion. Pull it out; turn it around; stick it back in. Does it work now? *Take words and return,* he said. I've given you some words; to where would you go back? Kemet, Pot Belly Hill,

Olduvai Gorge, the antebellum South? Like an egg, the facticity of civilization only yields its most nourishing fruit after it has been thoroughly broken. Our starting point for a second order of procreative activity is in the ruins of Babylon time.

And who turns off the clock?

The Kemites left us many stone tributes to their patient and industrious gods. After Atum – formless creative principle – their immediate god was Ra. The same star has been continuously shining over all of earth's history and every nanosecond of symbolically ordered human activity. The entirety of religion, politics, arts, sciences, the vacillations of war and peace, every lovers' quarrel and playground fight, all have been illuminated, energized and warmed by the celestial force that the Egyptians had the good sense to recognize as a god and that the Lakota called *Wi* and made the focal point of their most sacred ceremonial dance. Mathematically perfect, to these ancient stargazers, the stellar mass must have appeared as a constant disc of inerrant radial symmetry. Its circumference is the physical manifestation of the un-nicked completeness that the Greeks would later codify as a multiple of π for every unit of diameter.

π is a mystery. It is the most widely recognized mathematical constant and this essence of roundness, is also a numerical expression of reified infinity that is both transcendental and irrational. An endless stream of non-repeating digits each following the other in a way that is purely random, π is suspected by many mathematicians to contain someplace within its never-ending numerical music, every conceivable series of digits, and as such holds within its digital bosom any number that you could possibly think of. Once converted to binary code, even the unique genetic sequence from which your body was made could be found as a discrete region along π's infinite length. Circularity conveys this infinite plenum at whatever

scale it is found. The pupil of your eye, the compass of the solar disc – the same inexhaustible truth is always there. This most godly number defines the relationship of going around to cutting through any circle. It will never change and will never be known in the sense of a closed datum. After years of applying increasingly powerful computers to solve π to the trillions of decimal places, it is still the case that the sequence can be extended by a digit and that there is no systematic way to relate that digit to the one that precedes it in the sequence. Each successive digit represents a pure novelty.

For the Kemites the days were marked by *Khepera*, the dung beetle who rolls the great orb of Ra from East to West, dawn to dusk, and has done so (and will do so) forever. The Egyptians were good architects, but they were, with their baroque assemblage of anthropomorphic deities of mixed human and animal body parts, at root, primitive animists, theistic novices when compared to the religious movements that would come (out of Egypt apparently) much later in the form of the peoples of the Ibrahimic tradition – Muslims, Christians, and Jews who all had a much more mature, sophisticated, intellectually-nuanced God. An executive god, a conquering, vengeful god. Did they say he was a *jealous* God? The Egyptians saw Ra, their warm and glowing sky deity, disappearing behind the horizon every evening, in effect dying, only to be reborn with unfailing fidelity in the fiery spectacle of dawn's renewal. They trusted this cycle, this ordered oscillation between night and day as the foundational evidence of their god's great and eternal love. Yes, Sonny's antique blacks lacked the monotheistic finesse of the peoples of the book, but if they had had a watch, those Ancient Africans could have told you precisely when their god would return and done so from anywhere on the globe with numerical precision.

Everything that happens to you or within you, as well as everything that you do is driven by energy that has its source

in nuclear reactions occurring constantly within the central core of the Sun. There is an actual, materialist sense in which Ra functions as prime mover on this planet, at least at the scale of (almost all) biologically anchored activity. At 93 million miles in that direction (author is pointing), our local star is far enough away that a particle of light (photon) that leaves its surface traveling as fast as anything is allowed to travel in Einstein's universe, will take a full eight minutes to get here. This shower of cosmic energy is a generous gift of modulation by orbital station. Our immediate planetary neighbors are either too blazing hot or frigidly cold to be hospitable sites for life and its elaboration as either conscious history, or a history of consciousness. We sit in the galactic sweet spot, soaking up just enough of Ra's love to make it all blossom and move.

The sun is a constant, but as governed by Ma'at, its ancient stability rests upon a tautly coiled dynamic flux. The convection currents of plasma churned up by the explosive fusion reactions within the solar core set up a cacophonous drone which reverberates through a gaseous bulk that is held together only by the exactly opposing inward gravitational pull associated with all that mass. This movement, this humming dance of hydrogen, helium, and light is rotating with our star, but in an irregular and regionally improvisatory manner. This creates a friction within the solar soup, a friction that generates magnetism, a key component in the medley of forces that create solar weather and its effect on everyone in the neighborhood, including (so many millions and millions of miles away) the people of planet earth.

Thanks to public subsidies for science, we have at our disposal crisp, hi-definition images of the turbulent surface of our celestial source point. NASA even has a website where the public can see images of the sun's variable face in real time. At these magnifications, the idea of a smooth, geometrically

perfect disc gives way to a motley chromospheric patchwork, an angry, undulating sea of fire. And because image is ubiquitous, most of us are familiar with the dark nodules (sunspots) that intermittently dot the solar surface. We have probably also seen pictures of the ribbon-like arcs of plasma belched out from the solar surface. These flares are a much more transient event than sunspots, but are often associated with the magnetically induced cool blemishes that are always a blotchy feature somewhere on the sun's shimmering integument. Looking like glowing strands of lava as they follow the field lines of magnetic perturbations that are to solar weather what wind and rain are to a hurricane, these ribbons form parabolic bulges that spit bits of solar mass into the cosmic void. Usually these eruptions arc and flare off the surface at lazy velocities that allow most of the material thrown outward to be sucked back into the body of the sun. These pedestrian solar flares happen all the time and pose no real danger for the solar system, but occasionally the magnetic field lines cross – here we have our X, again – and as these bands of plasma-bound magnetism touch each other, there is an explosive ejection of cosmic particles and sun stuff. Should these blast out that way, they'll carry with them a charged cloud of gamma- and x-rays that pose no harm to empty space and the presumably unoccupied planets of our celestial hood, but every so often one of these coronal mass ejections (CME) is aimed right towards us.

The earth has its own insulating magnetic fields that serve to repel much of the cosmic energy that might otherwise be damaging to life on our planet, and the smallest solar ejections (C-class) are only detectable on earth with sophisticated instrumentation. M-class flares are the next level up and can enhance the appearance of the aurora borealis and regionally disrupt radio transmissions and power supplies, especially around the poles. The great white sharks of solar weather are

the so-called X-class CMEs, monstrous eruptions of radiation that can send billions of tons of solar material our way in a matter of hours. If the shock wave is strong enough, the planet's energy sheathing is overwhelmed and a geomagnetic storm is triggered as powerful electrical currents ripple beneath our very feet. In severe cases, as in the Quebec blackouts of 1989 or the telegraph-melting event of 1859 (believed to be the most powerful x-class solar storm in recorded history), these magnetic storms can dramatically interfere in human affairs. Of course, without our dependence on electrically-empowered networks whose earth-bound nodes are augmented by hundreds of orbiting (and CME-vulnerable) satellites, such solar storms would be barely noticeable facts of astrophysics, but a properly placed X-storm would be a civilization-killer should its effects be concentrated in the nations like the US that have been slow to harden their infrastructure against CME-induced surges.

> It's the end of an age really. Whenever it's the end of an age, wherein the Creator has to make it explicit, then when the age changes, all the laws change.
>
> Sun Ra

The coastline of South Carolina is feathered with rivers and creeks that in earlier times formed the waterways along which goods, people, raw materials, and war moved up and down the coast and penetrated its interior. The Rutledge family plantation with all its happy Negroes sat on one of these threads of life and commerce. Down the coast, on the other side of Charleston and about as far away, the black mouth of the Combahee River yawns into the Atlantic. This particular estuary was the site of one of the most compelling stories of the war to free the slaves. After Lincoln had issued his Proclamation, the South began suffering from an internal

war of attrition as first dozens, then scores, and finally hundreds of captive blacks slipped off their plantations and sought refuge behind Union lines. Seeking to accelerate this exodus and its disruptive effects, late in the spring of 1863, Lincoln's Army enlisted the help of the world's most notorious black liberator on a daring mission intended solely to free slaves. Harriet Tubman would guide a pair of ferryboats that had been mounted with guns up the Combahee, freeing from their suffering as many black people as possible along its meandering length. As Union soldiers held off any armed resistance, Tubman (aka Black Moses) stood on deck and she sang. In her full, once-slave voice she called her people past the peril of overseers' whips and sporadic rifle volleys. Her sun song pulled them out past whatever trepidation had fixed their feet in bondage. And they came to these boats, these arks of liberation, in droves, fleeing joyfully, without regret, or a single look back at the meek lives that they had left behind. Some came holding the tools of their labor, the food they had been cooking for master, the hoes they had been using to till his fields. Each time the huge paddleboats came within sight of a forced labor camp (plantation) and the slaves heard her crude song – an uninspired ditty promising the generosity of Uncle Sam – the Africans cried glory and bum rushed the boats, crowding upon their broad wooden decks by the hundreds. Harriet Tubman was not bullshitting. She carried a pistol in the hem of her dress and was fully prepared to shoot anyone that lost his or her nerve and looked back towards the white man's hell.

$$BCE + AD + CME = AD$$

Cry glory.

NOTES BY SECTION

AUTHORITY

[1] Zappa, Frank, "Cosmik Debris," *Apostrophe'/Overnite Sensation*. Rykodisc, 1973.
[2] Excerpt from *Space Is the Place: The Lives and Times of Sun Ra* by John F. Szwed, copyright © 1997 John F. Szwed. Used by permission of Pantheon Books, an imprint of the Knopf Doubleday Publishing Group, a division of Random House LLC. All rights reserved, page 109.
[3] Taylor, Art. *Notes and Tones: Musician-to-Musician Interviews*. Expanded ed., 1st Da Capo Press ed. New York: Da Capo Press, 1993, page 279.
[4] Goffman, Ken. *Counterculture through the Ages: From Abraham to Acid House*. 1st ed. New York: Villard, 2004, page 37.

EVOLUTION

[1] Schapp, Phil, Interview on WKCR, April 19, 1987.
[2] Coney, John. *Space Is the Place* [VHS]. Rhapsody Films, 1974.
[3] Danner, Mark. "After September 11: Our State of Exception." The New York Review of Books, October 13, 2011. <http://www.nybooks.com/articles/archives/2011/oct/13/after-september-11-our-state-exception/>
[4] Gardner, Kay. *Sounding the Inner Landscape: Music as Medicine*. Rockport, Mass.: Element, 1997.
[5] Sun Ra. Interview with author, October 1990.
[6] Crump, Thomas. *The Anthropology of Numbers*. Cambridge Studies in Social Anthropology 70. Cambridge; New York: Cambridge University Press, 1990, page 4.
[7] Sun Ra, and John Corbett. *The Wisdom of Sun-Ra: Sun Ra's Polemical Broadsheets and Streetcorner Leaflets*. Chicago, Il.: WhiteWalls, 2006.
[8] Sun Ra, and Hartmut Geerken. *The Immeasurable Equation: The Collected Poetry and Prose*. Wartaweil: Waitawhile, 2005.
[9] Sun Ra, Adam Abraham, James L Wolfe, and Harmut Geerken. *Sun Ra Collected Works, Vol. 1*. Chandler, Ariz.: Phaelos Books, 2005., p. xxxix
[10] Sinclair, John. "Sun Ra." Blastitude,#13, August 2002. http://www.blastitude.com/13/ETERNITY/sun_ra2.htm.

[11] Sun Ra , Toronto, February, 1991.
<http://www.youtube.com/watch?v=BslNucq9jXo&feature=yout ube_gdata_player>

[12] Sun Ra. Digital transfer of cassette recording, dated August 1979, held as part of the Creative Audio Archives at Experimental Sound Studio, catalogue number SR257.

[13] Szwed, John F. *Space Is the Place: The Lives and Times of Sun Ra.* 1st ed. New York: Pantheon Books, 1997, page 4.

[14] "Black Herman's Troupe." Cleveland Gazette, December 15, 1894.

[15] Cullen, Frank. *Vaudeville, Old & New: An Encyclopedia of Variety Performers in America.* New York: Routledge, 2007, page 782.

[16] "City Paragraph." The Colored American, May 2, 1903.

[17] "MAGICIAN HERRMANN DEAD: HE BREATHES HIS LAST IN HIS PRIVATE RAILROAD CAR." New York Times. December 18, 1896.

[18] Miller, Sammy. "Alonzo Moore Information." The Magic Café. Accessed December 14, 2012.
<http://www.themagiccafe.com/forums/viewtopic.php?topic=445271&forum=134>

[19] Chireau, Yvonne Patricia. "Black Herman's African American Magical Synthesis." Cabinet Magazine, no. 26, Summer 2007.
<http://cabinetmagazine.org/issues/26/chireau.php>

[20] Miller, Sammy, ibid.

[21] "JACKSON, TENN", The Freeman, Indianapolis, Indiana, November 13, 1915.

[22] Agamben, Giorgio. *Profanations.* New York: Zone Books, 2007, page 21.

[23] Ibid, page 22.

[24] Gilmore, John. Interview with author, July 17, 1993.

[25] Ibid.

[26] Luhrmann, T. M. "The Magic of Secrecy." Ethos 17, no. 2 (June 1, 1989), page 132.

[27] Agamben Ibid., p.10

[28] Rycenga, J. J. (1992). *The composer as a religious person in the context of pluralism.* (Graduate Theological Union). Interview with Sun Ra conducted by Rycenga in November, 1988. Transcribed and edited by Dan Plonsey. <http://www.plonsey. com/beanbenders/SUNRA-interview.html>

[29] Sun Ra. Interview with author, October 1990.

ASEXUAL REPRODUCTION

[1] Furnas, J. C. *Goodbye to Uncle Tom.* New York: W. Sloane Associates, 1956, page 378.

[2] Gill, John. *Queer Noises: Male and Female Homosexuality in Twentieth Century Music.* Minneapolis: University of Minnesota Press, 1995, page 60.

[3] Szwed, John F. *Space Is the Place: The Lives and Times of Sun Ra.* 1st ed. New York: Pantheon Books, 1997 page 338.

[4] Kagie, Rudie. "Rudie Kagie Interviews Warren Allen Smith About Sun Ra", September 2008. <philosopedia.org/index.php/Rudie_Kagie_Interviews_Warren_ Allen_Smith_About_Sun_Ra>

[5] Excerpt from *Space Is the Place: The Lives and Times of Sun Ra* by John F. Szwed, copyright © 1997 John F. Szwed. Used by permission of Pantheon Books, an imprint of the Knopf Doubleday Publishing Group, a division of Random House LLC. All rights reserved, page 41.

[6] Sun Ra. *This Planet Is Doomed.* New York: Kicks Books, 2011, page 4.

ANTICHRISTOS

[1] "Good Thoughts, Bad Thoughts." *Standing on the Verge of Getting It On.* Westbound, 1974.

[2] Rycenga, J. J. (1992). *The composer as a religious person in the context of pluralism.* (Graduate Theological Union). Interview with Sun Ra conducted by Rycenga in November, 1988. Transcribed and edited by Dan Plonsey. <http://www.plonsey. com/beanbenders/SUNRA-interview.html>

[3] West, Cornel. *The Cornel West Reader (A Basic Civitas Book).* Basic Civitas Books, 1999, page 62.

4 Davis, Francis interview maintained by Slought Foundation, Philadelphia 1225-2004-11-20-3-Ra.
5 Davis, ibid.
6 Sun Ra, and John Corbett. *The Wisdom of Sun-Ra: Sun Ra's Polemical Broadsheets and Streetcorner Leaflets*. Chicago: WhiteWalls, 2006, page 87.
7 Rycenga, ibid.
8 Sun Ra and John Corbett. *The Wisdom of Sun-Ra: Sun Ra's Polemical Broadsheets and Streetcorner Leaflets*. Chicago: WhiteWalls, 2006, page 133.

HIDDEN FIRE

1 Nisargadatta, Maharaj. *I Am That: Talks with Sri Nisargadatta Maharaj. Rev. U.S. ed.*, 2012. Durham, NC: Acorn Press, 2012.

CATALYTIC CONVERTER

1 Agamben, Giorgio. *Profanations*. New York: Zone Books, 2007, page 34.
2 Baraka, Amiri. "Jazzmen: Diz & Sun Ra." African American Review 29, no. 2 (July 1, 1995), page 254.
3 Stark, Karl, "Is Sun Ra The Start Of Something Bright?" Philadelphia Inquirer, February 2, 1992. <http://articles.philly.com/1992-02-02/entertainment/26038229_1_saturn-label-sun-ra-sound-sun-pleasure>
4 Walsh, Mike. "Sun Ra Stranger from Outer Space." Mission Creep. Accessed March 22, 2013. <http://www.missioncreep.com/mw/sunra.html>
5 Majer, Gerald. *The Velvet Lounge: On Late Chicago Jazz*. New York: Columbia University Press, 2005, page 38-39.
6 Allen, Marshall. Interview by author, 1995.
7 Ibid.
8 Scanlan, Joe. "Consumption and the Self: Elisabeth Wetterwald Interviews Joe Scanlan." Things That Fall <http://www.thingsthatfall.com/interviews/dispersion.php>

OVER JORDAN

1 Taussig, Michael. "History as Sorcery." Representations, no. 7 (July 1, 1984), page 93.
2 Sinclair, John. "Sun Ra." Blastitude, #13, August 2002. http://www.blastitude.com/13/ETERNITY/sun_ra2.htm.
3 Ibid.
4 Piraino, Stefano, Ferdinando Boero, Brigitte Aeschbach, and Volker Schmid. "Reversing the Life Cycle: Medusae Transforming into Polyps and Cell Transdifferentiation in Turritopsis Nutricula (*Cnidaria, Hydrozoa*)." Biological Bulletin 190, no. 3 (June 1996), page 302.
5 Central Intelligence Agency. "COUNTRY COMPARISON: LIFE EXPECTANCY AT BIRTH." *The World Fact Book*. <https://www.cia.gov/library/publications/the-world-factbook/rankorder/2102rank.html>
6 Xinhua. "Cuba overtakes Japan by percentage of centenarians." May 12, 2011. <http://news.xinhuanet.com/english2010/health/2011-05/26/c_13894858.htm>
7 Denyer, Simon. "China's Transformation Frays Traditional Family Ties, Hurting Many Seniors." The Washington Post, September 25, 2013. <http://www.washingtonpost.com/world/chinas-transformation-frays-traditional-family-ties-hurting-many-seniors/2013/09/18/50765b42-1538-11e3-961c-f22d3aaf19ab_story.html>
8 "Everything is Space" on *Somewhere Else*. Rounder / Umgd, 1993.
9 "What Is Brain Death?" Donate Life California/Donor Registry. <http://donatelifecalifornia.org/education/how-donation-works/what-is-brain-death/>
10 Uniform Determination of Death Act (UDDA) is a draft state law that was approved for the United States in 1981 by the National Conference of Commissioners on Uniform State Laws, in cooperation with the American Medical Association, the American Bar Association, and the President's Commission for the Study of Ethical Problems in Medicine and Biomedical and Behavioral Research.

11 "Transplant Living | Financing A Transplant | Costs." Accessed March 11, 2014. <http://www.transplantliving.org/before-the-transplant/financing-a-transplant/the-costs/>

12 Ibid.

13 "Police Say Female Suspect Gouged out Boy's Eyes." CNN. Accessed September 8, 2013. <http://www.cnn.com/2013/08/28/world/asia/china-eye-gouging/index.html>

14 Lock, Margaret. "Death in Technological Time: Locating the End of Meaningful Life." Medical Anthropology Quarterly 10, no. 4 (December 1, 1996), page 585.

15 Adams, Tim. "Sam Parnia — the Man Who Could Bring You Back from the Dead." The Guardian. http://www.theguardian.com/society/2013/apr/06/sam-parnia-resurrection-lazarus-effect.

16 Parnia, Sam, and Josh Young. *Erasing Death: The Science That Is Rewriting the Boundaries Between Life and Death.* Harper One, 2013.

17 Szwed, John F. *Space Is the Place: The Lives and Times of Sun Ra.* 1st ed. New York: Pantheon Books, 1997, page pages 40-48.

18 Ibid., page 50.

19 Walker, Lucy. *Countdown to Zero.* Documentary, 2011.

20 "Nuclear War." Sun Ra, *A Fireside Chat with Lucifer.* Saturn, 1982.

21 De Souza, Philip. *The Ancient World at War: A Global History.* London: Thames & Hudson, 2008.

22 Virilio, Paul. *Pure War: Twenty Five Years Later.* New and updated ed. Semiotext(e) Foreign Agents Series. Los Angeles, CA: Semiotext(e), 2008, page 34.

23 Brookman-Amissah, Joseph. "Akan Proverbs about Death." Anthropos 81, no. 1/3 (January 1, 1986), page 77.

24 Ibid.

25 Ibid.

26 Somé, Malidoma Patrice. *Of Water and the Spirit: Ritual, Magic, and Initiation in the Life of an African Shaman.* New York: Putnam, 1994, page 47.

27 Ibid., page 50.

28 Hinds, John and Peter, Interview with Sun Ra, San Francisco, October 31, 1988. <http://www.youtube.com/watch?v=ka6TPmhiVpA>

29 Rycenga, J. J. (1992). *The composer as a religious person in the context of pluralism.* (Graduate Theological Union). Interview with Sun Ra conducted by Rycenga in November 1988. Transcribed and edited by Dan Plonsey. <http://www.plonsey.com/beanbenders/SUNRA-interview.html>

30 Szwed, John F. *Space Is the Place: The Lives and Times of Sun Ra.* 1st ed. New York: Pantheon Books, 1997.

31 Corbett, John, Anthony Elms, and Terri Kapsalis. *Pathways to Unknown Worlds: Sun-Ra, El Saturn and Chicago's Afro-Futurist Underground 1954-68.* Chicago: WhiteWalls, 2006, page 87.

32 Corbett, John. *Extended Play: Sounding off from John Cage to Dr. Funkenstein.* Durham: Duke University Press, 1994.

33 Excerpt from *Space Is the Place: The Lives and Times of Sun Ra* by John F. Szwed, copyright © 1997 John F. Szwed. Used by permission of Pantheon Books, an imprint of the Knopf Doubleday Publishing Group, a division of Random House LLC. All rights reserved, page 299.

34 Taussig, Michael. "Dying Is an Art, like Everything Else." Critical Inquiry 28, no. 1 (October 1, 2001), 310.

35 Taussig, Michael. "History as Sorcery." Representations, no. 7 (July 1, 1984), pages 94-95.

36 Davis, On Ka'a. Email with author, May 29, 2013.

37 Taussig, Michael. "Dying Is an Art, like Everything Else." Critical Inquiry 28, no. 1 (October 1, 2001) page 307.

38 Rycenga, J. J. (1992). *The composer as a religious person in the context of pluralism.* (Graduate Theological Union). Interview with Sun Ra conducted by Rycenga in November 1988. Transcribed and edited by Dan Plonsey. <http://www.plonsey.com/beanbenders/SUNRA-interview.html>

39 Taussig, ibid, page 308.

40 Ibid.

NATURAL MYSTIC/NATIVE SKY

[1] Fools Crow. *Wisdom and Power*. Tulsa: Council Oak Books, 1991.

[2] Bob Marley, Lowney, Declan. *Time Will Tell* [VHS]. Polygram Video, 1992.

[3] Schapp, Phil, Interview on WKCR, April 19, 1987.

[4] Butler, Susan. "Greenville Native's First Book Available." East Carolina University, Daily Reflector, May, 2007
<http://www.ecu.edu/cs-lib/ncc/bboyd.cfm>

[5] Schapp, Phil, Interview on WKCR, April 19, 1987.

[6] Obadele, Imari Abubakari. *Foundations of the Black Nation*. Detroit: House of Songhay, 1975.

[7] Rutledge, Archibald. *God's Children*. History Press ed. Charleston, SC: History Press, 2009, page 8.

[8] Douglass, Frederick. "What to the American Slave is your Fourth of July?" July 4, 1852.
<http://www.historyplace.com/speeches/douglass.htm>

[9] Rutledge, page 8.

[10] Ibid.

[11] Ibid.

[12] Ibid.

[13] Ibid.

[14] Ibid., page 46.

[15] Ibid., page 51.

[16] Ibid., caption 29.

[17] Ibid., page 51.

[18] Weld, Theodore D. *American Slavery As It Is: Testimony of a Thousand Witnesses*. New York: The American Anti-Slavery Society, 1839, page 20.

[19] Sublette, Ned. *The World That Made New Orleans: From Spanish Silver to Congo Square*. Chicago: Lawrence Hill Books, 2008, page 233.

[20] Szwed, John F. *Space Is the Place: The Lives and Times of Sun Ra*. 1st ed. New York: Pantheon Books, 1997, page 342.

[21] Rutledge, ibid., page 49.

[22] Newton, Huey P. *Revolutionary Suicide*. 1st ed. New York: Harcourt Brace Jovanovich, 1973.

[23] Northern, Robert. Interview with author, January 2013.

[24] Epstein, Jules, Sun Ra interviewed on WXPN, date unknown.

[25] "This Song Is Dedicated to Nature's God" is heard on Sun Ra's 1978, *The Antique Blacks*. "To Nature's God" features the refrain *give some credit where credit is due* and appears on two live sessions recorded in 1971 in Helsinki and Cairo. Each tune in its own way bounces with a similar unspoiled impetuous groove.

[26] Excerpt from *Becoming Animal: An Earthly Cosmology* by David Abram, copyright © 2010 by David Abram. Used by permission of Pantheon Books, an imprint of the Knopf Doubleday Publishing Group, a division of Random House LLC. All rights reserved, page 127.

[27] Massumi, Brian. *A User's Guide to Capitalism and Schizophrenia: Deviations from Deleuze and Guattari*. Cambridge, Mass: MIT Press, 1992.

[28] Emerson, Ralph Waldo. "Nature". James Munroe and Company, 1836.
<emerson, nature http://oregonstate.edu/instruct/phl302/texts/emerson/nature-emerson-a.html#Introduction>

[29] Emerson, ibid.

TWINS

[1] As recorded by *Democracy Now* on March 26, 2013.

[2] Wade, David, *Symmetry: The Ordering Principle* 1st U.S. ed. Wooden Books. New York: Walker, 2006, page 6.

[3] Laszlo, Ervin. *Science and the Akashic Field: An Integral Theory of Everything*. 2nd ed., Updated 2nd ed. Rochester, Vt: Inner Traditions, 2007, page, 28.

4 Diop, Cheikh Anta. *The African Origin of Civilization: Myth or Reality* (Kindle Locations 364-366). Chicago Review Press, originally published in 1974. Kindle Edition.

5 Sun Ra. *The Antique Blacks*. Vinyl lp, Saturn Records, 1978.

6 Quirke, Stephen. *The Cult of Ra: Sun-Worship in Ancient Egypt*. New York: Thames & Hudson, 2001.

7 Budge, E. A. Wallis. *Osiris and the Egyptian Resurrection*. New York: Dover Publications, 1973, page vii.

8 Ibid., xviii.

9 Ibid., xxiv.

10 Browder, Anthony T. *Nile Valley Contributions to Civilization*. Washington, D.C.: Institute of Karmic Guidance, 1992, page 67.

11 Sun Ra. Digital transfer of cassette recording, "Foundation of Numbers / Class Tape-15 May, 1972", held as part of the Creative Audio Archives at Experimental Sound Studio, catalogue number SRC281.

TIME REBEL

1 Voegelin, Salomé. *Listening to Noise and Silence: Towards a Philosophy of Sound Art*. New York: Continuum, 2010., 130

2 Shipp, Matthew. Email correspondence with author, May 2013.

3 Richard Pelligrino, "Cymatic Music: Towards a Metatheory of Harmonic Phenomena: My Interactive Compositions and Environments," Leonardo 120 vol.16, no. 2, 1983, page 120.

4 Argüelles, José. *Time and the Technosphere: The Law of Time in Human Affairs*. Rochester, Vt.: Bear & Co., 2002, page 72.

5 Campbell, Robert L, and Christopher Trent. *The Earthly Recordings of Sun Ra*. Redwood, N.Y.: Cadence Jazz Books: Distributed by North Country Distributors, 2000.

6 Gross, Jason. "Interview with John Szwed", Perfect Sound Forever, August 1997. <http://www.furious.com/perfect/sunra2.html>

7 Sun Ra. Disco 3000. Art Yard, 2013.

8 Sinclair, John. Sun Ra: *Interviews & Essays*. Headpress, 2013, page 81.

9 Ho, Fred. "MR. MYSTERY: THE RETURN OF SUN RA TO SAVE PLANET EARTH," Big Red Media. <http://www.bigredmediainc.com/MrMystery.html>

10 Shipp, Matt. Email correspondence with author, May 2013.

11 Mugge, Robert. *Sun Ra: A Joyful Noise*. Documentary, 1980.

12 Excerpt from *Space Is the Place: The Lives and Times of Sun Ra* RA by John F. Szwed, copyright © 1997 John F. Szwed. Used by permission of Pantheon Books, an imprint of the Knopf Doubleday Publishing Group, a division of Random House LLC. All rights reserved, page 277.

DARK MATTER

1 King, Martin Luther, "Letter from Birmingham City Jail," April 16, 1963. <http://abacus.bates.edu/admin/offices/dos/mlk/letter.html>

2 Birmingham, Alabama, "Birmingham Weed & Seed," Accessed October 4, 2013. <http://www.informationbirmingham.com/birmingham-weed-and-seed.aspx>

3 Ghosh, Pallab. "Neanderthal Big Eyes Caused Demise," BBC News. Accessed April 22, 2013. <http://www.bbc.co.uk/news/science-environment-21759233>

4 Ray, Deborah. *Detroit Black Journal*, televised interview, 1981. <http://www.youtube.com/watch?v=mNgwzY0KzlM&feature=youtube_gdata_player>

5 Stewart, James T. "The development of the black revolutionary artist." *Black Fire: An Anthology of Afro-American Writing*, eds. Amiri Baraka and Larry Neal. 1968. (Kindle Locations 313-316). Black Classic Press. Kindle Edition.

6 Jackmon, Marvin X. Interview with author, January 2014.

7 Ibid.

8 Ibid.

9 Ibid.

[10] Ibid.

[11] Jackmon, Marvin X. "Beyond Religion, toward Spirituality." First Poet's Church of the Latter Day Egyptian Revisionists, July 14, 2011. http://firstpoetschurch.blogspot.com/2011/07/beyond-religion-toward-spirituality.html

[12] Jackmon, Marvin X. Interview with author, January 2014.

[13] Ibid.

[14] Sun Ra. Digital transfer of cassette recording, "Ra-Class, May 8, 1972," held as part of the Creative Audio Archives at Experimental Sound Studio, catalogue number SRC245.

[15] Sun Ra. Digital transfer of cassette recording, "A Quiet Place Shaped Notes Voaler 1 / Shaped Notes Voaler 2," held as part of the Creative Audio Archives at Experimental Sound Studio, catalogue number SR236.

[16] Sun Ra. Interview with author, October 1990.

[17] Ware, David S. Interview with author, May 1997.

MEDIA DREAMS

[1] Abbott, Edwin Abbott. *Flatland; a Romance of Many Dimensions.* 5th ed., rev. University Paperbacks 45. New York: Barnes & Noble, 1963.

[2] Houston A. Baker, Jr. "Handling 'Crisis': Great Books, Rap Music, and the End of Western Homogeneity (Reflections on the Humanities in America)." Callaloo 13, no. 2 (April 1, 1990): 173–94. doi:10.2307/2931668.

[3] Heise, Paul. Email with author, May 2013. <http://www.wagnerheim.com/>

[4] Sinclair, John. "Sun Ra." Blastitude, #13, August 2002. http://www.blastitude.com/13/ETERNITY/sun_ra2.htm.

[5] Sun Ra. Digital transfer of cassette recording, "Sun Ra reading poems on telephone with Alton Abraham," held as part of the Creative Audio Archives at Experimental Sound Studio, catalogue number SR211.

[6] Massumi, Brian. *Parables for the Virtual: Movement, Affect, Sensation. Post-Contemporary Interventions.* Durham, NC: Duke University Press, 2002, page 133.

[7] "Space is the Place." Sun Ra. *Concert for the Comet Kohoutek.* Esp Disk Ltd., 2006.

[8] Rycenga, J. J. (1992). *The composer as a religious person in the context of pluralism.* (Graduate Theological Union). Interview with Sun Ra conducted by Rycenga in November, 1988. Transcribed and edited by Dan Plonsey. <http://www.plonsey.com/beanbenders/SUNRA-interview.html>

[9] McLuhan, Marshall. *Understanding Media; the Extensions of Man.* 1st ed. New York: McGraw-Hill, 1964, page x.

[10] Sun Ra. Interviewed by Egyptian television, December 16, 1971.

[11] Sun Ra. Digital transfer of cassette recording, "African Speech U.C.B. / Rehearsal, October 1974", held as part of the Creative Audio Archives at Experimental Sound Studio, catalogue number SR271.

NOTHING IS

[1] Boyle, Alan, Science Editor, and N. B. C. News. "A Solar 'Blob' Is Coming, but This Show Won't Be Scary." NBC News. Accessed May 12, 2013. <http://photoblog.nbcnews.com/_news/2013/01/16/16549532-a-solar-blob-is-coming-but-this-show-wont-be-scary.retrieved>

[2] Kaczynski, Theodore John. Industrial Society and Its Future. self-published, 1995, section 173.

[3] Rycenga, J. J. (1992). *The composer as a religious person in the context of pluralism.* (Graduate Theological Union). Interview with Sun Ra conducted by Rycenga in November, 1988. Transcribed and edited by Dan Plonsey. <http://www.plonsey.com/beanbenders/SUNRA-interview.html>

[4] McKenna,Terence. "The World and its Double" Transcribed from a lecture given on September 11,1993. <http://alchemicalarchives.blogspot.com/2011/09/

terence-mckenna-world-its-double-11.html>

5 "Stuffs & Thangs." G. Clinton and E. Hazel. *Let's Take It to the Stage*. Westbound Records, 1975.

6 "C.R.E.A.M. (Cash Rules Everything Around Me)." WuTang Clan. *Enter the Wu-Tang (36 Chambers)*. Loud Records, 1993.

7 Hinds, Peter. Interviews Sun Ra, San Francisco, CA November 1, 1988.

8 Ridout, Nicholas, and Rebecca Schneider. "Precarity and Performance: Introduction." TDR: The Drama Review 56, no. 4 (Winter 2012), page 5.

9 Mills, David, Larry Alexander and Thomas Stanley. *George Clinton and P-Funk: An Oral History*. New York: Avon Books, 1998.

10 Fisher, Mark. *Capitalist Realism: Is There No Alternative?* Winchester, UK; Washington: Zero Books, 2009, page 79.

TRANSMOLECULARIZATION

1 Massumi, Brian. *A User's Guide to Capitalism and Schizophrenia: Deviations from Deleuze and Guattari*. A Swerve ed. Cambridge, Mass: MIT Press, 1992, page 1.

2 Rycenga, J. J. (1992). *The composer as a religious person in the context of pluralism*. (Graduate Theological Union). Interview with Sun Ra conducted by Rycenga in November, 1988. Transcribed and edited by Dan Plonsey. <http://www.plonsey. com/beanbenders/SUNRA-interview.html>

3 Godwin, Joscelyn. *Harmonies of Heaven and Earth: Mysticism in Music from Antiquity to the Avant-Garde*. Rochester, VT: Inner Traditions International, 1995, page 6.

4 Jahn, Robert G., and Brenda J. Dunne. *Margins of Reality: The Role of Consciousness in the Physical World*. ICRL Press, 2009, page 215.

5 Jenny, Hans. *Cymatics: A Study of Wave Phenomena and Vibration*. Newmarket, NH: MACROmedia, 2001.

6 Sun Ra. Digital transfer of cassette recording, "Foundation of Numbers / Class Tape-15 May, 1972", held as part of the Creative Audio Archives at Experimental Sound Studio, catalogue number SRC281.

7 Eshun, Kodwo. *More Brilliant than the Sun: Adventures in Sonic Fiction*. London: Quartet Books, 1998, page 05-071.

8 Lackey, Michael. *African American Atheists and Political Liberation: A Study of the Sociocultural Dynamics of Faith*. The History of African-American Religions. Gainesville: University Press of Florida, 2007, page 17.

9 Ibid., page 35.

10 Ibid., page 38.

11 Ibid., page 36.

12 Baraka, Amiri. *Black Music: Essays*. New York; London: Akashic, 2010, page 200.

13 "(You Make me Feel Like A) Natural Woman." Franklin, Aretha. *Lady Soul*. Atlantic, 1968.

OUTERSPACE AND SPACEMEN

1 Epstein, Jules, Sun Ra interviewed on WXPN, date unknown.

2 Strassman, Rick. *DMT: The Spirit Molecule: A Doctor's Revolutionary Research into the Biology of near-Death and Mystical Experiences*. Rochester, Vt.: Park Street Press, 2001, pages 177-178.

3 Baraka, Amiri. *Black Music: Essays*. New York; London: Akashic, 2010, page 199.

4 Blass, Charles, Interviews Sun Ra on WKCR, "Transmolecularization," cassette.

5 Davis, Erik. *Techgnosis: Myth, Magic + Mysticism in the Age of Information*. New York: Three River Press, 1998, page 227.

6 Bell, Pedro. Interview with author, November 1998.

SLEEPING BEAUTY/FALSE PROFIT

[1] Khan, Hazrat Inayat. *The Mysticism of Sound*. Pilgrims Publishing, 2002, page 41.
[2] Price, Peter. *Resonance: Philosophy for Sonic Art*. New York: Atropos Press, 2011, page 64.
[3] Sun Ra. Digital transfer of cassette recording, "A Quiet Place Shaped Notes Voaler 1 / Shaped Notes Voaler 2", held as part of the Creative Audio Archives at Experimental Sound Studio, catalogue number SR236.
[4] Ray, Deborah. *Detroit Black Journal*, televised interview, 1981. <http://www.youtube.com/watch?v=mNgwzY0KzlM&feature=youtube_gdata_player>
[5] Ibid.
[6] Jacson, James. Interview with author, 1995.
[7] "You Thought You Could Build A World Without Us" on *The Antique Blacks*. Saturn Records, 1978.
[8] Rycenga, J. J. (1992). *The composer as a religious person in the context of pluralism*. (Graduate Theological Union). Interview with Sun Ra conducted by Rycenga in November, 1988. Transcribed and edited by Dan Plonsey. <http://www.plonsey.com/beanbenders/SUNRA-interview.html>
[9] Thompson, Danny Ray. Interview with author, December 2013.
[10] Hodson, Geoffrey. *Brotherhood of Angels and Men*. 1st Quest ed. Wheaton, Ill: Theosophical Pub. House, 1982, page 66.

SOMEWHERE THERE

[1] Sun Ra. Reading poetry, unlabelled mystery cassette.
[2] Stockhausen held a press conference in Hamburg on September 16, 2001 in which he made a number of comments about the attacks in NY and Washington that were deemed by some observers to be insensitive and/or controversial.
[3] Taleb, Nassim Nicholas. *The Black Swan: The Impact of the Highly Improbable*. New York: Random House Trade Paperbacks, 2010.
[4] Taussig, Michael. "History as Sorcery." Representations, no. 7 (July 1, 1984), page 87.
[5] Rycenga, J. J. (1992). *The composer as a religious person in the context of pluralism*. (Graduate Theological Union). Interview with Sun Ra conducted by Rycenga in November, 1988. Transcribed and edited by Dan Plonsey. <http://www.plonsey.com/beanbenders/SUNRA-interview.html>
[6] Carter, Todd. Conversation with author, July 2013.
[7] Revelation 22:16, "I am the bright morning star."
[8] Sun Ra, and Henry Dumas. *Ark & The Ankh*. Higher Octave Music, 1966.
[9] Jacson, James, Interview with author, 1995.

Sun Ra

THE IMMEASUREABLE MIXTAPE
INDEXED LISTENING RECOMENDATIONS

PROLOGUE/CALLING PLANET EARTH

1. **Ancient Ethiopia**, Sun Ra & His Solar-Myth Arkestra
 The Solar Myth Approach (1970)

AUTHORITY

2. **Moon People**, Sun Ra
 New Steps (1978)

EVOLUTION

3. **There Is Change in the Air**, Sun Ra and the Myth Science Solar Arkestr
 The Antique Blacks (1978)

ASEXUAL REPRODUCTION

4. **The Exotic Forest**, Sun Ra
 Nothing Is... (1966)

ANTICHRISTOS

5. **Door of the Cosmos**, Sun Ra
 Sleeping Beauty (1979)

HIDDEN FIRE

6. **The Blue Set** (Single Version)
 Sun Ra and Arkestra (1960)

CATALYTIC CONVERTER

7. **Sunrise**, Sun Ra
 Blue Delight (1989)

OVER JORDAN

8. **Seductive Fantasy**, Sun Ra
 On Jupiter (1979)

NATURAL MYSTIC/NATIVE SKY

9. **Shadow World**, Sun Ra
 Nuits de la Fondation Maeght Nights (1970)

TWINS

10. **The Mystery Of Two**, Sun Ra
 Cymbals (1973)

TIME REBEL

11. **Space Probe**, Sun Ra
 Space Probe (1974)

DARK MATTER

12. **Astro Black**, Sun Ra Arkestra
 Live at Pit-Inn (1988)

MEDIA DREAMS

13. **Space is the Place**, Sun Ra
 The Other Side of the Sun (1978)

NOTHING IS

14. **Space Loneliness No. 2**, Sun Ra and
 his Myth Science Solar Arkestra
 Nidhamu (1971)

TRANSMOLECULARIZATION

15. **Untitled Synthesizer Solo**, Sun Ra
 and his Mythic Science Arkestra
 The Paris Tapes (1971)

OUTERSPACE AND SPACEMEN

16. **Dance of the Cosmo Aliens**, Sun Ra
 Disco 3000 (1978)

SLEEPING BEAUTY/FALSE PROFIT

17. **Love In Outer Space**, Sun Ra
 Somewhere Else (1988)

SOMEWHERE THERE

18. **There Are Other Worlds (They
 Have Not Told You Of)**, Sun Ra
 Lanquidity (1978)

CODA ONE/SOLVING FOR X

19. **Immortal Being**, Sun Ra and
 his Omniverse Arkestra
 Beyond the Purple Star Zone (1980)

BONUS TRACK

20. **It's After the End of the World**
 Sun Ra, *Soundtrack to the film
 Space is the Place* (1972)

About This Mixtape

Listening to the music of an uncompromising musical master is an intrinsically rewarding experience. Each track offered here has been aligned with the content of a particular section of this *Execution* in a manner that is intended to increase the likelihood of turning on your black part and preparing your natural self to migrate towards Alter Destiny. This list does not attempt to summarize Sun Ra's vast oeuvre. That would require a much larger mixtape. The dates indicate when the track was recorded or first released. Beyond sonic-textual intercompatibility, there were only two constraints imposed on the selection process. There was an attempt to work from the domain of recordings that are fairly accessible to ordinary music lovers, either as .mp3 files, cds, or vinyl (no bootlegs, cassettes or micro-releases). Also, due to the intended function of the mix, there was also a slight bias in the direction of instrumental selections. Some people, however, cannot read with any music in the background or do not enjoy doing so. While no study has been conducted, it is suspected that these tracks and the accompanying text might retain their neuroleptic effect if the mixtape is auditioned immediately following reading, even if the reader listens while asleep. This author has not entered into any commercial relationship with any party in the business of selling Sun Ra's music. Get your tracks, however, or wherever, you can.

Appendix Two

SUN RA INTERVIEWED BY
THOMAS STANLEY

Stanley, October 1990:

It's forbidden wisdom you know, They're not even supposed to hear it. The Bible forbids listening to forbidden wisdom. It forbids you to listen to anything that might get you on your feet. It's a anti-man book, anti-earth book. It doesn't offer man any hope whatsoever. They have to have something to hold onto so they hold onto that, but they don't read it. That's the problem. They don't read the book. But you know it's a law book. And any law book that's done you should read it, see what it says. It's a contract, you know. A covenant, a contract, a treaty; they should read the fine print. The trouble is they don't read. They just forgot it; it's all over the world.

Are you mentioned in the Bible:

Yes, but they got it concealed. They call it Jehovah, but it wasn't Jehovah at first. It was Ra. Then in another book, it's mentioned that the Holy Ghost, definitely it says Ra is the Holy Ghost. So then it's mentioned in the Bible, "Father, Son, and Ra." It's mentioned in the word Israel. It's right in the middle of Israel. That God said I am in the midst of Israel. The midst of Israel is R-A. So it is in there. It's right in the middle of Israel. That's the thing. The Bible is the truth, but it's not a good truth, but is at the same time. It's good and bad. It's good from the point of view, like if you tell a man, "tomorrow, I'm going to shoot you at twelve-o-clock in Freedom Plaza," and you shoot him, you've made your word good, because you did it. That's the way the Bible's a good book, because things in it are happening everyday. It's good to happen, because it's predestined to happen. As long as people believe that; it's according to what they believe. They say it's a good book. They say it's good to let the thief go, to crucify the son of god, so a thief is in charge of this planet.

How does your music fit into your mission:

Well, music is a language, you see. It's really the language of the gods. Hieroglyphics is a language of the gods. Hieroglyphics means language of the

212

gods in symbols. Music is a universal language. That is, it goes out to the whole universe. Everything played on this planet goes straight up. It does not stop. It goes on out forever. Sound travels. It goes to other universes, other beings. And they listen to the music to see what you're doing. They can tell by the music how far you've developed. That's how they tell. They can tell by the music how far you've developed.

If there was no Arkestra creating music, what would they think of us:

They'd probably eliminate you, because they can't stand confusion. They can't stand indecision and contradictions. They put a few down here for man. [inaudible two syllables] They say he's immature. Part [of the] answer of what you're asking is that God hasn't been in charge of this planet for a long time. He's got angels in charge of it. They're the administrators. They the ones who caused these things, these angels. They're the ones; they've been in complete charge. They don't care too much for man. They felt he should have never been created. So, they do everything they can to block him, even if he's trying to do something good. They want him to fail, yes.

Incredible love in your music:

Well, the music was really created for the Creator, so you have to have something that he didn't create. He didn't create love. So, then you play something for the Creator and people can hear it. But you have to play it for the Creator, not for people. He has to get it first and then he'll push it. I couldn't exist as a musician, if the Creator wasn't my sponsor. He does it. Every now and then, he does something unusual around me to make people notice me. Actually, I like the low profile. He did something yesterday that made people at the TV station notice. They might have thought I was just talking or joking, but he did something that made them sit up and take notice. He set the control board on fire. They were amazed. And according to one of the members of the band, he saw this smoke back behind me, like it was a figure of Spirit. He said 'what was that?' some kind of way. I don't know whether they're going to show it tomorrow, I think. It was on the monitor. It might be on the film, too. Smoke behind me, like a spirit moving. Now, I didn't do that. The Creator did that. The same way in Chicago. We stayed at a most beautiful hotel, it wasn't Ramada – what's that hotel that we was at in Chicago? Marriott. A fantastic hotel, but when we left, all the power went out of the hotel. It's probably still out. Now, that's two things related that the Creator did to make them notice something different.

Increasing importance of people seeing what his work is about:

It's the end of an age really. Whenever it's the end of an age, wherein the Creator has to make it explicit, then when the age changes, all the laws change. This is the end of the reign of Death. Death is supposed to be through. It's been ruling now for a long time. Death has been ruling ever since, according to the Bible, "from Adam to Moses, Death ruled." So if it ruled then, it's ruling now. And they came in through Jesus Christ, too. He represented Death, and he performed the symbol of it. He got up on that cross depicting Death. He definitely represented Death, at least according to the Bible. He's the son of Death. When he was talking about Father, he was talking about Death. And of course, if he went over into the Land of Death, he could only ask his father for permission to come back. He definitely was the first-born of Death. Death had a son. That's what it's about and the Bible says that. He was the first-born of Death,

the first-born of the dead. So, they really should write, "he was the first-born of Death." And then the book say, "the dead and Christ should raise first." So, then Christ represents Death.

Truth and its connection to Death:

Well, the Creator goes by what you say down here. James Baldwin said that "the only truth man knows is Death and the fire next time." He's right. And then you have to have equations to prove points. Well, what equation do you have to prove that Death is truth? Well, you have in Spain, when they fighting the bull, the moment they stick the sword in him and he dies, they call that the moment of truth. So, truth is Death then. So, if they're following truth, they would be dead. You have to see what else, what is another definition for Death? Freedom, free. Free among the dead. That's what the Bible said, "free among the dead." So they should read the book. Right after when Reverend King died, they put a big thing on his tomb that said Free at Last, but he's dead. So, it's right there for them to see: Freedom means Death. And every time you find somebody talking about freedom, somebody dies. In fact, Patrick Henry said, Give me liberty or give me Death'; he got both of them at the same time. He got liberty and he got the dead, too. He didn't know the Bible.

Philadelphia is the cradle of freedom. Very terrible things happen there every day. And then you got; it's psychic. America's a psychic-spiritual kingdom. You can prove it by where it's located....The number of Christ in numerology is five. And you got the Pentagon, right there in [inaudible] Christ, that's what these numbers will tell you – a story. You have to use numbers, equations. They don't lie. And you have to see, number one is the number of man, but number one is the number of Satan, too. So now, you got the same number as Satan. [inaudible short sentence] ...but number eight is the number of God, but that's number one, up on a higher level, so Satan is God. They're both do [as in do-re-mi] so you got number two that's Lucifer. But Jesus' number is number two, too. And then the name Jesus is number two. And then you got number three, that's woman, son, and angels. Number four is like Lord, God. Number five is Christ. Number six is Jehovah. Number seven is devil. Number eight is son, I mean God. And then nine is s-u-n. So, you got it over in music, but they got number five as do-re-me –fa-so, that means sun. So number five in music is sun and it's all fixed up. So, they got the Pentagon, in Washington, DC, right in the center of all that.

This is a psychic-spirit kingdom. It's not like any other kingdom on the face of the earth. It's fixed up and that's the reason why they can't move, besides that, the angels are in charge and the Bible says 'he gives the angels charge over it'. They don't read the book. God have nothing to do with it. He gave angles charge of it; he sent some guardian angels, the book is happening all kind of ways. You got the Guardian Angles in New York City, they got charge. Now, they have to now, white minister said, "be careful what you're doing. You're supposed to be worshipping God. If you don't do the things that he want you to do, we're gonna lose our country." That's what the southern white minister is saying, we're going to lose our country. We're going to lose everything we got. If we don't do what God wants us to do. Now, here you got the governments and rulers of today. Because, they're not doing what God wants. They should leave Saddam alone, because, you see at first you had Adam, and at the end of the age you have Saddam. S-Adam. Adam, Saddam. It's an equation. It's dangerous. They should not bother with Saddam."

Sun Ra Interviewed by Thomas Stanley

How bad could it get:

Well, if he attack Israel, America's through. That's all he got to do is attack Israel, then all the Arabs would be over there with him. You can't trust them. They're going to be for their brothers. They're going to be for their brothers. I know, because in Egypt, if I tipped one of them, they would divide it with their brothers and their friends. You give them a dollar, all of them would get some who was left. So I know that they stick together.

Special challenges and responsibilities for black people:

Well, they have to understand what black means. They say Black is beautiful, but you have to have equations to prove it. You have to prove it is. Black, spelled B-E-L-A-C means "beautiful" in the Benaen language. [He says something semi-audible connecting black people with the "special spirit of Caleb.] They have to use the Bible to get out of this. They got to have a sense of humor and they have to use it. They'll make it if they use it. First, they got to prove they're not man. Then the laws of man cannot affect them. They didn't come here as man. They didn't come here as a human being. So they didn't have no status to say about equal rights. They came in the commerce department. They came here as items of commerce. So, therefore if they want anything, they have to get it form the commerce department. They most certainly can't get it from the state department. Well, I'm dealing with mathematics. So, if they came here as items, things, then they'll see do the Constitution have anything mentioning things, do things have any rights in America? Of course, not. So then they'll have to go to congress and get a law passed for things. And say they're things. Of course, it's a different story. Things would have to be added onto the constitution so that you have some rights What rights do things have? Well, things don't have no ten commandments. They could eat of the tree of knowledge of good and evil, because God didn't say they couldn't eat it, he told man that. Now, what they have to do is to prove they're not man....

If you're not doing nothing you'll get punished [seems to catch himself] you'll have to pay for that. And if you do something right, you'll have to pay for that. And if you do something wrong you'll have to pay for that. And history proves a many a black man has been to jail for doing right, even died for it. And a many a black man has gone to jail for doing wrong. I'm dealing with what I see. I have to judge a tree by the fruit. It's not by what I think. I'm just like a computer – I say, this is this, and this is this. Because the Creator taught me and he says that the only sin that he holds against man is the bible. He says that book is a sin. The book itself is sin. The book does not give him credit. It does not even scratch the surface of what god is. And it's got a lot of impressionable things in there that are not true, but then it's got some things in there that it say about him that the angels took that book, used it on man. When they saw that it said man is filthy and abominable, they said human beings are filthy, they get a lot of filthy diseases. They used that book on him. When they said "man is like the beast that perish," they bring him down to the level of the beast. They using that book. You have some angels, archangels, that's been doing this to the black man a long time. I call them *Them*. One day you have to fight against them – the angels. Because they're in a position where man would have control of them, if they're not careful.

Composition "Of Invisible Them":

It's about Them. Invisible Them. Because the Bible says, "male and female created he them." It didn't say man. It says, "male and female created he them." It was talking about those angels. They aren't invisible, but they're on very high

frequencies. You can't see them, because they move so fast. They move fast. But if a man moves his mind up to move fast, he'll see them. Talk to them, too. But they keep him on a very low frequency. You know, it's just like TV or radio. You can't get FM unless you put it on FM – different frequencies. You go by frequencies and every man has frequencies. According to a book I got that some of the angels which they dictated to Turkey through computers and satellites, they say that they been in control for a long time. They burned the library down in Alexandria. That's the place where the Black man had all his wisdom. They burned it down because they said man was so immature, anyway. Atomic bombs, nuclear, everything was there; the black man had it in Egypt. They burned the libraries down to slow him up. They said they sent Moses. They sent Moses, said he came in there and killed all the first born of the Egyptians. They sent Jesus. They sent Mohammad. But they did not give him the book, the Qu'ran. They said the angel Gabriel gave that. And all the way through the Bible, it say the Angels of the Lord. It's always talking about the Angels of the lord. It doesn't never say, "Lord." So, this book came from the angels and angels have been in charge a long long time and people claim that it's God that's doing it, but he's not. And then the angels wrote that god rest on the seventh day but that is not true. Because this book from the angels say that in outer space you have a lot of empty space. Ain't anything out there. Said all at once you hear a big bang. And the big bang is God, he's made a another universe. In one split second nothing is there in the next something is there....Man is closer to God than they are, but they stay away from him because they're afraid. Because they said that man definitely has a closer relationship with him than they have.

Formulas used to create Sonny's music:

It just happens. It happens without reason, without purpose, without explanation. That's the way God works. There's no explanation of somebody making something out of nothing, and he's always doing that. That's why black people have a chance because he threw them over there into the zero. They over in zero now. That's where he got them at. He throwed them over into the category of things and that's where they are. Do the Bible say anything about things? Yes, it does. It says, God choose the weak and the foolish things of the world to dumfound the wise—that's black folks. They use the book to say we're the chosen, because we're the things. Because the world ain't going to say nothing. They gonna stand back, because they don't know what property things got, since God has chosen the things, it's better for you to be a thing than to be a man. If you're a thing then the constitution of the United States – they ain't got no law about putting things in jail. They have to go by the law. Now they can't find nowhere in the bible where things can be condemned, because God never condemned things. He never gave to things the sentence of Death he supposedly gave to man. God is quite simply, the Creator of the black things God has some white things too, some red things, some orange things, he's given everybody a chance to be a thing if they want to.

The only future for people is Death. You have to use an equation to use the vice future, the alter future.

SUN RA SPEAKS
TRANSCRIPTIONS FROM VARIOUS SOURCES

SR236/ESS/CAA

You hittin' a flat note, but you got to hit a round note...you see the notes are made round, therefore you got to hit a round note, because I got it written down there with a round note, therefore play a round tone. If I want a flat tone or a diamond tone, I'd do like they do the church music. If you look in there, they got some diamond notes, they got some flat notes, in the church music. Evidently, the people who wrote that music wanted them to sing diamond notes and flat notes, they didn't have no round notes. And when they wrote that, in order to sing that church music you must sing a diamond note and a flat. You look at the old church music and see if they don't have different – they got some round notes, they got some diamond notes, they got some flat notes. It's a difference then. Their music goes over into something far beyond what these musicians today know about. They just do the round notes. But there are flat notes and there are diamond-shaped notes and there are clover-shaped notes. All kind of shaped notes.

That's the reason I'm dealing with sound sculpture now – shaped notes. But it ain't nothing new. It's that musicians haven't been taught the full scale of music. They got all these instruments, but they don't know nothing about no music. Nowhere on the planet. And that's something to say – you ain't produced one musician, yet, on this planet as far as the forces outside [are concerned]. They said you have not produced one musician and this planet would not be recognized until you produced one musician and then they'll recognize [you]. I can show you the book. Well, if earth is able to develop one musician that they recognize, then everybody on this planet will be recognized, until then you have no recognition. That is when a planet gots a soul, when it produce one musician who the outside forces recognize – something that they don't have. That's the only way you get recognized on this planet. You must have something that nobody else in the universe got. It doesn't take but one man to have it and then you'll be a

part of the greater universe, until then you can't be a part of it because you have nothing to offer. That's just like going to the white man and offering him some money, he don't need no money. He got some money, but if you come up with something that he do not have, he will listen. Now if you want immortality and want to live, you got to come up with something for the Creator of the universe that he did not create, then he will recognize you. But you know, you got a hard job to come up with something he did not create. It's practically impossible, but that's what you must do to keep from dying on this planet. And if you got some people on here trying to do something different, do everything you can to help them, because your life depends on it. If you can't do it, then you can't do it. But if there's any kind of way that any man doing something different, help him all you can, because if he's successful, you will live, forever. But if he's not, you headed to the cemetery now.

Now all them other leaders who tell you other things, forget it, because I'm telling you the truth. There's no hope for any man in the church or anywhere until you produce one man that the Creator respects, because they tell you all the time, "God is no respecter of persons." I don't know why they won't listen. He's no respecter of persons. What does he respect then. He's no respecter of righteousness. What does he respect then? Righteous people die everyday. He's no respecter of men doing good deeds. What does he respect? You got to face it. All these men that came along, not a single one has won the respect of the Creator to keep him from dying. As far as he's concerned, they as good as a dog. I'm telling you the truth. As far as this planet's concerned, every man here, they're not even considered as good as a dog, because a dog does have some love and happiness. A dog be so happy when somebody loves him or he can love, he just shows it. Where men are a question mark in the universe. They don't have as much feeling as a dog. They do not have as much love as a dog. Because a dog laughs all the time when he's around somebody that's his friend. And a dog knows this is my friend. And a dog knows when it's a enemy, too. But man does not know that. Strange enough. He is the only thing in the universe that does not know the difference between a friend and an enemy. [Goes on to talk about a lady whose cat commits suicide because it does not like her.]

[In what follows from this recording made during a rehearsal he is chastising a particular musician, although it is unclear whom.]

I'm playing on a different plane from any other musician on the planet. You're not playing it right. You're playing the right note, but you don't hear what we're doing. You're out there by yourself. You're about a millionth of a billionth off. Just that little bit, but I'm dealing with precision and discipline. You can't – now the only way you can do it, you can't do it mentally. It can't be done, because I can't do it mentally. I didn't write it by my mind. I wrote it by my spirit. Spirit don't know nothing about no time; it's timeless. That's why there's none now, you see. But if you thinking of the time factor, like the rest of the band, it don't work. They hitting that note a certain way [inaudible] they listening to what I'm doing now. They listen and you're not listening.

Of all the musicians on the planet, I get severely criticized by the agent of the Creator if I'm not correct. Other musicians can get by with something. I can't. Other people can get by; I can't....I'm up under a different critical situation than other people. Men are allowed to make mistakes. Humans are allowed to make mistakes; I'm not, although, I'm in human form. That's why it's important to have musicians doing the way, what they supposed to, according to our standards. When I say "our", I'm not talking about man. I'm not talking about him. Because he's a series of errors you know, and confusion and Death and

destruction and he ain't nothing else, *yet*. There's a possibility he *can* become something else. That's my job on the planet. Possibly he can. Who knows? Since he ain't ever been nothing, don't nobody know. It's a question mark. It's a total question mark to the universe. And that's the reason why they be flying over this planet instead of landing here, because they know man's a terrible – he's a terrible creature. He got a lot of energy and he don't know what to do with it. Like, some teenagers up the street, they was out in the street hollering the other night talking about they didn't know what to do....It's like a total destruction machine. [on black people – black activists/rebellious teenagers – 14-year old that curses out a man in a stationery store.] ... Something gonna happen to these black folks, because all the people who really have been holding them together, gonna pull back, and you'll see something you never dreamed. When they pull back, all these black folks that you thought was makin' it gonna hit the dirt. You gonna see some tears and some gnashing of teeth. They gonna know they through. This is the end for them. Because they been up there for a long time, all evil and taking advantage of the good at heart. Black ones. Not the white ones. These black ones been hiding behind, talking about the white man this, that, and the other. It's them; you'll see them change. It's them and they will see the light, but it's gonna be a big fire burning them. And they'll see the light then, but it's gonna be the kind of light they ain't gonna want. They will be enlightened by themselves, burning in the fire. If I have anything to do with it, I will be the keeper of the pitchfork. And I'm gonna have me a nice time. [band can be heard laughing]

I will have powers over man, where it will be terrible, terrible, terrible, and when I get through with them, man will change. Because it's one thing he gonna say, "God is terrible, terrible terrible, terrible," and when he get up in the morning, the soul is going to tremble. I'm telling you brothers, his soul is going to tremble, because I'm on the planet and he will know, he will know. And there will never be any more wars on this planet. It won't be no more crime. There gonna be no more robbing anybody. It ain't gonna be no more nothing, just like it is, because for the first time in his life man is going to be afraid. And I'm sitting right up here now to tell you, he's gonna be afraid, because he ain't gonna know what I'm gonna do to him. And I got me some nice stuff set for him. And he will not escape. And when he holler to the Creator, he will get no answer. And when you pray to god, you'll get no answer. And if you try to die, Death will refuse him. And he have to come by me. I swear, he'll have to come by me. And then that's when man will get his discipline; because there will be no escape.

I'm gonna think of everything I can that's dirty to do to him. I got no mercy and no pity. And the Bible is telling them "the tender mercies of the wicked are cruel" and I am wicked...Because I got some stuff for him and I ain't gonna need no jails. I will not need any jails because as far as I'm concerned, when I get the powers in my hand, everyone of them I catch doing wrong, I'm going to turn into a statue and let the birds pee on them, let the planes fall on them, let the snow fall on them [Sun Ra sounds like he's saying "the planes," although clearly from context it should be the " the rains". Why?] I'm gonna come down and I'm gonna say, "How you like that? How do you like that? Now you ready to do what I tell you to do or would you rather stay out here and keep company with the pigeons?" You know, it's all kind of things, and let him feel it. He's a statue. He can't move, but he can feel when the dogs come and pee on his legs, he can feel that and when the birds doo-doo on his head, he can feel that and when the snow is there he can feel that and he still can't die. Ain't no sense in wasting time

with man anymore. He ain't scared of god. He ain't scared of the devil. So, the Creator sent me. And I've been nice to him so I could see, well, what is he, does he respond to kindness, does he respond to love, does he respond to friendship, what does he respond to? And then I have to say there isn't but one thing he'll respond to – fear. That's my conclusion. It's one thing that man will respond to – fear. And that's what it said: "The fear of the lord is the beginning of wisdom." Man is getting ready to learn something, from me. And that includes Italians, and Germans, and Frenchmens and Chinese and Japanese. The whole kaboodle – ain't none of them worth two cents and a half. But when I get through with them, they will all be beautiful to bring [to] the Creator and say, "here they are, they're all nice lovely people."

["What about they leaders?" Question from band member.]

Leaders? We killed all of them. They have no more.

["But they building Dick Gregory out to be a leader."]

Dick Gregory is one of my agents. I can call him in anytime I want to. I just ain't – I been thinking about it, but he serves a very good purpose for us to go around and to pretend like he can do something. I made him. That, John over there can tell you. And I got some more [leaders, prominent public people] I made. It's all like decoy ducks. [inaudible statement from band member] He's a decoy. That's so I can get my stuff and [unintelligible short phrase ending with "man," then from same band member: "He's supposed to be here. He's supposed to visiting the MOVE house headquarters."]

He been down there. Now I'll tell you one thing, one day I got real mad with him, and the next day I read in the paper where his house caught on fire without any kind of, they don't know why, they ran out in his nightclothes and I was quite happy, I mean I felt a little pleasure. [tape glitch eats a short phrase here] He run out. He ain't talking about nothing. [Band member explains that Gregory was most recently talking about a spiritual dimension of social struggle.] He cannot come over in this direction. I'm the keeper of the keys of spirituality and that Dick Gregory, although I made him a millionaire, has never given me a cup of coffee. He's not suitable for our kingdom. The same way like he had to come to me in Chicago, he got to come – well, I'm telling you what's going to happen. This very house, he got to come in here past me. I'm going to tell you what's going to happen: He's got to come past me before he can go any further. ["He said that what he's doing is listening to all the little kids."] Little kids ain't got it. I got it. [laughter from band] I got it. And the white race know I got it. That's the reason why they're having Sunday on a Wednesday in honor of me. And they making sure that it's legal, because they voting on it in Congress, and the House of Representatives, they making sure that they make it legal that they giving honor to me legally, so I won't bother them. Because I told them, if they give credit to me, I won't bother them...that's what I want. I wants the most intelligent, the most strongest man on the planet, I want to wrestle with him. I want to learn him and I need him badly because I got to try out my powers. Hitler tried out his, I got a right to try mine out. Every dog has his day and this is gonna be the Sun's day. Now the sun represents Death, and I can show you the books that the Sun is Death. That's where Death comes from, from the Sun; so does life. It just depends upon which side you get under. It depends on whether you get up under one of them sunspots, but it the giver of life and Death. That is your giver of life and Death – the Sun. The S-U-N. It controls here. And nobody can get past it and the white race seeing that, is getting ready to get out of it, where they will not be to blame. You just watch, they gonna really have some stuff going on in honor to the sun. And they spelled it out to me: S-U-N. and they had a minister to call me,

the top minister in Philadelphia. I think that's pretty good for the white race. It looks to me that Blackie needs to learn something and I'm a good teacher. I will teach him. So the creator has turned him over into my hands and I will be sure to change them. I'll take the Africans, too, and the Egyptians, and the Arabs. I'm just one person. I want all of them in my hands. With powers far greater than Moses ever had. I need it. I want control of the lightening, control of the thunder, control of the winds. Control of Death itself. I need all of that to whip the black man down to his knees. And in less than two weeks, he'll be a different man. Now, when I get this power to bring Reverend King back and to walk and talk in black neighborhoods with him and if all of these people that they know are dead and I can have them walking down... [tape ends]

SR236b/ESS/CAA
Now you got to do a total different dimensions thing in there because I'm moving past the earth rhythms. That's because the earth is changing. The earth is changing. The rhythms that the earth had it don't have it no more. That's the reason the mud is sliding. That's the reason houses are sliding down in the mud and that's the reason you got all this stuff happening, because the rhythms of the earth doing it. And musicians who are in tune with the earth are out of order now. Because it's the rhythms that's changed and since the earth using these rhythms to destroy things, all of the musicians who are in tune with the earth are destructive.

Very destructive. And you find them, they be playing them earth things back there in the past. Because why? Because the old order of the earth is no longer applicable to man today. And now you getting ready to see some stuff like them men in cages. Do you realize how long since that has happened on this planet? [Band members ask for clarification. It becomes clear that Sonny is referring to the 1978 trial in Turin, Italy of members of the Red Brigades.] Well, they having some men on trial in Italy where this come from and they got them over in, they're over in the cages. They in cages just like animals, about twelve of them. ["What'd they do?" This is the same voice doing most of the questioning on the previous session.] Well, they opposed the government. So, I told you that the leaders of the planet was getting ready to get together, so then the leaders said, well, ok, you opposing us, we gonna have trial, but they so bad where they've killed a few leaders, so now, I told you the leaders was gonna restrike so now, the leaders got them over in the cage, and they're having a trial.

If they keep on, Italy is going to come up and put up some more civilians, and the lions are going to be eating up people and you can go and see it for yourself. I'm telling you what's going to happen. If these folks keep on opposing leaders and they gonna have some more folks thrown to the lions. That's gonna be the sport. And the leaders gonna sit right up there and watch everybody that oppose them be eat up by the lions. Because why? They can make a lot of money. A country can actually get out of debt by having people from all over the world come and see the lions eat their enemies up. If they want to fight, give them something to fight, some lions. If they want to kill, and they got the enemies they want to kill, let them fight something with a lot of power. If they'd rather become a lion, then you honor them and everything.

SR149/ESS/CAA
Now, here's another word that's very important. [writing] Now you can permutate that word and it's P-A-T-H. Now, *path* is very important because you've got a word based on *path*, say, "pathetic." Now, that indicates that this path is

something pitiful. Things that are happening on this planet that are bad; it's because of this path, which is a way. It's a way that you have adopted. Every man is judged by the way. Now, black men have the wrong code. Now, you can go in New York City and you'll see up on the courthouse in big letters that they judge everyman by his persuasion. I mean, not only the way you think, but they talking about your persuasion. So it's up there. Like a man can be persuaded that something is seemingly right. Now, they always asking questions about where you work, what religion you in, what school you went to, how old you are, all that they add that up and put it in the computer thing and take it out and say, well, yeah, we can do such and such a thing to him. He doesn't know nothing; he's a big dummy and he can't protect himself. So, they have to have a certain number of people, like police have to go out and arrest a certain number of people. If they don't, they lose they jobs. So, you see, it's big business. If an undertaker don't get a certain amount of people for his business, then he won't have any business. And if the gravediggers don't get some people to bury, they, too, will be put out of work. Now, you have all these people to suffer. If the doctor's going to get somebody to cut into and all that, and the drugstores don't have nobody to sell medicines to, then you throw a lot of people out of work, but you don't ever do it. You make it a very prosperous business for the doctors and the undertakers and the gravediggers and they love you, because they always have something to work on – you. So, the point of it, if you would set somebody else up in business, not somebody that's always sitting up thinking about how profitable it's going to be for them when you die. If you would do some little something to move you another direction, it would happen.

Now, you take on the whole money, on the dollar bill, on one of the United States, it says, "he prospers our undertakings", you see. It either says undertaking or undertaken, but I told you about that undertaking; it's on the money and that's what the creator does. He makes the undertakers very prosperous. You've got it on your money. Now, whenever you put things over on money, and you send it all over the world, it say in God we trust; he prospers our undertaking, and you sit up and men get in a counsel together and put these words down there. Now you got a song that was sung by the so-called slave, saying, "but you better mind how you talk, you better mind what you talking about. You got to give account in glory. You better mind." Now, don't you think that they were ignorant. They had more sense than you got. They was telling you, "watch your words." [writing] Watch what you're saying, because you're going to have to give an account for it. In other words, you're going to reap what you sow. No, that reap what you sow is another thing that is dangerous. You're going to reap what you sow. That's what you think it means, but now, it's also there, you've got the phonetic: you're going to reap what you s . Now, what is that? So means something – you say, "it is so." That means something that you make true. It's over there with this truth thing. You're gonna, whatever you call the truth, you see, you're going to get that back. You're going to reap what you so. Now, what's so? It's represented by a plus, like you say, "that's so, that's positive." [writing] Plus sign. As I said when people die they give them a *sustificat* [sic] Something certified means something that is positified, something that is true, something that is so. It moves over into this, too. [writing] People get made and they say, they *so*...[writing] You see over there. And then you got this *so*, where people are ailing, and they over into this *so*. Now, I'm going to show you one more word on this thing, then I'm going to play some music.

Here's a word, phonetic, *pan*. That's a word meaning *all*, like you say pan-American. It means all. Now, this word moves over into this. [writing] That's

pain, when you bring it out like that, it moves over into this. [writing] That's *pǎn*, that's what black people's been, somebody's pawn, you know, like they're over in that. But, now you got this pain. Now, pain is something like when a person is ailing, you see. Now, *ail* can be spelled like this *a-l*, because that's phonetic. Now, *pan*, I told you, mean *all*. Now watch this. [writing] Now, here you got a case where pain means ail and you got a case where pan means all. And you see, it's the same thing, because you can spell all like this. [presumably, he writes a-l] And you can spell *ail* like that. And one of them is pan, which is all, and one of them is pain. So, you see somebody's been using words on you, but you haven't known about the mathematics of it. That's an indication, right there.

Now, you start getting down where you get the root of words, the only thing that is wrong with this planet is that you've got confusion on this planet. And intellectuals are wondering, why all the confusion? Where did it come from? But if they looked over in their Bible, it'd tell you where it came from. [Said, God did it. Of course, they trying to tell you the devil did it, but the book says that God did it. It says men wanted to go out and build a Tower of Babel, and they wanted to become as one. There that word *one* is again, too, by the way. Said, if they get over there they can do anything they want to do. They can achieve anything, and said, if they get over there, they can do anything they want to do; they can achieve anything. So, then God saw that and he came down and he confused everything. So, then the confusion on this planet is due to God. Now, who's that? Well, we'll say, suppose the white man is God. I mean at one time, he wasn't on the planet. So, at the same time that god was supposed to show up, the white man showed up. Now, suppose, he's god, well, Some people say he's the devil, but you know, black people get everything backwards most of the time. You got a choice whether he's god or whether he's a devil. Well, anyway, either he could be a devil like that [writing] or a devil like or he can be a god like this, or he can be a god like that. You got to make up your mind what he is. And then you got to make up your mind what you are, too, maybe this is you, that one, maybe that's you. Maybe this is you. You somewhere over in that somewhere, or else you down, for some people say the white man is a beast. [writing] Like that. But then, see, like if you get this book *To Babylon*, it'll tell you that in Chaldea you find out that an a is equal to an i. So, now put that down like that and you got a *beist*. [Sun Ra has turned the white race into be-ists, followers of be-ism, probably a positive in Sun Ra's world view.] "They neither buy nor sell unless they have the name and the number of the beast," you see, that's what's over in the Bible, too, the beast – the name and the number of the beast. Now, black folks took the name of the white man. They didn't have no name of their own. So when they got out of what you call slavery, they didn't have nothing but names like Mary, or Jim, or something like that. So, they needed them a last name, because that's the white's custom. So then they went and just took the white people's names away from them. There might have been some white people that said, "well, take my name," but in the majority of the cases went out, they was supposed to be free, but they went and took their master's name. That was dangerous. I'll tell you why that was dangerous. Because by taking those names, they made themselves part of the household of the white man, you see. So, how is it written in the Bible: "A man's enemies are they of his own household." [writing] So, if you go around and you got white people's names, you over in their household, they got a perfect right to be your enemy. The book say so. So, now you going to have to see how that book is working on you. Now, if you had your own name, of course, and then, you'd have to – Well, you can look in black families. It not only works

that way, but you look at black families – a man's enemies are they of his own household – now, you can go in any black family, in their house, and you'll find out that's true. One of them will be against the other. And it's just they enemies. So, then you come to a strange thing where it say love thy enemies. [writing] The point is, who is your enemy? According to this, your enemy is over in your own household, that's who you're supposed to love then. If you're going by mathematics, but if you're not over in the white race, part of that household, it doesn't mean you're supposed to love them. But these are your enemies, your worst enemies, right here. You can get over there, in your own household and you straighten out folks over in there when they do something wrong, and you tell them, that's wrong. You know that's wrong. If it's a little child, you tell him it's wrong. After a while, you keep on telling him, he'll black [sic] he'll say "yes, that's wrong."

And you start to getting your own household together – they say charity begins at home – and once you start to doing that, you're not going to have to be worrying about anything as a people. And as soon as white people look over there and see that you're getting your household together, then they going to say, well, I know that I'm superior to them. I can do a better job. Now, I'm going to get my household together and show them that white supremacy is really the truth. They're not going to beat me doing nothing. So, the point of it, if you loved one another and you did things for one another, a strange thing would happen in the white race. All at once you'd find out if they don't love each other, they'd be pretending they are, because they're not going to let – they watching you, because they know who you are.

They know that you are ancient Egyptians, the ones who are really ruling, and they know that you're the only people's talking about eternal life, immortality with this symbol. [writing] Now, they know that. If you go out and you start to doing something, you might jump right on the right track and begin to get immortality. And you going to get immortality, and you're the only people that been talking about it, [writing] and leave the white race out. You think they going to let you do that? No. They going to watch you. If you set up all of this and be right over in there and say, well, now, he's not getting away, because they haven't made up their mind whether you know what you're doing. You always doing something. I mean, you can come up completely ignorant and come up with solutions to problems and building things. So, they haven't looked [figured?] that out, that you not, that you don't have that immortality. After all, it says, life is in the Sun. [writing] And you prove you're the son by getting crucified. You've been dead about 3,000 years, maybe 6,000. You've been dead a long time. Now, the reason I know that you're dead is because a black man came up to me one day, he didn't have no education, and it wasn't him talking. He brought two friends up there and he said, "look, you know Sun Ra is the only one in the black race that's alive. The rest of us are dead and buried." Now, he said, "now, you know, I'm a bad man and you a bad man. We don't never do nothing, but wrong. We got to have somebody in the race who does something right, who knows something. He's the one." These were men out of the street. So, I listened to that, because I listen to everything. I have learned by listening to people when the Creator comes and talks to me. Now, the things I'm telling you are the things he wants me to tell you, because there's nothing in the world that can stand up against it. And nations in the world are going to recognize it. I mean they're setting up something for you. I had a vision once where I saw where you were going to go up on a mountain, a place that had a lot of mountains, that had all kind of brand new houses, made

out of sort of a rose-colored material that I had never seen before. And it was so new that they didn't have any roads leading to it and that's what is going to happen to you. Because the nations of the world, just like they took you out of Africa and brought you over here and made what they thought slaves out of you, they going to have to take you back, because it's written that you restore the landmarks and the boundaries – put back what you took.

And so these different nations are having a lot of trouble on this planet. Now they don't have any solution. I told them once before that nothing is going to happen good for the white race or anybody else on this planet until they restore back the identity of black people. And I said it on TV in New York. Of course, they didn't believe it. But the next day war broke out between Israel and Egypt. Then they wanted me to come back and talk some more. I said no, it's not going to do any good for me to talk. I've told you what's going to happen. You've broken nature's law and you've taken those people out of their home and you've taken their country away from them and nature gave them certain things. You simply can't do that, because nature is the boss. Now nature wants these folks put back where they belong. When they're not in their proper place, well, nothing's going to be right on this planet. That's the solution to the world's problems. When black folks get back where they belong, then they gonna change. You take like a black man told me in Paris, he went to Africa, he said he found out he was playing things on the instrument he couldn't play, when he came back out of Africa and came back to Europe, he couldn't play it. But as long as he was in Africa, he could play it. Africa has something for the black man. In fact they talk about equality of races, but it's a book called *Missionary Travels*, get that, too, by Livingston. *Missionary Travels* – in that book, he's telling where the black man came from. He's telling how he was in, uh, how he was sent over by the newspapers to prove that the black man was a beast and that he deserved to be in slavery. He wasn't supposed to be letting him out and all. He went over there to prove that, but when he went to Africa, he found out something else. Now in that book he's telling you what he found in the place where black people came from, central Africa, they had iron foundries and everything. The people weren't savages like you've been told. The black people that came over here [America] did not come from all over Africa. They came from one place – central Africa – right down where they call the Sudan, which means southern. They came down in central Africa. Now it's a book called *God Wills the Negro* that's got a map in there and everything. It tells you that they was down there in central Africa. I'll draw a crude map. But you had Egypt up here. I'll say ancient Egypt, up there around the Mediterranean. And then, you've got the Nile coming on down there. You've got the Sahara desert. Now these people up here were being attacked by – everybody wanted Egypt. It was one of the richest lands in the world. They wanted Egypt and they wanted the mysteries, They wanted the Sphinx; they wanted the gold he had. Kept on attacking them. Finally the original Egyptians couldn't stand it anymore. They came over Sahara desert; the white man hadn't never been down there. He came over the Sahara desert, now the Arabs knew who he was, because they had also come across the Sahara desert. Now, came on down here and down here was central Africa; over here was Ethiopia. Now these people came down here and settled. Now the Ethiopians didn't like [that], after all, that was down in their territory. They didn't like that, although they was black, too, these brothers. One time Egypt was united. It was two kingdoms. The pharaoh had this crown it symbolized that he was the ruler of the two Egypts – Upper Egypt and Lower Egypt. Everything is backward there, because this is Lower Egypt, up here and this is Upper Egypt down here. And it's different from over here, you see. In

other words the top is the bottom. So, we speak of Lower Egypt, it's up there and the Upper Egypt is down here. Now, they came down here, in Ethiopia, it's called Ethiopia, then.

Now, the Ethiopians didn't like that. Now, that's what this book says. Ethiopians went out and hired someone called Sambo, the man-eaters. Now, I went to Sacrament [?] the other day and I saw a restaurant called Sambo. Sambo and the man-eaters. Now these were very great warriors. These people here were over in a civilized state They really didn't believe in fighting nobody but themselves. They just like the American Negro over here – don't fight nobody, but themselves. They doing the same thing now, they was doing then. So, now the Ethiopians, they couldn't beat them themselves, so they got Sambo and the man-eaters and they come up from down in here somewhere and got them, and took them over here to the west coast of Africa and sold them into slavery. Now the Arabs went over in there, too. Everybody just had a good time on them, then, because they had been up there ruling, now they down.

SRC245B REH 5-2-72/ESS/CAA

[Music opens this tape: keyboard and drums, some mic feedback. Ra is caught in mid-sentence.]

It has nothing to do with this planet. I'm just passing by. That's all. Because I wouldn't stay here even if I was dead...[seems like a splice, context is lost] to know a man that stay like this, but the part of it is that some people may not understand because of the fact that I'm not seeking equality and I'm not seeking freedom. I'm not seeking any of the things that Black people have been saying that they want and I don't want those things for them. And since I'm part of them, they going to have to do what I say do anyway. There's nothing else they can do. That's the way it is with a race: they always follow the superian [sic, maybe *superiant*] spirit. It doesn't even have anything to do with the mind when you reach a certain point. A race always have to follow the superior spirit. That's what made the white race great. There were just a few white people who were able to go out and take Africa, take Australia, take America, take everywhere. Wasn't but a few white people who had the minds and the idea of what they wanted to do and none of the other white people believed that, so they opposed them. So, the white race has a record of opposing progress.

People who were trying to do something for the white race had very difficult time, even over in the music field. Like Stravinsky and others, they had a problem of how to get their people to recognize something progressive and a lot of them starved doing it. A lot of them died other ways trying to get the white race to wake up. So, I myself have never been around the white race much because I know their record of opposing progress. So, I never did approach them, and I only came out here [California Bay Area] because for the last twenty years, I've been teaching black people a whole new philosophy and a whole new way of life. It took them twenty years to see it was the truth. Now, all these black people are intellectuals on the East coast and it took them twenty years to see that I was telling them the truth. Now they changing their whole way of life. It's going to effect America, form the top to the bottom. Not only is it going to effect America, it's going to effect the whole world.

Now, that in a sense, is going to leave the white race out. So, in all fairness, I came here to talk to someone in the university. Now, in this university, a place supposed to be dedicated to academic freedom and other things like that that's come under some opposition to what I'm saying. But, in the universities that's giving all kind of help to people who are revolutionaries and militants and all

of that, I'm not talking all that stuff. I'm not even worried about governments falling; it's falling everyday. It's through. And I only said that the white race had one chance – me. So, then, if they want to take a chance and think that I am [inaudible] and oppose me, they're welcome, because I know I am what I am and I know I know what I know. And I know the results of force opposing me. And I only said simply, I'm an ambassador from the Creator of the Universe. And he hasn't sent any ambassadors on this planet before. Prophets and other teachers, not an ambassador. Now, I've approached this planet from the Creator as a ruler, not as a religious figure or nothing like that. But as the ruler of the universe. Now, to oppose a ruler of a universe, and this is part of the universe, is really going to be an all out war, spiritually, something the earth has never experienced before. Because, I'm under His protection. I'm not under man's protection, because I know that man doesn't know what he's doing. The fact that even one little child would oppose me means that they haven't been taught properly. So then this planet will have to learn and there's no better time than now for them to learn. Now America is already fallen, they learning now. I said that last week that their brother's would be dying and in their blood and crying, being defeated and my words have come true. That's exactly what's happened and I said the white race should turn now, before it's too late. I said I wasn't abusing the white race or any kind of way condemning them. Now, therefore, don't no white person have no reason to oppose me. Because of the fact it's the white race's survival at stake and out of all the voices that have come along, all kinds of prophets, like Jean Dixon, all the white prophets are prophesying doom for the white race and on this planet you won't find but one voice saying it's not too late, and that's me.

Now, if the white race could be so foolish, and the time is running out to do something like that, I mean, I'm stating publicly, it's not me. You can't ever say that I was your enemy. You can say I'm the best friend you ever had. So, then that's on the record that I'm saying that and I've given the white race a chance. I've said that they're wicked, and that's true. And I've said that they have to fall on the mercy of the creator of the universe, and that's true. And I've said that they surround me and I don't need to be a subversive. I don't have to do nothing like that. That's underground stuff. All our stuff is up above the earth and the surroundings. We can attack anytime [we] want to. It's a very young planet anyway. All the forces of nature could get rid of this planet in one split second. All that is true, too. I said that I'm another order of being and I am. I'm a different order of being. It just come down to the point of can man recognize something look like him, but not like him. It's very simple. Can you do that? It's all up to you.

I recognized you enough to come along and talk to you. Then, it's a one-sided affair. It isn't up to [whether I] want to teach here. I got plenty of Black folks that's awake now. They don't want me to be here, no way. They didn't want me to come out here. But I said no, I was coming out here, so I did. Now, they calling me up from all in the East coast to come back East. Which would mean this place is supposed to sink anyway down in the sea. So, it really doesn't pay people on the west coast to be arrogant or to be choosey. They in imminent danger of sinking down to the bottom of the sea. They can be stopped if they turn. If they change the whole course of their destiny, they can change the whole course of events that's going to happen. And that's off of me too; it's also off of the Creator of the universe – anybody that say that he wants to destroy people, because he sent me to tell the West coast, turn now. Now, opposition and all that, going try to beg people to change and all that, I don't have to do that. I already got my stuff set to

go to Egypt, teach at Cairo University, teach the Egyptians. I can do that or I can go to Berlin. Like the Germans said, "There's no love in America; there's a little left in Germany." And I'm finding out the Germans spoke the truth. That's what they told me – stay here. Now, if I'm not welcome in America, it's really farewell on America, because it's not going to be anymore America, unfortunately, I'm telling it like it is. It's not going to be an America. Neither mentally, nor spiritually, nor physically – the whole thing. Anything could happen to it, because I'm really telling you the truth when I tell you I'm representing the Creator of the universe – not in a religious manner, because I'm not righteous myself, so I couldn't approach you as a religious figure.

So then America doesn't have any excuse standing against me. I'm not from politics; I'm not in religion; I'm not really in education. I'm over in something about your survival. I'm not asking about mine. I don't belong on this plane of existence anyway. I'm just passing through, just looking at you, where you need help. I think that's pretty fair to tell you the truth. I'm telling you the truth. You can't look anywhere else and get any further consideration. It all comes down to me. I arrived here in this country and I've done remarkable things as far as dignifying music for America – for black and white -- from one end of the world to the other. If you think there's not going to be repercussions about me all over the world – politically, religiously, spiritually – you're wrong. It will be. It's already been said (and I can show you) by the Canadians that out of all the crimes that America has created, the greatest one has been neglect of me. Let me show it to you, by a Canadian: "The greatest crime that they have committed has been neglect of me." And so, no wonder that in this university they'd be trying to block me from teaching, but they can't block me. It's too late. I'm a world citizen. Not only am I a world citizen, I'm a universe citizen. And I'm more than that too, if they only knew. But then when people are given a chance, they're just given a little glimmer of light where maybe they will turn. If they don't turn, the universe doesn't care, because the universe has been here a long time and it's still here.

People come and they go. It's such a shame that they can't stay a little longer, maybe 5,000 years, 10,000 years, millions of years. What's going to stop them? If they would just listen, they would hear some voices telling them how to stay here or to stay around for a while. So it's all about that. Now, this country's based upon the Bible, supposedly. They use it [in] Congress. Judges use it. Everybody use it. I can use it, too. Only I'm using it in a different way. It's got a lot of things in there that you have bypassed and every word I have told you about these different things concerning your survival is quite true. I'm dealing with equations. Nobody can bypass equations. If I was dealing with theories, it would be a different story, but I'm not. I'm telling you some very hard truths, but they are the truths. It's the whole thing that's been running this planet and ruining it. Now, I'm going to show you two more equations to back up the fact that I told you the truth. [writing] It's all about this "freedom" and "peace". Muslims was talking aboutpeace" in New York City. Police came in, broke the door down, all of that. They was saying "peace brother." So, actually it might sound ridiculous what I'm saying, but it keeps on working out equation wise. And I said the Muslims should stop saying "peace," because it's bad for the black man. Now here a case where he's saying "peace" in the Muslim temple. Now you know temples are where there's supposed to be some kind of sanctity about it, where the police don't come in there. They're supposed to be over there with God, they're supposed to be respected. They talking about "peace." So then the, the police, the peace officers came in there; they broke in.

Equations keep on working out that way. I told you about that freedom. [writing] Here's another equation. [more writing] There you got the word again Freedom and Death. It's all around you. Here's another one. I told you the book seems very innocent. It seems to be a stupid sort of book to catch those that are just going to not listen anyway, that think they know so much. [more writing] Free among the dead. I told you when they killed Reverend King, that's what they said, "he's free at last, free at last, great god almighty, free at last." He was slain, too and he's over in the grave. He's free among the dead. Where he's at, Dead is free. How can anybody be against those equations when they're working? It's very simple. I told you truths that nobody has ever told you before, because it's been hidden from the world for thousands and thousands of years. And I thought enough of the planet to tell them, with these equations and these equations are deadly. And they set up just like an automatic clock or something, working on people, killing them. All over the planet, don't care what religion they are, don't care what persuasion they are politically, they all up under that law. Now freedom, there you are, now, that's quite simple.

If they don't like it, go over there and fight with the Bible, not me, because those are not my words. I'm only showing you what's already here before I got here. They were here and they were being taught in churches or at least the book is in churches, book's in school, book's over in the library, the book's over in the bookstores. Now, if you don't want people to talk about it or to read it, take it out of the bookstores, take it out of the churches, take it off the judge's bench and just tell everybody, well, don't pay any attention to the Bible. But see you can't be hypocritical and have a book on the judge's bench and sit up there with a book, sentence black folks to jail by it, kill them by it. You can't do that. I mean this simply can go so far; you don't go no further. Now you going to recognize that book or I'm going to take it off of every judge's bench. You can't use it no more to sentence black people. It's against my law. It's all wrong. You can't take the book and recognize it on one hand for selfish advantages and not take the book and do justice with it. It's not allowed anymore. So, I'm speaking for black folks. Don't use that book anymore to condemn them, because you condemn the book. I mean you got people up there in authority, and they can sit up there and don't want somebody to tell you the truth, you don't need no book. I mean if you going to disregard the word of god and that's what made America what it is and that's what enabled white people to get the whole world. If you going to disregard the thing that made you great and the thing that held you up against the whole world, then there's nothing I can do for you. How can I help you if you going to disregard the only friend you had, which was the Bible?

So, it's not about trying to get to teach here, because I don't call it teaching. I call it really the last tactics of survival strategy for you as men, women, and children. It's a survival strategy thing that I'm doing, telling you that you should want to live. You don't have to die. Now the first time the white race is facing something that they're resisting, they're resisting their survival. That's the only thing they can resist against me, because that's all I'm talking about. So then, they've got about two days to get their self together, because I'm not going to worry about it. I'm setting all my plans to go right up to Egypt and set me up my headquarters, and get every black person out of America that's black. And I can do it. Right by the Bible; it says so: "I will take you to Egypt again by way of ships." I didn't write that. It also says about Egyptians, "I will send them a savior and a great one and he will deliver them." You got it right by the book. The Egyptians they got a right for somebody to save them, but as Negroes, of course not. And as you might say, just black men, no. But as Egyptians, according

to the Bible, god, the Creator sent them a savior. So now that's very simple. It comes down to a lot of other things. I said there's a difference between god and the Creator. Here's a place in a book called Amos, fourth chapter and eleven. It say, "I have overthrown some of you as god overthrew Sodom and Gomorrah." Here's somebody talking about god, just like god is something else and that's supposed to be god speaking. So then you've got more than one god. It says so. "I have overthrown some of you as god overthrew Sodom and Gomorrah." That's quite simple; a little child could understand that. Now here's another book called [inaudible] that says that the Creator and god are two different things, that god is the caretaker of this planet, but that the Creator owns the planet and he owns the whole universe. And that book was written by a white man. I didn't write it. So then the things I've been telling you have been out of a lot of books that have been written by white scholars. I haven't told you anything that was written by black scholars. They haven't written too much. Except, I did mention *God Wills the Negro* where a black scholar had some things in there, but he had some white scholars helping him at the University of Chicago, and I do think that scholars should recognize scholars.

I haven't been talking about theories or emotions or nothing like that. I've been telling you things that have been written by scholars. Now when it comes to a place where a university can't recognize scholars, it's not a university after all; it's just a political unit and a brainwashing machine or something. It most certainly isn't a university, because universities don't do that. When black men had universities in Africa, everyone was free to come down and to learn and to listen at everything that could be taught. A university is supposed to have everything there, whether good or bad. How you going to have some students that go out into the world and face it, unless you bring everything to them in the university. You bring it to them and they can discriminate themselves. I mean if they're in the university, they ought to have sense enough to be able to discriminate against what is good or what is bad for them, but if you don't present to the students all facets of what is being said out there, you're not a university. I went to a all black college and they most certainly brought people in there to talk to us and they wasn't telling us to believe it, but they started us hearing some white philosophers that not even white schools hear. They brought some that the white race wouldn't listen to, they brought them right to this black college and we were able to hear them. They weren't famous or nothing like that. They were just different individuals. We heard it. So now it come to a place where the white race has universities where they don't want somebody black talking something that's different. Well, I don't think black folk should stay in a place like that. I think they should go back to their own black schools, where they won't be placed in a position where they cant' hear what's happening. Because if you can't hear what's happening from all points in the universe, well, you not an educated man. And they talking at this black college I was going to, they wasn't trying to teach us to know everything, they was trying to teach us anything that we would want to know, we would know where to go to get it. And I think that's very good. That's the reason I am what I am today, because of black teachers and black colleges. I never was around white people too much and I've stated that.

That's why I'm really already a free spirit and about 10 years ago that's what a white person said speaking about the music. Down at the bottom it had: "Summation - Sun Ra, a free spirit." That's right, so then as far as that's concerned, all the white intellectuals in the underground and other places that recognize me, Voice of America, too – I told you, the Voice of America put me in

Carnegie Hall for two days. Swedish government put me in the Royal Dramatic Theater [for] two days. Egyptian government put me in the Balloon Theater. Counsel of Egyptian Ballet one night, put me on TV. Now, how can the white race stand in any kind of way among men if you got division in your race where you got some people not going to recognize something that's valid. I can see why you losing out if you got people like that, but, of course, I don't know what you can do about it because you're most certainly not going to stand in the world among men if you do that. Because men might be bad themselves, but they always have the idea of looking for justice. And men all over the world like to see a man do justice. That's the bravest thing of all, to be able to do justice and speak the truth. And you won't find any men anywhere in the world that won't respect something like that.

Now, in this case, like in Paris, I was talking to some of the fellows in the band and then a person from Persia, got down off the barstool and came down wanted me to talk to him. He was a Muslim and what he said was he had never heard nothing like what I was talking about, but for some reason, he knew it to be the truth. Here's a complete stranger. Egypt: Top musician, coming around, he told me, he'd never heard things like what I was talking about. Now, here's two strangers; never saw them before. I think Americans should really be listening to me, because they got a constitution talking about freedom of speech, and really you didn't have no business putting Angela Davis in jail, even if she's wrong. You can't be setting up things like that before the eyesight of the world, talking about freedom of speech and take a person and put [them] in jail because they saying something you don't like. You can't be a hypocrite like that. I'm telling you for your own good. Why don't you let that woman out? She could be ever so wrong. It makes no difference. I can't think of a single white person that's not doing wrong in some way. So, then you don't have no right to sitting up and judge somebody. You're doing wrong yourself. Don't no white person have no business sitting up there judging Angela Davis, and don't have no business sitting up and judging no black person. If you're perfect and you're righteous, yes, but then no white people are righteous, and I said that. They're wicked. So, how is it the case where the wicked going to sit up and judge whether a black person is right. No, that's out. Other black people might approve of it; I don't as a spiritual being. Because I wouldn't let no black person sit up and judge a white person. It wouldn't be right, because different people are over in different circumstances, environmentally and other ways. And so man sometime can't help doing what he's doing or being what he is because of the circumstances that cause him to be the way he is. And if someone's going to judge him, they would have to have been with him when he was a little baby and took care of him, seen that he didn't get anything wrong, protect him and then when he gets to be a man, then you sit up you can judge him. But, it's not right to sit up and judge somebody that you didn't feed, that you didn't clothe. You didn't do that. You didn't bring him into the world, no. It's improper. It's taking advantage of someone.

Of course, man has been following traditions and he got that kind of stuff fixed up, but it most certainly doesn't apply to me. Because I don't mind calling for the Creator to be out to destroy the planet. I'm not going through all that Christ stuff because I don't have to. But anyway, so the best thing I can do is to tell folks that. For a long time, I didn't want to tell them that. But [I am] under the Creator's orders to tell them, so I told them. Now what? It's up to them. They got two things to decide really. I'm setting all my stuff to go to Canada, and after that I'm going to France, and Denmark, and Russia, and Finland again, and Holland and Egypt and all the rest of the African countries. I'm even going down into

South Africa to see what they're doing. I bet you one thing: the white people in South Africa ain't as bad as the white people here. I've had a lot of experiences where I went around in the Deep South where white men acted more like men than the ones who talking about integration, than the ones who supposed to be liberals. I've had that personal experience in the Deep South.

I've had cases where I told white people what I had to tell them, and they didn't do nothing to me, FBI and everybody else. They didn't try to tell me to stop talking. They might have suggested it. One time the FBI told me "well, just don't talk to them niggers, because they ain't going to believe nothing you say no way." But I said, "no, you can't tell me what to say." That's the only time I ever had anyone say that: the FBI told me don't talk to niggers 'cause they don't ever believe nothing. Except in Chicago once, a white fella told me I was trying to tell a fella how Russia (this was ten or twelve years ago) Russia was going to be up in the space program and they was going to be up there co-ruling with the United States for a while. I told him that. He said it wasn't going to happen. I told him it was. He insisted it wasn't. A white fella about seventy-ears old said, "Well, come over and talk to me. He's a Negro; he's not going to believe you, but [I'm] seventy years old, and I ain't never heard nothing like that before. Come over and talk to me." Well, I went over and started talking to him and he told me, "you're a different order of being. He'll never understand; you could talk to him forever. I respect you as a different order of being. Talk to me." That was a white man. [tape ends]

SRC281/ESS/CAA

The music got to be changed immediately. The savage beast in people – they been saying music soothes the savage beast, so that's where the music come in. Got to have another kind of music and meter from morning till night. Radio, television, movies, everything needs to be stopped, at least for a month; fill the airwaves with pure music. You'd be surprised how people will change right before your eyes. [inaudible] All the people need to do is to soothe them mentally, spiritually, physically, and they'd be all right. With the music is uh, taking them on out, because the music reaches them quicker than anything else and more continuously than anything else. People listen at music from morning to night. Radio, television, movies, records – nothing but music. Now the world you see today is the results of the music. You judge a tree by the fruits and look. The music has been designed to suit the earth desires of people: Sell whiskey, sell dope, sell sex, sell religion, sell politics, sell war.

The music. Don't give anything unless you have a benefit. The musicians, they start the whole thing. Whenever someone wants to start something they get a musician to play a benefit. The music opens up things then. Still the musicians don't have a part in society. But think what kind of planet it would be if you didn't have any music. You didn't have any birds singing. Nothing. No records, no musicians and you'd see that everything else you got wouldn't seem to be so beautiful....You can't walk without rhythm. You walk on the balls of your foot. You see, that roundness, there also is that movement on to something, forward means to, you got to again. You move to something, they said towards, forward, onward. You see this word "on" is very important. We had a city in ancient Egypt called "On", the City of the Sun. Now, that means that this Bible that is affecting everybody today, it's making headlines in subtle ways, although people think it's not important. It is. It's affecting America all kinds of ways., It's affecting president, rich people, paupers, insane people. They're there because of the book. All the sickness is there because of that book It's really a

scenario for people's lives. It's a place in there that say, "we live our lives like a tale that is told." You see, it's very simple; everything you're living is some story that's been told. And what's the story? The greatest story ever told, of course. Why is the greatest story ever told great? Because it's got everybody's life over in it. You look in there, you'll see where you're playing a part in it. People is getting heart transplants; that's over in there, too. I see all kind of things happening in a subtle way. Say, "I will take away the stony heart and give them a heart of flesh." That's heart transplants. That's what they're doing. They're going in there and people got hearts calcified or something, they reach in there and take it out and put another one in there.

Now that's what the book says. It's got all kind of thing in there like, "I will plant my people in pleasure, and they shall dwell in the earth forever." You know, that might sound very good – He's going to plant his people. You plant somebody – look at black folks. Down on *plan-nations*, when they was in so-called slavery. I mean, it was on these *plan-nations*, somebody planted them on *plan-nations*. Plant my people. Now, you go out to the cemetery, they planting somebody now. In some cemeteries, that's all they do, is plant folks down in the ground, like seeds. They actually say when a person is like on skid row or something, they [say] something like, he's going to seed or something like that. So he's going to seed, what you going to do with him? Do like you do with the rest of the seeds – put him down in the ground. Now all that kind of thing is happening to all the people on the planet – it's very bad, very unnecessary. It get so in America that when a person just *say* he wants to run for president, he gets shot. [inaudible] That's what I'm talking about; you know it's not like that. This whole thing is a set-up. You can't go no further than the supervisor let's you go. [Inaudible] Every nation that ever rose up, didn't rise up itself. Something picked it up, put it there. It didn't make no difference what color they were. It didn't make no difference whether they was the world's greatest sinner. Something reached down, put it there. Some say the white race is there now. They're not doing it. They're no worse than the other people on the planet. All these people are bad as far as the Cosmos is concerned, but it's just time for them to come down. At least there's something equational about it: If you could find ten honest men in the gentiles, they could be saved. [inaudible] ...I said ask him if he could find one honest man of the white race, if he could save the white race. [tape becomes very inaudible here.] Why don't you recognize the truth, you might need it one day. [inaudible]

SR280/ESS/CAA

The same thing goes to man. [inaudible] He's not supposed to be riding up above the bounds When I read the history of human beings, I don't see any progress. Everything is standing still. It's like humanity is on a treadmill. Just walking and they are far from getting anywhere. They should see that if you're going somewhere, the scenery changes. But it's still the same old dull scenery and nothing changes. They say history repeats itself. If history repeats itself, then nobody is getting anywhere. If the history itself is no good, it's not going to do anybody no good to be a part of a history if that history is bad and it's bad all right. It's worse than anything that anybody could write about. With all the schools they have and all the philosophers sent to them, it's not supposed to be like that on this planet, but you see it is. So, you can't blame the men who came and sacrificed their lives and gave up their time to science and education. These men gave up a lot of things to humanity, and all the time they gave up, all the pleasures they sacrificed, [inaudible] love and everything for the sake of people, All the time

233

these men gave up was in vane. All the men who went to war to die for a better world, died in vain. Now the Creator of the universe doesn't like anything like that and this planet will be penalized far beyond its endurance if it's not careful. Not only will it be penalized, it'll be eliminated out of the solar system, because it's not serving any useful purpose. If a planet gets to where it's no use to its own self, then it can't be any use to the Creator of the universe. But if people get so they're no use to where they're no use to their own self, then how can they be of any use to the creator or to anything? Yet, it has reached that point, and it is a very dangerous point. Millions and millions of lives are at stake at this point in a way which has never been like this before. Because this is another age of people living here, and, of course are different from the age that has just gone by. But you see they're still over in that other age, thinking that they can achieve something with the same rules they have.

Now, I don't expect people to listen to me. Listen to the voice of nature and tune into the greater nature. I'm not talking about nature on this planet; it's out of tune. Tune into the greater nature of the universe. It's always in tune. Nature's like an instrument. This planet is like an instrument. Instruments get out of tune and when they do the best person to tune it is really a master musician. He's got the natural sound and know how it's supposed to sound. It's just like on the piano: If you got all the Gs out of tune, you can arrange a scale and nobody's going to miss that note you took out. You can add fourteen notes or you can do some more, down to five notes. You can change the scales and so can the Creator. He's a musician too, you know. If this planet keeps on being out of tune, he can take it right out of the *arkestry*. You've heard about the music of the spheres; that's what it means. Every planet is a sphere and every planet has got a note. This one is on the note G right now. Maybe it's not supposed to be G, but it named itself G. Now, that's over in England where they have that in a [inaudible] called [inaudible]. Now this note G. you notice everything is based on seven. You have seven days of the week. You have seven notes in the scale. You start at A and you go up to G, so that makes G seven. Now G is the name of the Earth as I said before. The seventh day is the day of rest. This rest and this seven is because God rested on the seventh day. Now among black people and [inaudible phrase] Like in Chicago, a black man was out talking to some black people, seven or eight years ago, and all at once, he said, "They said that God made the Earth in six days and on the seventh day he rested." He said, "that didn't make goddamned fucking sense." At that time it really surprised me that someone would say something like that, but I kept on listening to black men who didn't have any education, and they kept on talking things that I had to recognize, because I knew that they weren't saying these things. I knew that something was talking through them. Sometimes, the Creator of the universe and other beings want to talk to people and they come to an intellectual and their minds are so full up with what they know, they might think that the people will say that it's ridiculous and they won't speak. But every now and then, a voice will come and speak to any man, and say tell the people I said such and such a thing. Now this man got so much wisdom and everything...

Because I'd be ashamed to tell people that. But you find that the greatest men to come along, the prophets, they didn't care nothing about what people thought. You find that they had to go through a lot of shame. A lot of men came up and told the truth by saying the world is round, got burnt up for it. As far as truth is concerned, you've had many men to suffer and to die for the word true. That's very strange that they would have to do that. If the Creator of the universe is just, why would he let them go through all of that. Then I found out that there are

234

certain laws on this planet. The Creator doesn't really come on the planet and do anything about it as long as the people on the planet don't care anything about themselves. If they want to take all that, that's them, because he's not a human being. So he's not going to be enforcing his laws and things on a human being.

Thanks to John Corbett and Experimental Sound Studio
for housing, preserving, and allowing access to these materials.

d.c. space © Michael Wildermann

INDEX

THANKS TO MY "ARKESTRA"

This Execution was brought to you by...

Cosmo Crowd Funding

FUNDING SPONSOR

P Fadwah Halaby, CNM	Joe's Record Paradise	Bill Warrell d.c.space, dciproduction.com

SOLID ALLY

Nkechi Taifa, Esq. Sara Donnelly	Ceci Cole McInturff Tommy Nutt	Janet Morgan

PATRON

Matt Nolan	Arnaé ♶	ALAN DIAZ de LEWINE
Rusty Hassan	Helen C. Frederick	CJ Marsicano
Sam Morrison	Robert Hill	Gary Mollica
Herb Taylor	Paul S.H. Griffiths	Rick Massumi
Kirby Malone and	Pat Gillis	Chris Downing
Gail Scott White	mark cooley	Janeece R. Warfield
Justin Raphael Roykovich	Lynne Constantine	Zinnia Maravell
Groovy Nate	john szwed	Ramez
Matt o' Nancy Daynard	stewlyons@aol.com	
tom ashcraft	yotte	

BOOK PREORDERS

Sue Wrbican	vina sananikone	David Jenkins	Steve Hoffman
Joey Smith	Luke Stewart	Jeff Surak	Njemile Carol Jones
pronoblem	Scott Enriquez	John Bonner	Kimberly Sheridan
Paolo Valladolid	Moe Jordan	Jonathan Morris	James D. Dilworth
Doug Calvin	Alan Shaw	Brett Isaacoff	Steven Joerg
Mike Conway	Amber Dunleavy	John Melton	Ward McDonald
Janel Leppin	Jim Kleissler	Alia Thabit	Chris Videll
Lili White	Illana A Stanley	Cynthia Robbins	Janice Marks
Michael Verdon	Michael Wilderman	Jenny Moon Tucker	Lindsey Tharp
David Gouldsmith	Michael Sargent	lunapik	Issa Sherzad
Walter Kravitz	Doris Vila Licht	Anthony Pirog	Marian McLaughlin
Keith Sinzinger	sean westergaard	Joshua James	Issam Asali
(Fast Forty)	Steven Hammer	Sven Abow	Garth Muhammad
Stephanie White	Jonathan Eaker	Ray F. Triana	Mika'il Abdullah Petin
miyuki	Peter Mosher	Alexander Belinfante	Byron Hawk
Reuben Jackson	Finn McCool	Lee McKinster	
Colin Masso	Garrison Fewell	James Lindbloom	

TEE-NINCHY TASTE

Brittani Renee George	Aaron Robbs	Peter Lee	greg tate
Michael Tree	Daniel Dean	Rose Sadegh	Erica Fallin
Sue Mulligan	Andrius and Joshua	Sharon Levy	Michael McGregor
Jason Mullinax			

SPIRITUAL SUPPORT SQUAD

Uncle Tomas Shash and the Dancers at Aztlan Nana Kofi Asiedu Ofori	Grandma Cynthia Harsley Suresh Kodolikar

CPSIA information can be obtained
at www.ICGtesting.com
Printed in the USA
FFOW02n1014160215
11102FF